MARCEL DUCHAMP

by Octavio Paz

POETRY

Configurations
Eagle or Sun?
Renga: A Chain of Poems (by Octavio Paz, Jacques
 Roubaud, Eduardo Sanguinetti, and Charles Tomlinson)
Early Poems
Anthology of Mexican Poetry (Editor)

ESSAYS

Alternating Current
The Bow and the Lyre
Claude Lévi-Strauss: An Introduction
Labyrinth of Solitude: Life and Thought in Mexico
Marcel Duchamp, or the Castle of Purity
The Other Mexico: Critique of the Pyramid
Conjunctions and Disjunctions
Children of the Mire
The Siren and the Seashell

MARCEL DUCHAMP

APPEARANCE STRIPPED BARE

by

OCTAVIO PAZ

translated by Rachel Phillips and Donald Gardner

SEAVER BOOKS
NEW YORK

ACKNOWLEDGMENTS

Jonathan Cape Ltd., and Grossman Publishers: For *The Castle of Purity* by Octavio Paz, translated by Donald Gardner. English language translation Copyright © Jonathan Cape Ltd., 1970.

The Museum of Modern Art: * *water writes always in* * *plural*, translated from the Spanish by Rachel Phillips, and the chronology from *Marcel Duchamp*, edited by Anne d'Harnoncourt and Kynaston McShine. Copyright © 1973 The Museum of Modern Art, New York. All rights reserved. Reprinted by permission.

Published by Seaver Books, 333 Central Park West,
New York, New York 10025
Distributed in the United States by Henry Holt and Company, Inc.
521 Fifth Ave., New York, New York 10175
Distributed in Canada by Fitzhenry & Whiteside,
195 Allstate Parkway, Markham, Ontario L3R 4T8

Library of Congress Cataloging in Publication Data
Paz, Octavio, 1914–
Marcel Duchamp, appearance stripped bare.
"A Seaver book."
Contents: The castle of purity.—* Water writes
always in * plural.
1. Duchamp, Marcel, 1887–1968. I. Title.
ND553.D774P352 759.4 78–17560
ISBN: 0-8050-0149-2

First published in English in hardcover as
A Richard Seaver Book/The Viking Press in 1978

First paperback edition published by Seaver Books in 1981

Printed in the United States of America
10 9 8 7 6 5 4 3 2

ISBN 0-8050-0149-2

FOREWORD

■ In 1923 Marcel Duchamp left the *Large Glass (The Bride Stripped Bare by Her Bachelors, Even)* "finally unfinished." That was when the legend began: one of the most famous painters of our century had abandoned art to devote himself to chess. But in 1969, a few months after his death, critics and public discovered to their amazement that Duchamp had been working in secret for twenty years (1946–66) on a work that was probably no less important and complex than the *Large Glass.* It was an Assemblage called *Etant donnés: 1° la chute d'eau, 2° le gaz d'éclairage (Given: 1. The Waterfall, 2. The Illuminating Gas),* and it

is now housed in the Philadelphia Museum of Art, as are most of Duchamp's works. The title of the Assemblage alludes to one of the most important notes in the *Green Box*, that collection of ninety-three documents (photographs, drawings, and manuscript notes from 1911 to 1915) published in 1934 and constituting a sort of guidebook or manual to the *Large Glass*. And so the new work may be seen as another version of *The Bride Stripped Bare by Her Bachelors, Even*.

In the autumn of 1973 a large retrospective Duchamp exhibition was organized in the United States by the Philadelphia Museum of Art and the Museum of Modern Art of New York. At the request of both institutions I wrote for the occasion an essay on *Given: 1. The Waterfall, 2. The Illuminating Gas*. That essay complements another text of mine, written in 1966 and included in the "portmanteau book" *Marcel Duchamp, or the Castle of Purity* (New York, 1970). The present volume comprises both studies. The first, after a brief introduction to Duchamp's work, analyzes the *Large Glass;* the second examines the Assemblage and shows the relationship between these two works. When I was preparing this new edition I made a few scattered corrections in the first essay; in the process I added some thirty pages in which I try to uncover all the elements making up the *Large Glass*, the function of each one, and the relationships that unite them. I also revised the second essay and added another fifty pages. In these, my most recent reflections on the subject, I have tried to show where Duchamp's work belongs in the main tradition of the West—the physics and metaphysics not

of sex but of love—and its meta-ironic relationship with that tradition.

It is above all the rigorous unity of Marcel Duchamp's work that surprises anyone reviewing it in its entirety. In fact, everything he did revolves around a single object, as elusive as life itself. From the *Nude Descending a Staircase* to the naked girl in the Philadelphia Assemblage, via the *Bride Stripped Bare by Her Bachelors, Even,* his life's work can be seen as different moments—the different appearances—of the same reality. Anamorphosis in the literal meaning of the word: to see this work in its successive forms is to return to the original form, the true source of appearances. An attempt at revelation, or, as he used to say, "ultrarapid exposure." He was fascinated by a four-dimensional object and the shadows it throws, those shadows we call realities. The object is an Idea, but the Idea is resolved at last into a naked girl: a presence.

O.P.

Mexico, August 20, 1976.

CONTENTS

ILLUSTRATIONS

MARCEL DUCHAMP

THE CASTLE OF PURITY

Sens: on peut voir regarder.
Peut-on entendre écouter, sentir?
M.D.

■ Perhaps the two painters who have had the greatest influence on our century are Pablo Picasso and Marcel Duchamp. The former by his works; the latter by a single work that is nothing less than the negation of work in the modern sense of the word. The transformations that Picasso's painting has gone through—metamorphoses would be a more accurate word—have astonished us consistently over a period of more than fifty years; Duchamp's inactivity is no less astonishing and, in its way, no less fruitful. The creations of the great Spanish artist have been incarnations and, at the same time, prophecies of the mu-

tations that our age has suffered between the end of Impressionism and the Second World War. Incarnations: in his canvases and his objects the modern spirit becomes visible and palpable; prophecies: the transformations in his painting reveal our time as one which affirms itself only by negating itself and which negates itself only in order to invent and transcend itself. Not a precipitate of pure time, not the crystallizations of Klee, Kandinsky, or Braque, but time itself, its brutal urgency, the immediate imminence of the present moment. Right from the start Duchamp set up a vertigo of delay in opposition to the vertigo of acceleration. In one of the notes in the celebrated *Green Box* he writes: "use *delay* instead of 'picture' or 'painting'; 'picture on glass' becomes 'delay in glass'. . . ." This sentence gives us a glimpse into the meaning of his activity: painting is a criticism of movement, but movement is the criticism of painting. Picasso is what is going to happen and what is happening, he is posterity and archaic time, the distant ancestor and our next-door neighbor. Speed permits him to be two places at once, to belong to all the centuries without letting go of the here and now. He is not the movements of painting in the twentieth century; rather, he is movement become painting. He paints out of urgency and, above all, it is urgency that he paints: he is the painter of time. Duchamp's pictures are the presentation of movement: the analysis, the decomposition, the reverse of speed. Picasso's drawings move rapidly across the motionless space of the canvas. In the works of Duchamp space begins to walk and take on form; it becomes a machine that spins arguments and philosophizes; it resists movement with delay and delay with irony. The pictures of the former

are images; those of the latter are a meditation on the image.

Picasso is an artist of an inexhaustible and uninterrupted fertility; the latter painted fewer than fifty canvases and these were done in under ten years: Duchamp abandoned painting, in the proper sense of the term, when he was hardly twenty-five years old. To be sure, he went on "painting" for another ten years, but everything he did from 1913 onward is a part of his attempt to substitute "painting-idea" for "painting-painting." This negation of painting, which he calls "olfactory" (because of its smell of turpentine) and "retinal" (purely visual), was the beginning of his true *work*. A work without works: there are no pictures except the *Large Glass* (the great delay), the Readymades, a few *gestures*, and a long silence. Picasso's work reminds one of that of his compatriot Lope de Vega, and in speaking of it, one should in fact use the plural: the works. Everything Duchamp has done is summed up in the *Large Glass*, which was "finally unfinished" in 1923. Picasso has rendered our century visible to us; Duchamp has shown us that all the arts, including the visual, are born and come to an end in an area that is invisible. Against the lucidity of instinct he opposed the instinct for lucidity: the invisible is not obscure or mysterious, it is transparent. . . . The rapid parallel I have drawn is not an invidious comparison. Both of them, like all real artists, and not excluding the so-called minor artists, are incomparable. I have linked their names because it seems to me that each of them has in his own way succeeded in defining our age: the former by what he affirms, by his discoveries; the latter by what he negates, by his explorations. I don't know if they are the "greatest"

painters of the first half of the century. I don't know what the word "greatest" means when applied to an artist. The case of Duchamp—like that of Max Ernst, Klee, De Chirico, Kandinsky, and a few others—fascinates me not because he is the "greatest" but because he is unique. This is the word that is appropriate to him and defines him.

The first pictures of Duchamp show a precocious mastery. They are the ones, however, that some critics describe as "fine painting." A short time afterward, under the influence of his elder brothers, Jacques Villon and the sculptor Raymond Duchamp-Villon, he passed from Fauvism to a restrained and analytical Cubism. Early in 1911 he made the acquaintance of Francis Picabia and Guillaume Apollinaire. It was undoubtedly his friendship with these two men that precipitated an evolution that had until then seemed normal. His desire to go beyond Cubism can already be seen in a canvas of this period; it is the portrait of a woman passing by: a girl glimpsed once, loved, and never seen again. The canvas shows a figure that unfolds into (or fuses with) five female silhouettes. As a representation of movement or, to be more precise, a decomposing and superimposing of the positions of a moving body it anticipates the *Nude Descending a Staircase*. The picture is called *Portrait (Dulcinea)*. I mention this detail because by means of the title Duchamp introduces a psychological element, in this case affectionate and ironic, into the composition. It is the beginning of his rebellion against visual and tactile painting, against "retinal" art. Later he will assert that the title is an *essential* element of painting, like color and drawing. In the same year he painted a few other

canvases, all of them striking in their execution and some of them ferocious in their pitiless vision of reality: analytical Cubism is transformed into mental surgery. This period closes with a noteworthy oil painting: *Coffee Mill.* The illustrations to three poems of Laforgue also come from this time. These drawings are interesting for two reasons: on the one hand, one of them anticipates the *Nude Descending a Staircase;* on the other, they reveal that Duchamp was a painter of *ideas* right from the start and that he never yielded to the fallacy of thinking of painting as a purely manual and visual art.

In a conversation he had in 1946 with the critic James Johnson Sweeney[1] Duchamp hints at the influence of Laforgue on his painting: "The idea for the *Nude* . . . came from a drawing which I had made in 1911 to illustrate Jules Laforgue's poem *Encore à cet astre.* . . . Rimbaud and Lautréamont seemed too old to me at the time. I wanted something younger. Mallarmé and Laforgue were closer to my taste. . . ." In the same conversation Duchamp emphasizes that it was not so much the poetry of Laforgue that interested him as his titles (*Comice agricole*, for example). This confession throws some light on the *verbal* origin of his creative activity as a painter. His fascination with language is of an intellectual order; it is the most perfect instrument for producing meanings and at the same time for destroying them. The pun is a miraculous device because in one and the same phrase we exalt the power of the language to convey meaning only in order, a moment later,

1. Quoted in *Marchand du sel*, écrits de Marcel Duchamp, introduction by Michel Sanouillet (Paris: Le Terrain Vague, 1958).

to abolish it the more completely. Art for Duchamp, all the arts, obey the same law: meta-irony is inherent in their very spirit. It is an irony that destroys its own negation and, hence, returns in the affirmative. Nor is his mention of Mallarmé fortuitous. Between the *Nude* and *Igitur* there is a disturbing analogy: the descent of the staircase. How can one fail to see in the slow movement of the woman-machine an echo or an answer to that solemn moment in which *Igitur* abandons his room forever and goes step by step down the stairs which lead him to the crypt of his ancestors? In both cases there is a rupture and a descent into a zone of silence. There the solitary spirit will be confronted with the absolute and its mask, chance.

Almost without realizing it, as if drawn by a magnet, I have passed over in a page and a half the ten years that separate his early works from the *Nude*. I must pause here. This picture is one of the pivotal works of modern painting: it marks the end of Cubism and the beginning of a development that hasn't yet been exhausted. Superficially—though his work is constant proof that no one is less concerned with the superficial than Duchamp—the *Nude* would seem to draw its inspiration from preoccupations similar to those of the Futurists: the desire to represent movement, the disintegrated vision of space, the cult of the machine. Chronology excludes the possibility of an influence: the first Futurist exhibition in Paris was held in 1912 and, a year before, Duchamp had already painted a sketch in oils for the *Nude*. The similarity, moreover, is only an apparent one: the Futurists wanted to suggest movement by means of a dynamic painting; Duchamp applies the notion of delay—or, rather, of analysis—to movement. His aim is more objective

and goes closer to the bone: he doesn't claim to give the illusion of movement—a Baroque or Mannerist idea that the Futurists inherited—but to decompose it and offer a static representation of a changing object. It is true that Futurism also rejects the Cubist conception of the motionless object, but Duchamp goes beyond stasis and movement; he fuses them in order to dissolve them the more easily. Futurism is obsessed by sensation, Duchamp by ideas. Their use of color is also different. The Futurists revel in a painting that is brilliant, passionate, and almost always explosive. Duchamp came from Cubism and his colors are less lyrical; they are denser and more restrained: it is not brilliance that he is after but rigor.

The differences are even greater if we turn from the external features of the painting to considering its real significance, that is to say, if we really penetrate the vision of the artist. (Vision is not only what we see; it is a stance taken, an idea, a geometry—a *point of view* in both senses of the phrase.) Above all, it is one's attitude toward the machine. Duchamp is not an adept of its cult; on the contrary, unlike the Futurists, he was one of the first to denounce the ruinous character of modern mechanical activity. Machines are great producers of waste, and the refuse they leave increases in geometric proportion to their productive capacity. To prove the point, all one needs to do is to walk through any of our cities and breathe its polluted atmosphere. Machines are agents of destruction and it follows from this that the only mechanical devices that inspire Duchamp are those that function in an unpredictable manner—the antimachines. These apparatuses 7 are the equivalent of the puns: the unusual ways in which

they work nullify them as machines. Their relation to utility is the same as that of delay to movement; they are without sense or meaning. They are machines that distill criticism of themselves.

The *Nude* is an antimachine. The first irony consists in the fact that we don't even know if there is a nude in the picture. Encased in a metal corset or coat of mail, it is invisible. This suit of iron reminds us not so much of a piece of medieval armor as of the body of an automobile or a fuselage. Another stroke that distinguishes it from Futurism is the fact that it is a fuselage caught in the act not of flight but of a slow fall. It is a mixture of pessimism and humor: a feminine myth, the nude woman, is turned into a far more gloomy and threatening apparatus. I will mention, as a last point, a factor that was already present in his earlier works: rational violence, so much more ruthless than the physical violence that attracts Picasso. Robert Lebel says that in Duchamp's painting "the nude plays exactly the same role as the old drawings of the human skeleton in the anatomy books: it is an object for internal investigation."[2] For my part I would emphasize that the word "internal" should be understood in two senses: it is a reflection on the internal organs of an object and it is interior reflection, self-analysis. The object is a metaphor, an image of Duchamp: his reflection on the object is at the same time a meditation on himself. To a certain extent each one of his paintings is a symbolic self-portrait. Hence the plurality of meanings and points of view of a work like the *Nude:* it is pure plastic creation and meditation on

2. Robert Lebel, *Sur Marcel Duchamp* (Paris: Trianon, 1959).

painting and movement; it is the criticism and culminating point of Cubism; it is the beginning of another kind of painting and the end of the career of Duchamp as a pictorial artist; it is the myth of the nude woman and the destruction of this myth; it is machine and irony, symbol and autobiography.

After the *Nude* Duchamp painted a few extraordinary pictures: *The King and the Queen Surrounded by Swift Nudes, The Passage from Virgin to Bride,* and *Bride.* In these canvases the human figure has disappeared completely. Its place is taken not by abstract forms but by transmutations of the human being into delirious pieces of mechanism. The object is reduced to its most simple elements: volume becomes line; the line, a series of dots. Painting is converted into symbolic cartography; the object into idea. This implacable reduction is not really a system of painting but a method of internal investigation. It is not the philosophy of painting but painting as philosophy. Moreover, it is a philosophy of plastic signs that is ceaselessly destroyed, as philosophy, by a sense of humor. The appearance of human machines might make one think of the automatons of De Chirico. It would be quite absurd to compare the two artists. The poetic value of the figures of the Italian painter comes from the juxtaposition of modernity with antiquity; the four wings of his lyricism are melancholy and invention, nostalgia and prophecy. I mention De Chirico not because there is any similarity between him and Duchamp but because he is one more example of the disturbing invasion of modern painting by machines and robots. Antiquity and the Middle Ages thought of the automaton as a magical entity; from the Renaissance on-

ward, especially in the seventeenth and eighteenth centuries, it was a pretext for philosophical speculation; Romanticism converted it into erotic obsession; today, because of science, it is a real possibility. The female machines of Duchamp remind us less of De Chirico and other modern painters than of the Eve Future of Villiers de L'Isle-Adam. Like her, they are daughters of satire and eroticism, although, unlike the invention of the Symbolist poet, their form doesn't imitate the human body. Their beauty, if this word can be applied to them, is not anthropomorphic. The only beauty that Duchamp is interested in is the beauty of "indifference": a beauty free at last from the notion of beauty, equidistant from the romanticism of Villiers and from contemporary cybernetics. The figures of Kafka, De Chirico, and others take their inspiration from the human body; those of Duchamp are mechanical devices and their humanity is not corporeal. They are machines without vestiges of humanity, and yet, their function is more sexual than mechanical, more symbolic than sexual. They are ideas or, better still, *relations*—in the physical sense, and also in the sexual and linguistic; they are propositions and, by virtue of the law of meta-irony, counterpropositions. They are symbol-machines.

There is no need to seek further for the origins of Duchamp's delirious machines. The union of these two words—"machine" and "delirium," "method" and "madness"—brings to mind the figure of Raymond Roussel. Duchamp himself has on various occasions referred to that memorable night in 1911 when—together with Apollinaire, Picabia, and Gabrielle Buffet—he went to a performance of *Impressions d'Afrique.* To his discovery

of Roussel must be added that of Jean-Pierre Brisset.[3] In the conversation with Sweeney referred to earlier, Duchamp talks enthusiastically about both people: "Brisset and Rousseau were the two men I most admired at that time for the wildness of their imaginations. . . . Brisset was preoccupied with the philological analysis of language—an analysis that consisted of spinning an unbelievable web of double entendres and puns. He was a kind of Douanier Rousseau of philology. But it was fundamentally Roussel who was responsible for my glass, *The Bride Stripped Bare by Her Bachelors, Even.* This play of his, which I saw with Apollinaire, helped me greatly on one side of my expression. I saw at once that I could use Roussel as an influence. I felt that as a painter it was much better to be influenced by a writer than by another painter. And Roussel showed me the way. . . ."

The Bride is a "transposition," in the sense that Mallarmé gave the word, of the literary method of Roussel to painting. Although at that time the strange text in which Roussel explains his no less strange method, *Comment j'ai écrit certains de mes livres,* had not yet been published, Duchamp intuited the process: juxtaposing two words with similar sounds but different meanings, and finding a verbal bridge between them. It is the carefully reasoned and delirious development of the principle that inspires the pun. What is more, it is the conception of language as a structure in movement, this discovery of modern linguistics that has had so much influence on the anthropology of Lévi-

3. For Brisset see the *Anthologie de l'humour noir* by André Breton (Paris: Sagittaire, 1940).

11

Strauss and, later, on the new French criticism. For Roussel, of course, the method was not a philosophy but a literary method; equally, for Duchamp, it is the strongest and most effective form of meta-irony. The game that Duchamp is playing is more complex because the combination is not only verbal but also plastic and mental. At the same time, it contains an element that is absent in Roussel: criticism, irony. Duchamp *knows* that it is insane. Roussel's influence is not limited to the method of delirium. In the *Impressions d'Afrique* there is a painting machine; although Duchamp did not fall into the trap of naïvely repeating the device literally, he resolved to suppress the hand, the brushstrokes, and all personal traces from his painting. Instead, ruler and compass. His intention wasn't to paint like a machine but to make use of machines for painting. However, his attitude does not show any affinity for the religion of the machine: every mechanism must produce its own antidote, meta-irony. The element of laughter doesn't make the machines more human, but it does connect them with their center, which is man, with the source of their energy, which is hesitancy and contradiction. "Beauty of precision" in the service of indetermination: contradictory machines.

In the summer of 1912 Marcel Duchamp went to Munich for a time. There he painted several pictures that laid the groundwork for his "magnum opus," if it is permissible to use the terms of alchemy to describe the *Large Glass:* *Virgin (No. 1* and *No. 2), The Passage from Virgin to Bride,* the *Bride,* and the first drawing on the theme of *The Bride Stripped Bare by Her Bachelors,* still without the adverb that makes the phrase stumble. The project of the

Large Glass was on his mind from 1912 to 1923. Despite this central preoccupation, he was possessed by a will to contradiction that nothing and no one escaped, not even himself and his work, and there were long periods in which he almost totally lost interest in his idea. His ambiguous attitude to the work—whether to realize it or to abandon it—found a solution that contained all the possibilities that he could adopt toward it: to contradict it. This is, in my opinion, the meaning of his activity over all these years, from the invention of the Readymades and the puns and word games distributed under the female pseudonym Rrose Sélavy, to the optical machines, the short *Anémic Cinéma* (in collaboration with Man Ray), and his intermittent but central participation first in the Dada movement and later in Surrealism. It is impossible in an essay of this length to enumerate all Duchamp's activities, gestures, and inventions after his return from Germany.[4] I will mention only a few of them.

The first was his journey to Zone, a community in the Juras, again in the company of Apollinaire, Picabia, and Gabrielle Buffet. This excursion, to which we owe the title of the poem by Apollinaire that opens *Alcools,* already foretells the future explosion of Dada. The enigmatic marginal notes of the *Green Box* mention this brief journey, which was no less decisive than the one to Munich in the same year. In the personal evolution of Duchamp it has a

4. Despite the time elapsed, the book by Robert Lebel that I have already quoted is still the most lucid study of Duchamp's life and development. On the puns, see *Duchamp du Signe* (Paris: Flammarion, 1975), which is a collection of his writings by Michel Sanouillet and Elmer Peterson. This volume completes and replaces *Marchand du Sel.*

significance analogous to his discovery of Roussel: it confirms his decision to break not only with "retinal" painting but also with the traditional conception of art and the common use of language (communication). In 1913 the first exhibition of modern art (the Armory Show) was held in New York and *Nude Descending a Staircase*, which was shown there, obtained an immediate and literally scandalous renown. It is significant—exemplary, I should say—that in the same year Duchamp gave up "painting" and looked for employment that would allow him to dedicate himself freely to his investigations. Thanks to a recommendation from Picabia, he found work in the Bibliothèque Sainte-Geneviève.

Many notes, drawings, and calculations have been preserved from this period, almost all of them relating to the long-delayed execution of the *Large Glass*. Duchamp calls these notes *physique amusante*. They could also be called *comic calculations*. Here is an example: "a straight thread one meter long falls from a height of one meter onto a horizontal plane and, twisting *as it pleases*, gives us a new model for the unit of length." Duchamp carried out the experiment three times, so that we have three units, all three of them equally valid, and not just one as we have in our poor everyday geometry. The three threads are preserved in the position in which they fell, in a croquet box: they are "canned chance." Another example: "By *condescension* this weight is denser going down than going up." All these formulas have the aim of rendering useless our notions of left and right, here and there, East and West. If the center is in a state of permanent seism, if the ancient notions of solid matter and clear and distinct reason disap-

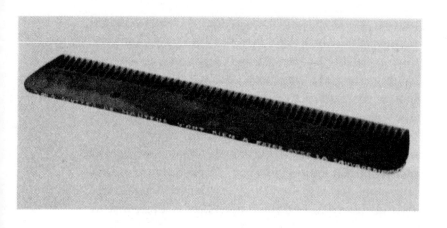

Comb, *1916. (Readymade.) Philadelphia Museum of Art: The Louise and Walter Arensberg Collection.*

pear and give place to indetermination, the result is general *disorientation*. Duchamp's intention is to get rid forever of "the possibility of recognizing or identifying any two things as being like each other": the only laws that interest him are the laws of exception, which apply only for one case and for one occasion only. His attitude to language is no different. He imagines an alphabet of signs to denote only the words that we call abstract ("which have no concrete reference") and concludes: "This alphabet very probably is suitable only for the description of this picture." Painting is writing and the *Large Glass* is a text that we have to decipher.

In 1913 the first Readymade appears: *Bicycle Wheel*. The original has been lost, but an American collector possesses a version of 1951. Little by little others arrive: *Comb, With Hidden Noise, Corkscrew, Pharmacy* (a chromolithograph), *Water & Gas on Every Floor, Apolinère Enameled* (an advertisement for Sapolin enamel), *Pocket Chess Set*, and a few others. There aren't many of them; Duchamp exalts the gesture without ever falling, like so many modern artists, into gesticulation. In some cases the Readymades are pure, that is, they pass without modification from the state of being an everyday object to that of being a "work of anti-art"; on other occasions they are altered or rectified, generally in an ironic manner tending to prevent any confusion between them and artistic objects. The most famous of them are *Fountain*, a urinal sent to the Independents exhibition in New York, and rejected by the selection committee; *L.H.O.O.Q.*, a reproduction of the *Mona Lisa* provided with a beard and mustache; *Air de Paris*, a 50-cc glass ampul that contains a sample of

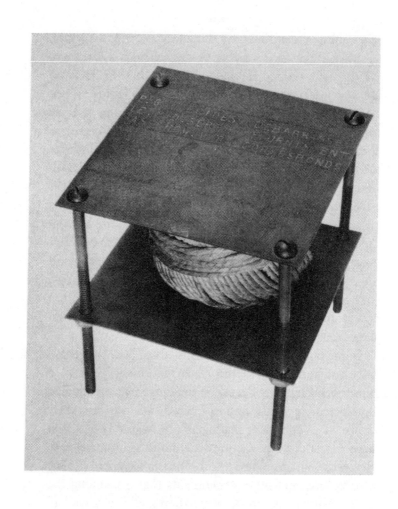

Ball of Twine (With Hidden Noise), *1916. (Readymade.) Philadelphia Museum of Art: The Louise and Walter Arensberg Collection.*

the atmosphere of that city; *Bottlerack; Why Not Sneeze?*, a birdcage that holds pieces of marble shaped like sugar cubes and a wooden thermometer. . . . In 1915, to avoid the war and encouraged by the expectations that the *Nude* had aroused, he went to New York for a long period. He founded two pre-Dadaist reviews there, and with his friend Picabia and a handful of artists of various nationalities, he went about his work of stimulating, shocking, and bewildering people. In 1918 Duchamp lived for a few months in Buenos Aires. He told me that he spent the nights playing chess and slept during the day. His arrival coincided with a coup d'état and other disturbances that "made movement difficult." He made very few acquaintances—no one who was an artist, a poet, or a thinking individual. It is a pity: I don't know of anybody with a temperament closer to his own than Macedonio Fernández.

In the same year (1918) he returned to Paris. Tangential but decisive activity in the Dada movement. Return to New York. Preparatory work on the *Large Glass*, including the incredible "dust raising," which we can see today thanks to an admirable photograph by Man Ray. Explorations in the domain of optical art, static or in movement: *Rotorelief, Rotary Glass Plate (Precision Optics), Rotary Demisphere*, and other experiments that are among the antecedents of Op art. Continuation and final abandonment of the *Large Glass*. Growing interest in chess and publication of a treatise on a move. Monte Carlo, and an abortive attempt to discover a formula that would enable him neither to lose nor to win at roulette. Participates in various exhibitions and manifestations of the Surrealists.

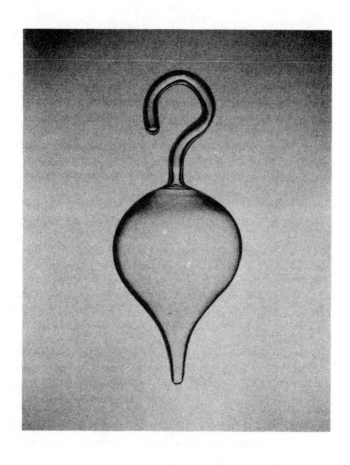

Air de Paris (Readymade.) Philadelphia Museum of Art: The Louise and. Walter Arensberg Collection.

During the Second World War settles finally in New York. Marriage to Teeny Sattler. Interviews, fame, influence on the new painting of England and America (Jasper Johns, Rauschenberg) and even music (John Cage) and dance (Merce Cunningham). The chess game goes on. And always the same attitude to good fortune or bad—metairony. In the summer of 1967, when I heard that they were going to hold a retrospective exhibition of his work in London, I asked him, "When will they have one in Paris?" He answered me with an indefinable gesture and added, "No one is a prophet in his own country." Freedom personified, he is not even afraid of the commonplace, which is the bogey of most modern artists. . . . This summary of his life leaves out many things, many encounters, various names of poets and painters and of women whom he found charming or who were charmed by him. It is impossible, however, not to mention the *Box in a Valise* (1941) and the *Green Box* (1934). The former contains miniature reproductions of almost all his works. The latter holds ninety-three documents—sketches, calculations, and notes from 1911 to 1915—and a colorplate of *The Bride*. These documents are the key, though incomplete, to the *Large Glass:* "I wanted to make a book, or rather, a catalog that would explain every detail of my picture."[5]

The Readymades are anonymous objects that the artist's gratuitous gesture, the mere fact of choosing them, con-

5. "Conversations avec Marcel Duchamp," a chapter of Alain Jouffroy's book, *Une Révolution du regard* (Paris: Gallimard, 1964). In 1967, after this essay was written, another collection of notes appeared that completes and amplifies those in the *Green Box*. The new collection is entitled *In the Infinitive*, also known as the *White Box*. It is not impossible that still more unpublished notes on the *Large Glass* and its speculations may be in existence.

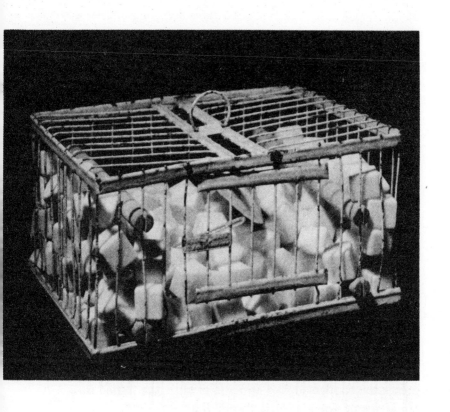

Why Not Sneeze Rrose Sélavy? *1921. (Readymade.) Philadelphia Museum of Art: The Louise and Walter Arensberg Collection.*

verts into works of art. At the same time this gesture does away with the notion of art object. The essence of the act is contradiction; it is the plastic equivalent of the pun. As the latter destroys meaning, the former destroys the idea of value. The Readymades are not anti-art, like so many modern creations, but rather *an-artistic*. Neither art nor anti-art, but something in between, indifferent, existing in a void. The wealth of commentaries on their significance—some of them would certainly have made Duchamp laugh—shows that their interest is not plastic but critical or philosophical. It would be senseless to argue about their beauty or ugliness, firstly because they are beyond beauty and ugliness, and secondly because they are not creations but signs, questioning or negating the act of creation. The Readymade does not postulate a new value: it is a jibe at what we call valuable. It is criticism in action: a kick at the work of art ensconced on its pedestal of adjectives. The act of criticism unfolds in two stages. The first belongs to the realm of hygiene, intellectual cleanliness—the Readymade is a criticism of taste; the second is an attack on the idea of the work of art.

For Duchamp good taste is no less harmful than bad. We all know that there is no essential difference between them—yesterday's bad taste is the good taste of today—but what is taste? It is what we call pretty, beautiful, ugly, stupendous, marvelous, without having any clear understanding of its raison d'être: it is execution, construction, style, quality—the trademark. Primitive people don't have any idea of taste; they rely on instinct and tradition—that is to say, they repeat almost instinctively certain archetypes. Taste probably came into existence with the first

cities, the state, and the division of classes. In the modern West it began in the Renaissance, but was unaware of itself until the Baroque period. In the eighteenth century it was the distinguishing mark of the courtier, and later, in the nineteenth, the sign of the parvenu. Today, since popular art is extinct, it tends to propagate itself among the masses. Its birth coincides with the disappearance of religious art, and its development and supremacy are due, as much as anything, to the open market for artistic objects and to the bourgeois revolution. (A similar phenomenon, though it is not identical, can be seen in certain epochs of the history of China and Japan.) "There's no law about tastes," says the Spanish proverb. In fact, taste evades both examination and judgment; it is a matter for samplers. It oscillates between instinct and fashion, style and prescription. As a notion of art it is skin-deep both in the sensuous and in the social meaning of the term: it titillates and is a mark of distinction. In the first case it reduces art to sensation; in the second it introduces a social hierarchy founded on a reality as mysterious and arbitrary as purity of blood or the color of one's skin. The process has become accentuated in our time: since Impressionism, painting has been converted into materials, color, drawing, texture, sensibility, sensuality—ideas are reduced to a tube of paint and contemplation to sensation.[6] The Readymade is a criticism of "retinal" and manual art; after he had proved to himself that he "mastered his craft," Duchamp denounced the superstition of craft. The artist is not the maker of things;

6. According to Duchamp all modern art is "retinal"—from Impressionism, Fauvism, and Cubism to abstract art and Op art, with the exception of Surrealism and a few isolated instances such as Seurat and Mondrian.

his works are not pieces of workmanship—they are acts. There is a possibly unconscious echo in this attitude of the repugnance Rimbaud felt for the pen: *Quel siècle à mains!*

In its second stage the Readymade passes from hygiene to the criticism of art itself. In criticizing the idea of execution, Duchamp doesn't claim to dissociate form from content. In art the only thing that counts is form. Or, to be more precise, forms are the transmitters of what they signify. Form projects meaning, it is an apparatus for signifying. Now, the significances of "retinal" painting are insignificant; they consist of impressions, sensations, secretions, ejaculations. The Readymade confronts this insignificance with its neutrality, its nonsignificance. For this reason it cannot be a beautiful object, or agreeable, repulsive, or even interesting. Nothing is more difficult than to find an object that is really neutral: "Anything can become very beautiful if the gesture is repeated often enough; this is why the number of my Readymades is very limited. . . ." The repetition of the act brings with it an immediate degradation, a relapse into taste—a fact Duchamp's imitators frequently forget. Detached from its original context—usefulness, propaganda, or ornament—the Readymade suddenly loses all significance and is converted into an object existing in a vacuum, into a thing without any embellishment. Only for a moment: everything that man has handled has the fatal tendency to secrete meaning. Hardly have they been installed in their new hierarchy, than the nail and the flatiron suffer an invisible transformation and become objects for contemplation, study, or irritation. Hence the need to "rectify" the Readymade—injecting it with irony helps to preserve its anonymity and neutrality.

Marcel
Duchamp

24

A labor of Tantalus for, when significance and its append-
ages, admiration and reprobation, have been deflected
from the object, how can one prevent them from being
directed toward the author? If the object is anonymous,
the man who chose it is not. And one could even add that
the Readymade is not a work but a gesture, and a gesture
that only an artist could realize, and not just any artist but
inevitably Marcel Duchamp. It is not surprising that the
critic and the discerning public find the gesture significant,
although they are usually unable to say what it is significant
of. The transition from worshiping the object to worship-
ing the author of the gesture is imperceptible and instanta-
neous: the circle is closed. But it is a circle that closes us
inside it: Duchamp has leaped it with agility; while I am
writing these notes, he is playing chess.

One stone is like another and a corkscrew is like another
corkscrew. The resemblance between stones is natural and
involuntary; between manufactured objects it is artificial
and deliberate. The fact that all corkscrews are the same
is a consequence of their significance: they are objects that
have been manufactured for the purpose of drawing corks;
the similarity between stones has no inherent significance.
At least this is the modern attitude to nature. It hasn't
always been the case. Roger Caillois points out that certain
Chinese artists selected stones because they found them
fascinating and turned them into works of art by the simple
act of engraving or painting their name on them. The
Japanese also collected stones and, as they were more as-
cetic, preferred them not to be too beautiful, strange, or
unusual; they chose ordinary round stones. To look for
stones for their difference and to look for them for their

similarity are not separate acts; they both affirm that nature is the creator. To select one stone among a thousand is equivalent to giving it a name. Guided by the principle of analogy, man gives names to nature; each name is a metaphor: Rocky Mountains, Red Sea, Hells Canyon, Eagles Rest. The name—or the signature of the artist—causes the place—or the stone—to enter the world of names, or, in other words, into the sphere of meanings. The act of Duchamp uproots the object from its meaning and makes an empty skin of the name: a bottlerack without bottles. The Chinese artist affirms his identity with nature; Duchamp, his irreducible separation from it. The act of the former is one of elevation or praise; that of the latter, a criticism. For the Chinese, the Greeks, the Mayans, or the Egyptians nature was a living totality, a creative being. For this reason art, according to Aristotle, is imitation; the poet imitates the creative gesture of nature. The Chinese artist follows this idea to its ultimate conclusion: he selects a stone and signs it. He inscribes his name on a piece of creation and his signature is an act of recognition— Duchamp selects a manufactured object; he inscribes his name as an act of negation and his gesture is a challenge.

The comparison between the gesture of the Chinese artist and that of Duchamp demonstrates the negative nature of the manufactured object. For the ancients nature was a goddess, and what is more, a breeding ground for gods—manifestations in their turn of vital energy in its three stages: birth, copulation, and death. The gods are born and their birth is that of the universe itself; they fall in love (sometimes with our own women) and the earth is

peopled with demigods, monsters, and giants; they die and their death is the end and the resurrection of time. Objects are not born: we make them; they have no sex; nor do they die: they wear out or become useless. Their tomb is the trash can or the recycling furnace. Technology is neutral and sterile. Now, technology is the nature of modern man; it is our environment and our horizon. Of course, every work of man is a negation of nature, but at the same time it is a bridge between nature and us. Technology changes nature in a more radical and decisive manner: it throws it out. The familiar concept of the return to nature is proof that the world of technology comes between us and it: it is not a bridge but a wall. Heidegger says that technology is nihilistic because it is the most perfect and active expression of the will to power. Seen in this light the Readymade is a double negation: not only the gesture but the object itself is negative. Although Duchamp doesn't have the least nostalgia for the paradises or infernos of nature, he is still less a worshiper of technology. The injection of irony is a negation of technology because the manufactured object is turned into a Readymade, a useless article.

The Readymade is a two-edged weapon: if it is transformed into a work of art, it spoils the gesture of desecration; if it preserves its neutrality, it converts the gesture itself into a work. This is the trap that the majority of Duchamp's followers have fallen into: it is not easy to juggle with knives. There is another condition: the practice of the Readymade demands an absolute disinterest. Duchamp has earned derisory sums from his pictures—he has given most of them away—and he has always lived mod-
27 estly, especially if one thinks of the fortunes a painter

accumulates today as soon as he enjoys a certain reputation. Harder than despising money is resisting the temptation to make works or to turn oneself into a work. I believe that, thanks to irony, Duchamp has succeeded: the Readymade has been his Diogenes' barrel. Because, in the end, his gesture is a philosophical or, rather, dialectical game more than an artistic operation: it is a negation that, through humor, becomes affirmation. Suspended by irony, in a state of perpetual oscillation, this affirmation is always provisional. It is a contradiction that denies all significance to object and gesture alike; it is a pure action—in the moral sense and also in the sense of a game: his hands are clean, the execution is rapid and perfect. Purity requires that the gesture should be realized in such a way that it seems as little like a *choice* as possible: "The great problem was the act of selection. I had to pick an object without it impressing me and, as far as possible, without the least intervention of any idea or suggestion of aesthetic pleasure. It was necessary to reduce my personal taste to zero. It is very difficult to select an object that has absolutely no interest for us not only on the day we pick it but that never will and that, finally, can never have the possibility of becoming beautiful, pretty, agreeable or ugly. . . ."

The act of selection bears a certain resemblance to making a rendezvous, and for this reason, it contains an element of eroticism—a desperate eroticism without any illusions: "To decide that at a point in the future (such and such a day, hour, and minute) I am going to pick a Readymade. What is important then is chronometry, the empty moment . . . it is a sort of rendezvous." I would add that it is a rendezvous without any element of surprise, an encounter

Marcel
Duchamp

28

in a time that is arid with indifference. The Readymade is not only a dialectical game; it is also an ascetic exercise, a means of purgation. Unlike the practices of the mystics, its end is not union with the divinity and the contemplation of the highest truth; it is a rendezvous with nobody and its ultimate goal is noncontemplation. The Readymade occupies an area of the spirit that is null: "This bottlerack, which still has no bottles, turned into a thing that one doesn't even look at, although we know it exists—that we only look at by *turning our heads* and whose existence was decided by a gesture I made one day. . . ." A nihilism that gyrates on itself and refutes itself; it is the enthroning of a nothing and, once it is on its throne, denying it and denying oneself. It is not an artistic act, this invention of an art of interior liberation. In the *Large Sutra on Perfect Wisdom*[7] we are told that each one of us must strive to reach the blessed state of Bodhisattva, knowing full well that Bodhisattva is a nonentity, an empty name. That is what Duchamp calls the beauty of indifference—in other words, freedom.

The Bride Stripped Bare by Her Bachelors, Even is one of the most hermetic works of our century. It stands apart from most other modern texts—because this painting is a text—in that the author has given us a key: the notes of the *Green Box*. I have already said that it is an incomplete key, incomplete as is the *Large Glass* itself; furthermore, in their way the notes are also a riddle, scattered signs that

7. *The Large Sutra on Perfect Wisdom,* translated by Edward Conze (London: Luzac and Co., 1961).

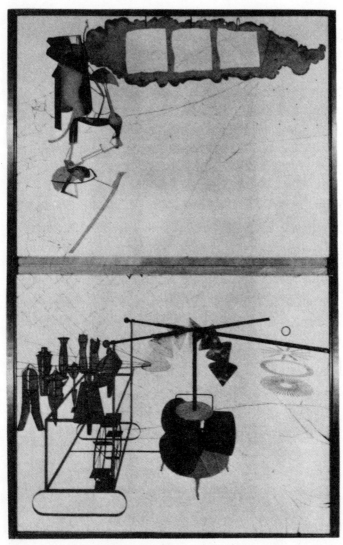

The Large Glass, *or* The Bride Stripped Bare by Her Bachelors, Even, *1915–23. (Oil and lead wire on glass.) Philadelphia Museum of Art: Bequest of Katherine S. Dreier.*

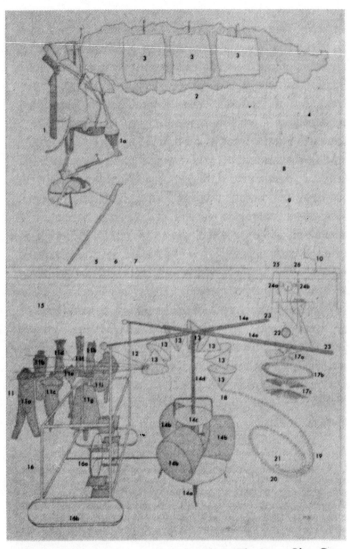

This diagram is based on Duchamp's etching, The Large Glass Completed, *1965. By permission of the Museum of Modern Art, New York. Photo by Bacci.*

we have to regroup and decipher. *The Bride* and the *Green
Box* (to which we must now add the *White Box*) make up
a system of mirrors that exchange reflections; each one
clarifies and *rectifies* the others. There are numerous inter-
pretations of this enigmatic work. Some of them show
perspicacity.[8] I will not repeat them. My purpose is a
descriptive one: I want to assemble some preliminary notes
for a future translation into Spanish. I will begin with the
title, *La Mariée mise à nu par ses célibataires, même*. It is
not easy to translate this oscillating, convoluted phrase.
First of all *mise à nu* doesn't exactly mean denuded or
unclothed; it is a much more energetic expression—
stripped bare, exposed. It is impossible not to associate it
with a public act or a ritual—the theater *(mise en scène)*
or an execution *(mise à mort)*. The use of the word "bache-
lor" *(célibataire)*, instead of the seemingly normal "fiancé"
or "suitor," sets up an unbridgeable separation between
feminine and masculine; the bachelor is not even a suitor,
and the bride will never be married. The plural ("bache-
lors") and the possessive adjective heighten the inferiority
of the males; they bring to mind the image of a herd, rather
than polyandry.

8. One of the most noteworthy is Michel Carrouges' *Les Machines célibataires*
(Paris: Arcannes, 1951). The best descriptive synthesis of the painting is found
in André Breton's "Phare de la Mariée," in *Minotaur* (Paris, vol. 2, no. 6, 1934).
The present essay was already written when two excellent studies appeared, both
containing complete and perceptive descriptions of the *Large Glass* and how it
works. The first is by John Golding, *The Bride Stripped Bare by Her Bachelors,
Even . . .* (London: Allen Lane, 1973). The second is Jean Suquet's *Miroir de
la Mariée* (Paris: Flammarion, 1974). Suquet has subsequently published another
essay, *Le Guéridon et la Virgule* (Paris: Christian Bourgeois, 1976), on a charac-
ter who was not painted in, but is essential to the *Large Glass*, the Juggler of
Gravity.

The adverb "even" *(même)*, which Duchamp added later on, has been discussed at great length. For one critic the allusion is transparent: "the Bride loves me" *(m'aime)*. Duchamp has more than once denied this interpretation. In his conversations with Pierre Cabanne[9] he says again that he added the adverb precisely because it had no significance or connection either with the painting or with its title. The adverb, a magnificent demonstration of "adverbiality," meant nothing. In another interview he said that *même* reminded him of the famous double monosyllable of Bosse-de-Nage, Doctor Faustroll's monkey: Ha-Ha. The adverb *même* is the particle of hesitancy, the verbal capsule that contains those two solvents, irony and indifference. It is the "neither this nor that" of the Taoists. The adverb turns the *Large Glass* and its subject matter into a veritable act of ex-position, in the photographic sense of the word, but in the liturgical and the worldly sense also. All the elements of the work are already there in the title: myth, barrack-room humor, eroticism, pseudoscience, and irony.

The name of each part also has a meaning—or rather, several meanings—and these complete the sense of the plastic composition. They complete and sometimes contradict it. They are signs that orient and disorient us, like the adverb *même.* The Bride's names are Motor-Desire, Wasp, and Hanged Female. For H. P. Roché the Bride is a mixture of dragonfly and praying mantis. Carrouges, for his part, has discovered that *mariée* is the popular French

9. Pierre Cabanne, *Dialogues with Marcel Duchamp,* translated by Ron Padgett (New York: Viking, 1971).

name for a nocturnal butterfly, the *noctuelle*. The group of bachelors has a whole repertoire of gloomy names: Bachelor Apparatus, Nine Malic Molds *(Neuf Moules Malic)*, and finally, Cemetery of Uniforms and Liveries. At first there were eight males, but, no doubt for numerological reasons, Duchamp added another. Nine is a magic number; it has an aura. It is a multiple of three, and three is the number into which the Indo-Europeans concentrated their vision of the universe; it has been the focal point of their intellectual systems for thousands of years, from the days of Vedic India to modern Europe. The males are molds—the Spanish expression *machotes* suits them admirably—empty suits inflated by the illuminating gas that is their life's breath, their desiring soul. They represent nine families or tribes of men: gendarme, cuirassier, policeman, priest, busboy, stationmaster, department-store delivery boy, flunky, and undertaker. It is hard to imagine a more somber list. The Cemetery of Uniforms and Liveries is also called Eros' Matrix. One commentator has pointed out the ambivalence: the bachelors' tomb is their place of resurrection. The other meaning of matrix will not allow me to accept this interpretation completely—a matrix is a mold. The nine males are nine prototypes. Again we sense ambiguity, now confusing Platonic archetypes and mechanical molds.

The other parts have names that indicate their functions, though not without contradictions and ambivalences. Since I will discuss their positioning and their interaction later on, I will only list them here: Milky Way; Top Inscription, or Three Pistons; Nine Shots; Glider, Chariot, or Sleigh; Water Mill; Waterfall (invisible);

Sieves, or Parasols; Capillary Tubes; Chocolate Grinder (made up of Bayonet, Necktie, Rollers, and Louis XV Chassis); Scissors; Bride's Horizon-Garment; Boxing Match (not painted); Oculist Witnesses; Handler of Gravity, or Juggler of Gravity, or Inspector of Space (not painted).

The Bride Stripped Bare by Her Bachelors, Even is a double glass, 109¼ inches high and 69¼ inches long, painted in oil and divided horizontally into two identical parts by a double lead wire. "Finally unfinished" in 1923, the *Large Glass* had its first public viewing in 1926, during the *International Exhibition of Modern Art* at the Brooklyn Museum. It was broken when it was being returned from the museum to the house of its owner; the damage was not discovered until years later, and Duchamp did not repair the work until 1936. The dividing line, which serves both as horizon and as the Bride's transparent garment, was smashed; it is now merely a thin strip of glass held between two metallic bars. The scratched surface of the *Large Glass* is like the scarred body of a war veteran, a living map of campaigns endured. Duchamp confessed to Sweeney: "I love these cracks because they do not resemble broken glass. They have form, a symmetrical architecture. Better still, I see in them a strange purpose for which I'm not responsible, a design ready-made in a way that I respect and love." Like all radical skepticism, Duchamp's skepticism is open, and ends in the acceptance of the unknown. Not in vain did he take an interest in Pyrrho during his speculative period in the Bibliothèque Sainte-Geneviève. Chance is only one of the manifestations of a master plan that goes far beyond us. About this plan we know nothing,

or next to nothing, except its power over us.

The upper half of the *Large Glass* is the Bride's domain. A complicated piece of machinery fills the far left. It is the Bride herself, or to be exact, the Bride in one of her personifications. In the central figure, which Duchamp called Hanged Female, Lebel has wanted to see "a sort of profile, in very schematic form, that could be that of a woman wearing a hat, whose face is covered by a veil." (A real widow, but whose?) Duchamp's commentary, which Lebel himself relayed, was rather enigmatic: "Voluntarily it might be the head, but accidentally what is seen is a nonvoluntary profile." The word "head" here does not indicate an anthropomorphic form but a position and probably a function within the ensemble. The vague similarities to a human form are accidental; the Bride is an apparatus, and her humanity lies neither in her shapes nor in her physiology. Her humanity is symbolic: the Bride is an ideal reality, a symbol manifested in mechanical forms, producing symbols in its turn. It is a symbol machine. But these symbols are distended and deformed by irony; they are symbols that distill their own negation. The way the Bride works is physiological, mechanical, ironic, symbolic, and imaginary all at the same time; the substance on which she runs is a secretion called "automobiline," her ecstasies are electric, and the physical force that moves her gears is desire.

The mystery surrounding the Bride comes not from a dearth but from an excess of information. The *Green Box* contains a fairly complete description of her morphology and of how she works. Frequently these notes are ambiguous and even contradictory; Duchamp's formula, beauty of

precision, becomes a trap of uncertainties and confusions once it is subjected to the operation of meta-irony. It is hardly necessary to add that these uncertainties and confusions are an essential part of the Bride: they are her transparent veil. Furthermore, to really understand the painting we need not know exactly where her organs are, but we must have some idea of how they work. Having made that reservation, I shall now list, from top to bottom and from left to right, the different parts that comprise the apparatus.

At the top we can see a sort of hook. The Bride, in the proper sense of the term—the silhouette identified by Lebel as a female figure wearing a hat and veil—hangs from the hook. Though any anthropomorphic resemblance is deceptive, it is impossible not to notice a curious coincidence (if we can talk about coincidences in this realm): the painting *Portrait (Dulcinea)*, which dates from 1911, is a "simultaneist" vision of a stripping in five stages; the woman doing the striptease keeps her hat on throughout, like the Bride in the *Large Glass*.

Moving to the right, below the Milky Way, a groove[10] holds up a metallic shaft or stalk connected with the "desire-magnet" lower down. The desire-magnet contains in a cage the "filament substance" (invisible). This substance is the Bride's secretion, which materializes at her moment of "blossoming." The *Green Box* indicates that it "is like a solid flame . . . which licks the ball of the Handler of Gravity, displacing it as it pleases." The shaft

10. Paz comments here on the double meaning in Spanish of Duchamp's French word *"mortaise."* It translates into Spanish as *muesca* (groove) and *mortaja* (shroud). This ambiguity is lost in English. [Translator's note.]

of the desire-magnet is an axis, which is why its other name is "arbor-type." It is hard to decide if it is also called "motor with quite feeble cylinders," or if this expression denotes another part of the machinery. The arbor-type axis or spinal column is connected to a sort of syringe or lancet: this is the "wasp." The wasp has unusual characteristics: it secretes the "love gasoline" by osmosis; it possesses a sense of smell that allows it to perceive the "waves of unbalance" emitted by the black ball of the Juggler of Gravity; furthermore, it is endowed with a vibratory property that determines the pulsations of the "needle" and of a ventilation system. In turn this determines the "swinging to and fro of the Hanged Female with its accessories."

Below the wasp is the "tank of love gasoline or timid power." This erotic gasoline "distributed to the motor with quite feeble cylinders, in contact with the sparks of her constant life (desire-magnet) explodes and makes this virgin, who has attained her desire, blossom." The tank, also called an "oscillating bathtub," is what provides for the "hygiene of the Bride." Lower down, the "pulse needle" is balanced. It is mounted "on a wandering leash. It has the liberty of caged animals." The pulse needle is in the shape of a rather threatening pendulum, swinging over the void: the horizon-garment of the Bride.

The Bachelor-Machine is a "steam engine on a masonry substructure on this brick base, a solid foundation." The machine has "a tormented gearing," and it gives birth to its "desire-part." Thanks to the latter, the steam engine turns into a "desire motor." But this motor is separated from the Bride by a "cooler of transparent glass" that blends into the horizon-garment. In the *Large Glass*

Marcel
Duchamp

38

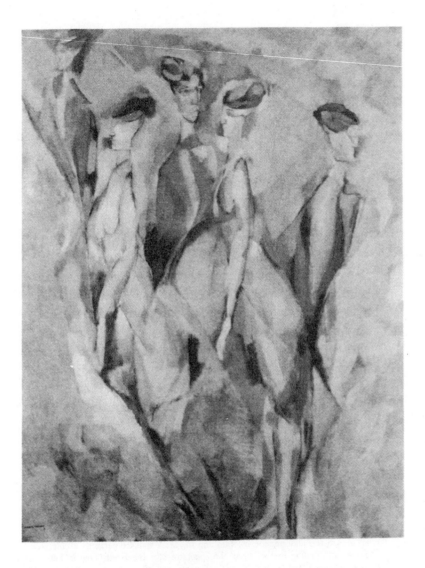

Portrait (Dulcinea), *1911. (Oil on canvas.) Philadelphia Museum of Art: The Louise and Walter Arensberg Collection.*

these items are hard to identify, and the Bride's architectonic masonry base does not appear.[11]

My description of the Bride is an interpretation. There are other versions of her morphology. For example, in Richard Hamilton's admirable "Typographic Letter" the "motor with quite feeble cylinders" and the tank of erotic gasoline appear below the Hanged Female. The position of the other parts is also slightly different in Hamilton's schema: on the right of the Hanged Female he places the wasp or "sex cylinder" with the cage of capillary tubes lower down, and below this the desire-magnet, which emits artificial sparks.

The *Green Box* tells us that the Bride is an agricultural machine, a plow (an allusion to Ceres?), a skeleton, an insect, a Hanged Female, a pendulum . . . "the Hanged Female is the form in *ordinary perspective* of a Hanged Female for which one could perhaps try to discover the *true form.*" And so the forms of the Bride are only an appearance, one of her possible manifestations. Her true form, her real reality, is other. Duchamp has said that she is the projection of a three-dimensional object that in its turn is the projection of an (unknown) four-dimensional object. The Bride is the copy of a copy of the Idea. We are dealing with a mixture of speculations on non-Euclidean geometry, popular when Duchamp was young,

11. In *Given: 1. The Waterfall, 2. The Illuminating Gas,* (1946–66), the Assemblage discovered after Duchamp's death and now in the Philadelphia Museum of Art, the masonry construction and the brick wall are perfectly visible. Through an opening in the bricks the spectator sees the Bride, now in her three-dimensional shape, as a blond, naked girl reclining on a bed of twigs. Beyond her, on the wooded hillside, can be seen the silvery semicircle of the waterfall.

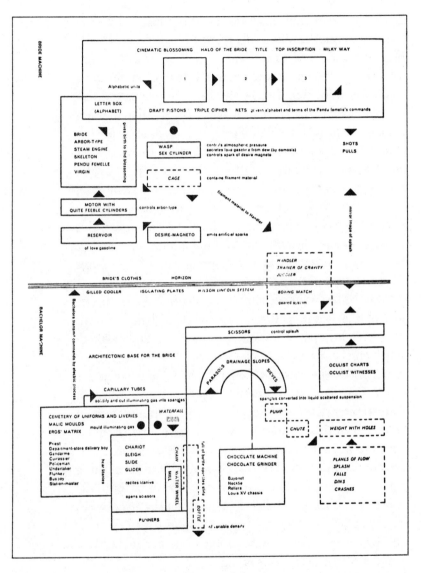

Typographic version of the Large Glass. *Courtesy of Richard Hamilton.*

and that current of Neoplatonism that has irrigated the soil and the subsoil of our civilization from the end of the fifteenth century onward. I am not talking of a conscious influence; as though they were our spiritual blood, the ideas stemming from Neoplatonic hermeticism circulate invisibly through us, blended into our ways of thinking and feeling. Alongside this Platonizing vision—that reality beyond the senses whose shadows we are—there appears another; Lebel thinks that the reality referred to as the fourth dimension is the moment of the carnal embrace, during which the pair fuses time and space into one unique reality. The fourth dimension is the erotic dimension. But is there an embrace? Before that question is answered, it fades away, dissolved in the transparency of the *Large Glass*.

The Milky Way occupies the center of the upper half of the painting. It is a grayish cloud hanging from above, slightly pinkish at the extreme left (flesh-colored, Duchamp insists). The cloud seems to emerge from that part of the Hanged Female that I have called the head. Except that it doesn't come out like Minerva from Jupiter's broken forehead, but in a strange fashion from the Bride's occiput—if we may give an anatomical name to a machine part. Roché sees the cloud as a gaseous crocodile. For Michel Carrouges it is a gigantic caterpillar, an earlier version of the nocturnal butterfly *(noctuelle)* that is the Bride. This is a risky hypothesis, since the Milky Way, far from being an earlier form of the Bride, is rather an emanation from her in her moment of "cinematic blossoming."

Here I must interrupt my description to make a point.

The accepted translation for *épanouissement*, the word Duchamp used, is "blossoming." There are several English equivalents for the French word,[12] as may be seen by checking dictionary entries—opening out, blooming, blowing (of flowers); beaming, brightening up (of the countenance); full bloom (of beauty); expansion—but none that captures all its nuances. Duchamp uses the word in a figurative sense: the Bride blossoms, opens out, dilates with pleasure. It is not orgasm but the sensations that precede it. The *Green Box* is explicit: the blossoming "is the last state of the nude Bride before the orgasm that might make her fall. . . ."

"Milky Way *flesh color* surrounds, unevenly densely, the 3 Pistons." Like the boards used in stadiums to mark up the scores or in airports to indicate the arrivals and departures of planes, the Pistons hang from three nails. Their other name is Nets. Duchamp hung a square piece of white cloth over an open window; the Nets are three photographs of that piece of material: "piston of the draft—that is, cloth accepted and rejected by the draft." The Nets or Pistons are also called Top Inscription because their function consists of transmitting to the Bachelors and to the Juggler of Gravity the Bride's discharges—her sensations, her commands. For Roché they are "the original Mystery, the Cause of Causes, a Trinity of empty boxes."

At the top right, below the Milky Way, there is a region of dots: the dents made by the Bachelors' Nine Shots. There are other parts not painted by Duchamp that must be kept

12. Paz makes this point vis-à-vis Spanish, but the statement holds true for English also. [Translator's note.]

in mind by anyone who wants to have an idea of how the machinery works. Below the region of the Nine Shots we ought to find the Cast Shadows, and below them the Image of the Sculpture of Drops. The Nine Shots were obtained by firing nine times—three times from three different angles, making up the number of the Malic Molds—from a toy cannon loaded with matches soaked in fresh paint. On the far left, above the line indicating the horizon that separates the *Large Glass* into two halves, is the Bride's fallen, transparent garment. Naturally it is invisible. Farther down, in the realm of the Bachelors, appears the "air (or water) cooler" in transparent glass. It is also invisible. On the horizon itself, farther to the right, is the Wilson-Lincoln system. It can't be seen either. It is an optical trick based on those prisms that make us see the same face in two ways, looking like Wilson from one side and like Lincoln from the other. On the far right, still on the horizon, there is another character who has not been painted—the Juggler of Gravity. Had he ever been given a form, it would have been that of a spiral spring, resting on a small three-legged table, holding up a sort of tray on which a ball should roll (a black ball, as specified in a note in the *Green Box*). The Juggler of Gravity should dance on the horizon, the Bride's garment. Since he is a spring, he is elastic and grows upward until he bumps into the region of the Nine Shots and offers his black ball to the Bride, to the solid flame of her tongue.

In the lower half of the *Large Glass,* at the far left, we find the group of the Nine Malic Molds, or Cemetery of Uniforms and Liveries, or Eros' Matrix. All three names suit them because the Bachelors have no true personality. They are empty suits, hollow pieces inflated by the il-

luminating gas. "The Bachelors serve as an architectonic base of the Bride, which thus becomes a sort of apotheosis of virginity."

The differences between the Bride's and Bachelors' respective universes are vast. First of all, "the principal forms of the Bachelor-Machine are imperfect . . . that is, they are measurable. . . . The principal forms of the Bride are more or less large or small, have no longer, in relation to their destination, a mensurability." (In the *White Box* an identical explanation appears under the heading "Perspective.") The region of the Bachelors is governed by the laws of classical perspective; the Bride's by a free geometry where "more or less" is the rule. A world of free forms, which cannot be measured and can be seen only with difficulty: the realm of indetermination, where causality has disappeared or, if it survives, obeys laws and principles that are different from those here below. The Bachelors' domain is that of measurements and causality, the region of our two- and three-dimensional geometry and, therefore, of imperfect forms. This opposition between our forms down here and hers up there is yet another example of the way in which Duchamp places certain popular ideas of modern physics—the fourth dimension and non-Euclidean geometry—in the service of a metaphysics whose origin is Neoplatonic. For Plotinus and for his fifteenth- and sixteenth-century followers, the One and its emanations, the Ideas, were also free forms that escaped mensuration by the senses. Geometry is the shadow of Ideas. Furthermore, it is the chink through which we see the true forms. We see them without ever being able to
45 see them completely, we see them more or less.

There is another, equally telling difference between the Bride and the Bachelors: "The Bride has a life-center; the Bachelors have not. They live on coal or some other raw material, drawn not from them but from their not-them." Being a liberated form, the Bride is self-sufficient; the Bachelors, subject to geometry and perspective, are empty molds filled by illuminating gas. They are uniforms and liveries: "The gas castings so obtained would hear the litanies sung by the chariot, refrain of the whole Bachelor-Machine. But *they* will never be able to go beyond their Mask . . . as if enveloped, alongside their regrets, by a mirror reflecting back to them their own complexity to the point of their being hallucinated rather onanistically."

The Nine Malic Molds are joined to the Sieve by means of a system of capillary tubes that are none other than "the metrical units of capricious length" calculated according to the method described above. The Sieve is "a reverse image of porosity" and is made up of seven parasols arranged in a semicircle. Dust is used in the parasols like "a kind of color (transparent pastel)." Duchamp made "breeding grounds to raise dust on glass. Dust of four months, six months, afterward hermetically closed up." The Sieve is equipped with an aspirator pump, and each parasol has holes to facilitate circulation. "The holes of the sieves should give *in the shape of a globe* the figure of the . . . molds . . . by subsidized symmetry." The last parasol is endowed with a "ventilator-mixer" that has the shape of a butterfly. By virtue of its functions and the strange transformations that take place in its inner galleries, the Sieve is a sort of Chamber of Metamorphoses.

Between the Nine Malic Molds and the Sieve is the

Chariot, a little wagon on runners that is also known as the Sleigh. It appears in "the costume of Emancipation, hiding in its bosom the landscape of the Water Mill." The Mill is set in motion by a Waterfall. It is invisible, but the *Green Box* describes it as "a sort of waterspout coming from a distance in a semicircle, over the Malic Molds."[13] The runners of the Chariot slide on an underground rail. The metal of which the Chariot is made "is emancipated horizontally—that is, free of all gravity in the horizontal plane." The Water Mill is the wagon's propeller. Thanks to an ingenious mechanism that includes, among other devices, the fall of a bottle of Benedictine (or, in another version, four weights shaped like name-brand bottles), the Chariot is kept going with a fluctuating motion: "It goes, a weight falls and makes it go. It comes by the friction of the runners...." This second movement is a "phenomenon of inversion of friction ... that is transformed into a returning force equal to the going force." Now we can perceive why the little wagon is made of emancipated metal.

Swinging to and fro, the Chariot recites endless litanies: "Slow life. Vicious circle. Onanism...." These litanies are the Bachelors' theme, the leitmotif of the celibate life here below. The Nine hear them and want to escape from themselves, to get rid of their masks—their liveries and uniforms—but they cannot.... Another strange property: the weight of the bottle of Benedictine "by condescension ... is denser going down than going up." Its density "is in perpetual movement, not at all fixed like that of

<hr>

13. Though the Waterfall appears in the Assemblage in the Philadelphia Museum, the Nine Molds are not visible there.

metals." We can only call this property of the Benedictine bottle *philosophical:* its density is oscillating and thus "expresses the liberty of indifference," the only liberty to which we can aspire in this world of horizontal relationships.

The Chocolate Grinder occupies the center of the Bachelors' realm. Despite its position and size, its functions are rather limited. It is made up of a Louis XV Chassis, some rollers, a necktie provided "at the four corners with very sharp points," and the bayonet that holds up the Large Scissors. The continuous gyratory movement of the rollers is explained by the action of a "principle of spontaneity," which is summed up in this formula: "The bachelor grinds his chocolate himself." A chocolate that "comes from one knows not where" and that "would deposit itself, after grinding, as milk chocolate." The Scissors open and close thanks to the seesaw motion of the Chariot, whose chanting keeps the movement rhythmical.

On the right-hand side of the Chocolate Grinder are the Oculist Witnesses. Once again, by an immediate association of ideas,[14] the eyewitnesses of our religious and juridical traditions become another ambiguous breed. The Oculist Witnesses are represented by three circles, like those disks and diagrams on the charts used in optical establishments to test one's sight. Above the three circles there is a smaller one that ought to have been a magnifying glass. I shall come back to the Oculist Witnesses and the function of the glass when I deal with the overall movement

14. In Spanish "eyewitness" is *testigo ocular.* The "slight shift of letters and sounds" which, as Paz notes, turns Testigos Oculistas into *testigos oculares* is lost in English. [Translator's note.]

that unifies all these elements—that is, when I get to their interrelated existence.

Below the Oculist Witnesses are the Drainage Slopes of Planes. They are in the shape of a toboggan "but more of a corkscrew." In the Bachelors' domain this part bears a certain resemblance to the Nine Shots in the Bride's. It is called the Region of Spray and ends in a movable Weight with nine holes in it. None of these details was painted. The same thing happens with another item, the last one, situated above the Oculist Witnesses and a little to their left: the Boxing Match. This has nothing to do with a fight between two pugilists in a ring, but with the banging of a "combat marble" against three targets mounted on three summits. Every time the marble reaches a summit, its impact releases a clockwork spring that makes two rams fall. I will refer to the consequences of their fall later on. For the time being, I want to point out that the system is governed by a red steel spring. Once the operation is over, the marble returns to its place and the indented clockwork wheels put the rams, which hold up the Bride's garment, back where they started.

The reader should round out my description by seeing for himself. One does not have to go to Philadelphia to see the *Large Glass;* it can be adequately examined in some of the good reproductions published in recent years. In my opinion the best and most faithful is that made in Plexiglas by Vicente Rojo, since it retains the transparency of the original.[15] To understand more clearly how the different

15. In the portmanteau-book designed by Vicente Rojo (*Marcel Duchamp o El castillo de la pureza.* Mexico: Era, 1968). (Translated into English by Donald Gardner as *Marcel Duchamp, or the Castle of Purity,* New York: Grossman,

parts of the machinery work, one must consult the 1965 sketch *(The Complete Large Glass)*, in which Duchamp numbered all the component parts of the work and traced in red ink those that are missing. Richard Hamilton has provided a clear guide in his "Typographic Letter" that accompanies the admirable translation of the *Green Box* by George Heard Hamilton (New York, 1960). I must also mention the schemata in Jean Suquet's book, *Miroir de la Mariée,* (1974) and of course, the two documents that have guided me in my exploration, the notes of the *Green Box* and the *White Box.*

The *Large Glass* is a picture of a bride's undressing. Her striptease is a spectacle, a ceremony, a physiological and psychological phenomenon, a mechanical operation, a physico-chemical process, an erotic and spiritual experience all rolled into one, and all governed by meta-irony. Music hall, church, a lonely girl's room, laboratory, factory where gases and explosives are made, a clearing in a wood at the foot of a waterfall, spiritual theater. . . . The *Large Glass* is the painting of a re-creative physics and of a metaphysics poised, like the Hanged Female, between eroticism and irony. Figuration of a possible reality that, because it belongs to a dimension different from ours, is essentially invisible. Also, and especially, an ecstatic representation of movement. What we see is a moment in a process, when the Bride reaches her "blossoming," itself the consequence

1970.) The Mexican edition contains the first version of this essay, a selection of texts by Duchamp, the Plexiglas reproduction of the *Large Glass,* three color plates, an envelope with nine reproductions of Readymades, a photo album with reproductions of autograph texts, and a souvenir portrait of Marcel Duchamp.

of her stripping and the antecedent of her orgasm.

The notes of the two *Boxes*, like Duchamp's confessions, make it clear that the ceremony begins with the Bride and at her initiative. It is not in vain that she has a life-center. That vital center is the origin of the pulse-needle, which holds in equilibrium the sex cylinder, itself none other than the wasp. "At her base," says the *Green Box*, "the Bride is a tank of love gasoline or timid power." The Bride's autonomy, her sovereignty, is an attribute of her nature: "basically she is a motor, but before being a motor that transmits her timid power, *she is this very timid power.* " The other name for this timid power is automobiline: love gasoline. Where does this gasoline come from? From the Bride herself—it is a secretion of the wasp. The Bride is a desiring motor that desires herself. Her essence, both in the chemico-physiological and in the ontological meanings of the word, is desire. This essence is, at one and the same time, a lubricant and her being in itself. Her essence, her being, is desire, and this desire, which cannot be reduced to feelings although it originates in them, is but a desire for being.

Another of the wasp's properties springs from her self-desiring self: she has a ventilation system, "an interior draft." It is no exaggeration to call this draft a *vital breath*, the Bride's soul or spirit. The draft is responsible for the vibratory movement of the pulse-needle. The sex cylinder, excited by the needle's vibration and lubricated by the gasoline, "spits at the drum the dew that is to nourish the vessels of the filament paste." As the reader will remember, the filaments are contained in a cage and are transformed at the moment of "blossoming" into a "solid flame." Up

to this point we can trace the preparatory operations, the physiology and psychology of the Bride in her erotic awakening.

The draft of warm air that runs through the different parts of the machinery and sets them in motion is a metaphor for the desiring soul, and for sexuality also. Duchamp imagines the sighs and moans of desire as the snorts and backfiring of the motor of a car going up a hill . . . "faster and faster until it roars triumphantly." The draft—the Bride's desire, her amorous soul—reaches the Three Pistons, which are charged with transmitting her commands. There are no more than ten of these commands, and they may be reduced to only one. Two versions of this operation exist. In one, the draft is merely a warm vibration that, by unspecified channels, but in the form of electric discharges and sparks from the desire-magnet, reaches Eros' Matrix and awakens the Bachelors. In the second version—or is it a later stage of the ceremony?—the Bride's sighs and desires are air passing through the Three Pistons and being transformed into alphabetic unities. Thus the Pistons become the supports of the Top Inscription. A piece of the Hanged Female—it could be her brain—fills the function of an electric mailbox or matrix of letters. The mailbox contains an alphabet in which each sign or group of signs is an unrepeatable unity. We are dealing not with a phonetic but with an ideographic alphabet. Moreover, it has no synonyms and cannot be translated into any other language. A vocabulary-alphabet made up of "prime words, divisible only by themselves and by unity." The unities are written up on the Three Nets like the scores of games in stadiums. The writing of this mobile, instantaneous in-

Marcel
Duchamp

52

scription of Desire is particular, but its reading universal.

Meanwhile, in the world below, life is slow, corrupt, and circular: the Chariot comes and goes, intoning its litanies; the bottle of Benedictine falls and returns to its place; the wheel of the Water Mill turns; the rollers grind their chocolate; the Scissors open and close. Then, shaken by the electric commands of the Bride, the Bachelors emerge from their stupor and wake up. The illuminating gas, coming who knows from where, inflates them. Pressure forces it to escape upward, through the capillary tubes. "By the phenomenon of stretching in the unit of length," the gas is "congealed, solidified, and transformed into elemental rods" or, according to another passage in the *Green Box*, "into thin, solid needles." Duchamp does not explain how the congealing of the gas is brought about. The needles, impelled by pressure, come out of their tubes, break, and become an infinity of "sequins lighter than air." Something like "retailed fog," made of myriads of sequins of "frosty gas." However, each sequin retains its "malic tint" and, therefore, tends to rise. Erotic desire is lighter than air and violates the laws of gravity. The sequin-gas is possessed by a "determination to rise." But as they rise, the sequins fall into the trap of the first parasol, which absorbs them. They enter the "labyrinth of the three directions."

The passage of the gas through the seven parasols is like a surprising derby. What is obvious here is ambivalence, the law which governs the *Large Glass* and which is brought about by introducing into each phenomenon the solvent of *irony*. On one hand, the journey of the sequins is a descent to hell, a veritable pilgrimage to the under-
53 world; on the other, it is an excursion to a fun fair, like

those of our childhood, when we risked ourselves on the roller coaster or went into those booths filled with marvels—trapdoors, mirrors, ghosts, corridors, and caverns (today's modest equivalents of the specular labyrinths of the Baroque). Swept hither and yon, drawn in and blown out from one side to the other, the sequins lose their sense of direction and confuse the notions of right and left, up and down, backward and forward. They had kept their "malic" form, but the comings and goings, ups and downs, make them so seasick that they lose their individuality and forget their "determination to rise." The only thing left them is the "instinct for cohesion"; their gregarious impulse causes them to dissolve in an elemental liquid, "a vapor of inertia." And so they reach the end of their journey. As they emerge, they are awaited by the "butterfly-shaped ventilator-mixer," which, by turning, changes them into a substance that "resembles glycerine mixed with water." The gas has been transformed into a perfumer's item and into liquid explosive. In this state it hurls itself down the Slopes in the shape of a corkscrew and crashes three times. Clatter and splash.

The explosive liquid falls and is fired upward. But the Scissors literally cut its wings and force it to return and follow another path. The mission of the Scissors is to direct traffic, like traffic wardens when there are bottlenecks. The Weight with its nine holes collects the liquid, channels it, and takes it upward—a new voyage. The liquid seeps into the Oculists' hideout. Bedazzlement and metamorphosis: the Spray is turned into the Sculpture of Drops. A particularly choice metaphor: which of us, seeing water or steam gushing out from somewhere, has not wanted to see it

turned suddenly into a sculpture? The Sculpture of Drops continues its flight, headed toward the upper half of the *Glass* "to meet the Nine Shots." But the drops sent back are not the real drops; this is a "mirrorical" trajectory and each drop has become its own image. Mutations: gas turned into solid needles turned into sequins lighter than air turned into inert vapor turned into liquid explosive turned into reflection in a mirror-glance.

The Sculpture of Drops is transformed from something that one looks at into something that looks. Like every act of looking, it is bounded by the horizon, that transparency that is the Bride's garment. Then it undergoes the effects of the Wilson-Lincoln system. The *Green Box* describes this transformation in a rather enigmatic way: "A mirrorical return. Each drop will pass the three planes at the horizon between the perspective and the geometrical drawing of two figures which will be indicated on these three planes by the Wilson-Lincoln system. . . . The mirrorical drops, not the drops themselves but their image, pass between these two states of the same figure." The drops now are something else, though they have not ceased to be themselves. This is one of the themes or axes of the *Large Glass:* forms change, not essences. Universal anamorphosis: each form we see is the projection, the deformed image, of another one. The *White Box*, which makes a distinction between appearance and apparition, is explicit: what we see is almost always the *appearance* of objects—that is, "the retinal impression and other sensory consequences." The *apparition* is the object's mold, its archetypal pattern—its essence.

55 The "mirrorical drops" climb until they touch the re-

gion of the Nine Shots. There is an undoubted correspondence—and more, a *rhyme*—between the Image of the Sculpture of Drops and the Nine Shots. The former is the projection of the illuminating gas after its metamorphosis and its final transfiguration through the speculations of the Oculist Witnesses and the Wilson-Lincoln prism; the latter—the Bachelors' Nine Shots—is "the projection of the principal points of a three-dimensional body." The *Green Box* adds, "With maximum skill this projection will be reduced to a point. With ordinary skill," as is the case of the Bachelors, "the projection will be a demultiplication of the target." Desire is the common element, the source of both figures; rather, we might say that shots and "mirrorical drops" are only the projections of desire. A desire that *never* hits the mark. The *Green Box* says that "the coefficient of displacement"—that is to say the farther or the closer each shot is to the target—"is nothing but a souvenir." A strange, hermetic affirmation that, however, is not impossible to decipher: what we see is only a souvenir (vague, imprecise, unfaithful) of what it really *is*. Knowledge is remembrance. Amorous, desiring remembrance. A new appearance of Neoplatonism, voluntary or reflexive, in the *Large Glass*. True reality is elusive, not because it is changeable but because it lives in another sphere, in another dimension. We walk among shadows and illusions, and nothing that we see, touch, and think has real consistency. Between us and real reality intrudes the horizon—that horizon which is the limit of our gaze and which is none other than the Bride's transparent garment. The horizon of our memory. Deceptive transparency, light trick of the

Wilson-Lincoln prism: the object we see from this side is not the one we see from the other. However, the object is one and the same. To desire is to remember this object, to take aim at its image.

It is no exaggeration to describe as celestial the region of the *Large Glass* that occupies the right-hand side of its upper half. Celestial not only because it borders on the Milky Way but also because the three elements that give it form are three constellations. All three are made of dots and luminous shadows, like those we see in astronomers' maps. The first is the region of the Nine Shots; the third is the Image of the Sculpture of Drops; the one in between is made by the Cast Shadows. Though it was not painted, we have a note dating from the same period as those of the two *Boxes*, in which Duchamp describes what its function was to have been. Duchamp imagines a method to "obtain a hypophysical analysis of the successive transformations of objects (in their form-outline)." It is the philosophical application, we might say, of the principle of the magic lantern, which so intrigued the minds of the seventeenth century. The object analyzed was to have been "constructed sculpturally in three dimensions," an aim compatible with Duchamp's intellectual preoccupations during those years. The note specifies "for the upper part of the *Glass* included between the horizon and the nine holes, cast shadows formed by the splashes/coming from below like some jets of water/that weave forms in their transparency."[16] The correspondence between the Nine Shots, the

16. The prototype of this idea is the last canvas painted by Duchamp, *Tu m'* (1918), which is still awaiting detailed analysis. The same is true of another prototype, that of the Oculist Witnesses, executed on glass in Buenos Aires, also

Cast Shadows and the Image of the Sculpture of Drops is amazing. The duality of the *Large Glass* begins to reveal its true meaning to us: down below, the world of here and now; up there, the world of real reality, essences, and ideas. Or to use the language of the *White Box:* up there *apparitions* (or their shadows *more or less* reflected by our senses) and down below *appearances,* what we touch and see, what we can measure and weigh. The forms up there are *relatively* real because they are only projections of the true forms that make up the fourth dimension. The world up there is not the projection of our desires; we are their projection. Our desire is nostalgia, the remembrance of that world.

While one portion of the Sculpture of Drops passes through the metamorphoses I have talked about, another crosses through the magnifying glass found above the three oculist circles. The glass turns the drops into a ray of light. Again the act of looking, through which the universal magnetism is conveyed. The magnifying glass throws the ray onto the combat marble. Struck by its luminous energy, the marble jumps up and hits the first summit. In this way it sets in motion the clockwork mechanism of the Boxing Match. The first fall of the rams that hold up the Bride's garment makes the Juggler of Gravity give a little jerk. The ball attacks again, "very hard": the rams fall again, the first one is unfastened, and the Juggler pirouettes. Attack number three, a "direct" attack this time: the second ram is unfastened; the Juggler jumps like the spring he is, and lifts

in 1918, *To Be Looked at (from the Other Side of the Glass), with One Eye, Close to, for Almost an Hour.*

Marcel Duchamp

58

his tray up to the "solid flame" in which the Bride's desire is manifest. The two rams pull the horizon-garment with them in their fall. Balanced on a shaky three-legged table resting on the garment, the Juggler of Gravity dances dangerously on its wobbling surface. With this dance the stripping reaches its climax.

The three "blossomings" accompany all these phenomena. The first is the result of the stripping by the Bachelors and is electrically controlled. Between the Bride and the Bachelors there is contact, though not at close quarters: sparks from the "desire-magnet"; explosions from the "motor with quite feeble cylinders"; the Bride's sighs, which make the fabric of the Three Pistons undulate in order to give her commands to the Bachelor-Machine; transformation of the filament substance into a "solid flame" that licks the black ball offered to it on a tray by the Juggler of Gravity; rattles from the car going up the slope; the movement of the gearbox and the serrated wheels. . . . Duchamp compares this "blossoming" to the "throbbing jerk of the minute hand on an electric clock." The Bride accepts this stripping; she even provides the "love gasoline" to feed the sparks and "adds to the first focus of sparks the second focus of sparks of the desire-magnet." The first "blossoming" provokes the second, in which the desiring Bride voluntarily imagines her stripping. It is a sensation closely connected with the "arbor-type," so that it is expressed "in boughs frosted in nickel and platinum."[17] To this "blossoming" corresponds the

17. The expression seemed unintelligible until the discovery of the Assemblage now in the Philadelphia Museum, in which the Bride appears reclining on a bed of twigs and leaves.

image of the automobile climbing the slope in first gear. The two "blossomings" are only one, the third a "mixture, physical compound of the two causes (Bachelors and imaginative desire) unanalyzable by logic." It is the "cinematic blossoming" that reveals itself as a flesh-colored Milky Way, "halo of the Bride, sum total of her splendid vibrations." When it reaches this point, says the *Green Box*, "the picture will be an inventory of the elements of this blossoming, elements of the sexual life imagined by her, the desiring Bride." There follows in the manuscript a revealing sentence that was later crossed out: "This blossoming has nothing to do with either the Bachelors or the stripping." In the "Bride's last stage before orgasm" the Bachelors disappear. The operation is circular: it begins in the Bride's Motor-Desire and ends in her. A self-sufficient world. It has no need even of spectators because the work itself includes them: the Oculist Witnesses. How can we not recall Velázquez and his *Meninas?*

The *Large Glass* is a design for a piece of machinery and the *Green Box* is therefore a bit like one of those sets of instructions that tell us how to put machines together and how they work. Since the former is a static illustration of a moment in the total operation, to understand it in its totality we must resort to the notes in the latter. Really the composition should have three parts: one plastic, another literary, and the third sonorous. Duchamp has made a few annotations for this third part: the litanies of the Chariot, the adagio of the Chocolate Grinder, shots or discharges, the noise of a car engine as it goes up a hill, and so forth. It is a transposition of the moans and sighs of eroticism to

the world of machines. On the other hand the *Large Glass* is also a mural (a portable one) representing the Apotheosis of the Bride, a picture, a satire of the machine mentality, an artistic experiment (painting in glass), a vision of love.

Of all possible interpretations, the psychoanalytical one is the most tempting and the easiest: onanism, destruction (or glorification) of the Virgin Mother, castration (the Scissors), narcissism, retention (anal symptoms), aggressiveness, self-destruction. A well-known psychiatrist ends his study—not devoid of brilliance—with the expected diagnosis: autism and schizophrenia. The drawback of such hypotheses is that their authors look at works only as symptoms or expressions of certain psychic tendencies; psychological explanation turns reality (the painting) into shadow, and shadow (the sickness) into reality. A personal encounter with Duchamp would have been enough to make one realize that his schizophrenia must have been of a very odd variety, for it did not prevent him from dealing with people or from being one of the most open men I knew. Furthermore, the rightness or wrongness of the diagnosis does not change the reality of the *Large Glass.* The realities of psychology and of art exist on different levels of meaning: Freud offers us a key to understanding Oedipus, but the Greek tragedy cannot be limited to the interpretations of psychoanalysis. Lévi-Strauss says that Freud's interpretation of the myth is nothing more than *another* version of it: in other words, Freud tells us, in the language that is appropriate to an age that has substituted logical thought for mythological analogy, the same story as Sophocles told us. Something similar could be said of the *Large Glass:* it
61 is a version of the ancient myth of the great Goddess,

Virgin, Mother, Giver and Exterminator of life. It is not a modern myth: it is the modern version—or vision—of the Myth.

In an interview with Jean Schuster, Duchamp tells us this story of the origin of his picture: "the fairground stalls of those days (1912) gave me the inspiration for the theme of the bride. They used to display dolls in the sideshows that frequently represented the partners of a marriage. The spectators threw balls at them, and if they hit the mark, they beheaded them and won a prize." The Bride is a doll; the people who throw the balls are her Bachelors; the Oculist Witnesses are the public; the Top Inscription is the scoreboard. The idea of representing the males as bachelors in uniform also has a popular origin. The bachelor keeps his virility intact while the husband disperses it and so becomes feminine. The husband, Tomás Segovia says, breaks the closed circle of the adolescents, and until he is redeemed by becoming a father, he is seen by his former comrades as a traitor to his own sex. This attitude expresses the adolescent's terror of woman and the fascinated revulsion that he feels for her hidden sexual organs. The uniform preserves his masculinity for two reasons: it belongs by right to men, is a sign that proclaims the separation between the two sexes, in such a way that women who put it on look like men; second, the uniform makes a group of the men, it turns them into a separate collectivity, bearing some resemblance to the ancient guilds and other secret male societies. So then, behind the modern masquerade another reality appears, archaic and fundamental: the separation between men and the Woman, the ambiguous cult the former profess and the dominion of the latter over

them. We are moving from farce to sacred mystery, from popular art to the religious mural, from folk tale to allegory.

The *Large Glass* is a scene from a myth or, rather, from a family of myths related to the theme of the Virgin and the closed society of men. It would be curious to attempt a systematic comparison between the other versions of the myth and that of Duchamp. It is a task, however, beyond my ability and my purpose as translator of the text. I will limit myself to isolating certain elements. The first is the insurmountable separation between the males and the Bride and the dependency on her of the former; not only does the appeal of the Virgin wake the life in them but all their activity, a mixture of adoration and aggression, is a reflex action aroused by the energy which the woman emits and which is directed by her and toward herself. The spatial division into two halves is also significant: the here-below of the males—a messy and monotonous hell as the litanies of the Chariot tell us—and the solitary above-and-beyond of the Virgin, who is not even touched by the shots—the supplications of her Bachelors. The meaning of this division is plain; energy and decision is above, below there is passivity in its most contemptible form: the illusion of movement, self-deception (the males are led to believe that they exist only by way of a mirror that prevents them from seeing themselves in their comic unreality). The most noteworthy feature is the circular and illusory character of the operation: everything is born from the Virgin and returns to her. There is a paradox here: the Bride is condemned to remain a virgin. The erotic machinery that sets things in motion is entirely imaginary, as much because her

males have no reality of their own as because the only reality which she knows and by which she is known is reflex: the projection of her Motor-Desire. The emanations that she receives, at a distance, are her own, filtered through a meaningless piece of machinery. At no moment of the process does the Bride enter into any relation with the true masculine reality or with the real reality: the imaginary machine that her Motor projects comes between her and the world.

In the version of the myth that Duchamp offers us there is no hero (the lover) who, by breaking the circle of males, setting fire to his livery or uniform, crossing the zone of gravity, conquering the Bride, and liberating her from her prison, will open her and break her virginity. It is not surprising that some critics, influenced by psychoanalysis, have seen in the *Large Glass* a castration myth, an allegory of onanism, or the expression of a pessimistic vision of love in which a true union is impossible. This interpretation is not false; it is inadequate. I hope to demonstrate that the theme of the *Large Glass* is another myth; in other words, that the myth of the Virgin and her Bachelors is the projection or translation of another myth. For the moment I will limit myself to emphasizing the circular nature of the operation: the Motor-Desire causes the Bride to rise out of herself, and this desire encloses her all the more completely in her own being. The world is her representation.

The Tantric imagery of Bengal represents Kali dancing in frenzy over two bodies that are as white as corpses. They are not dead; they are two ascetics covered with ashes. In one of her hands Kali grasps a sword, in another a pair of shears, in the third she holds a lotus, and in the last a cup.

By her side are two little female figures who hold a sword in one hand and also hold a cup in the other. Around the five figures there is a profusion of bones and broken human limbs. A number of dogs are gnawing and licking them. The two white bodies are placed on top of each other and represent Shiva, the husband of Kali. The first of them has his eyes closed; he is fast asleep and unaware of what is happening; according to the traditional interpretation he is the absolute unconscious of itself. The other figure, a sort of emanation of the former, has his eyes half open and his body is hardly formed; he is the absolute already in a state of awareness or consciousness. The Goddess is a manifestation of Shiva and the three figures represent the stages of the manifestation: the unconscious passivity of the absolute, the phase of consciousness that is still passive, and the emergence of activity and energy. Kali is the world of phenomena, the incessant energy of this world, which is shown as destruction (sword and shears), as nourishment (the cup full of blood), and as contemplation (the lotus of the interior life). Kali is carnage, sexuality, propagation, and spiritual contemplation.

It is obvious that both the image and its philosophical explanation offer more than one parallel with the *Large Glass* and the *Green Box:* Kali and the Bride, the Oculist Witness and the two attendants, masculine passivity and feminine activity. The most obvious resemblance is that in both cases we are present at the representation of a circular operation that unveils the phenomenal reality of the world (strips it bare: ex-poses it) and simultaneously denies it all true reality. This parallel is not external but constitutes the essence or fundamental theme of both representations.

The undeniable similarities between the Hindu image and the *Large Glass*, the *Green Box*, and my explanation of the Tantric tradition do not mean, of course, that there is a direct relation between them. Nor is the parallel a chance coincidence. They are two distinct and independent versions of the same idea—perhaps of a myth that refers to the cyclic character of time. Of course, neither Hindu tradition nor Duchamp was necessarily aware of this myth; the two versions are responses to the traditional images that both civilizations have made of the phenomenon of creation and destruction, woman and reality. I do not insist on this, because my purpose is not anthropological and the only thing that interests me in comparing these two images is to get somewhat deeper into the work of Duchamp.

There is another image of Kali that helps to clarify the resemblance. The Goddess is again dancing on the two pale Shivas. Seized by her delirium, she has decapitated herself; instead of the lotus, she is holding her own head in one of her hands, the mouth half open and its tongue hanging out. Three streams of blood gush from her neck: two of them into the cups of her attendants and the central one into her own mouth. The Goddess feeds the world and herself with her own blood in exactly the same way as the Bride sets her Bachelors in motion simply by gratifying herself and stripping herself bare. In the first case the operation is related to us in terms of myth and sacrifice; in the second, in pseudomechanical terms that, however, do not exclude the idea of sacrifice. The separation of the female body into two is equally striking: the Goddess and her head, the Bride and her Motor. This last point calls for further comment. The subdivision of the Goddess and the Bride into two parts—

Marcel
Duchamp

66

Tantric Imagery of Kali. *Ediciones Era.*

one active and the other receptive—is in its turn the conse-
quence of another division; the Goddess and the Bride are
projections or manifestations of something which Hindu
imagery represents in the mode of myth (Shiva in his
double form) and which Duchamp preserves invisibly, the
fourth or archetypal dimension. Kali and the Bride are a
representation and the real world is another representa-
tion, the shadow of a shadow. The circular movement is
the reintegration of the energy dispersed by the dance or
by desire, without any extraneous element enriching or
changing it. Everything is imaginary. It is time to pass from
myth to criticism.

Neither the Hindu myth nor that of Duchamp is self-
sufficient. To understand the Tantric image we have to
resort to the methods of traditional exegesis and, in the
case of the *Large Glass,* to the *Green Box.* The enigma
of the two images consists in this: if Kali and the Bride are
projections, or representations, what do they represent,
what is the energy or entity that they are projecting? The
Hindu myth gives a clear account of the origin of the
Goddess. A frightful demon threatens the universe with
destruction; the gods go in terror to the greater divinities,
Shiva and Vishnu, to seek refuge; Shiva and Vishnu, on
being informed of what is happening, become angry and
swell with rage; the other gods imitate them, the assembly
of divine angers fuses into a single image—the black God-
dess with eight arms. Male power abdicates in favor of a
female deity who will destroy the monster.[18] Philosophical

18. Heinrich Zimmer, *Myths and Symbols in Indian Art and Civilization* (New
York: Pantheon, 1946).

commentary translates this story into metaphysical and ethical terms: energy and the world of phenomena are representations or manifestations of the absolute (unconscious and conscious, asleep and half awake). Energy is feminine for two reasons: woman is creation and destruction; the world of phenomena is Maya, illusion *(la ilusión)*. Duchamp's version of the myth is different from that of the Hindu commentator in that he rejects the metaphysical explanation and keeps silent. The Bride is a projection of the fourth dimension, but the fourth is, by definition, the unknown dimension.

Michel Carrouges concludes from this silence that he is an atheist. From the point of view of Christian tradition, his verdict is correct. But our believers and our atheists belong to one and the same family: the former affirm the existence of a single God, a personal Creator; the latter deny it. The negation of the latter makes sense only in the context of the Judeo-Christian monotheistic concept of God. As soon as it abandons these grounds, the discussion loses interest and turns into a quarrel inside a sect. In reality our atheism is antitheism. For a Buddhist atheist, Western atheism is only a negative and exasperated form of our monotheism. Duchamp has declared quite rightly on a number of occasions that "the genesis of the *Glass* is exterior to any religious or antireligious preoccupation." (In this context the word "religion" refers to Christianity. The rites and beliefs of the East, for the most part, don't constitute what we would call a "religion"; this term should be applied only to the West.) Duchamp expresses himself even more clearly in a letter to Breton: "I don't accept discussions about the existence of God on the terms of *popular metaphysics,* which means

69

that the word 'atheist,' as opposed to 'believer,' doesn't even interest me. . . . For me there is something else that is different from *yes, no,* or from *indifferent*—for example: *absence of investigation in this area."* Duchamp hasn't represented the Motor of the Motor-Desire because this would have meant dealing with a reality about which, as he himself honorably says, he knows nothing. Silence is more valid than dubious metaphysics or than error.

In Duchamp's silence we find the first and most notable difference between the traditional method of interpretation and the modern. The one affirms the myth and gives it a metaphysical or rational support; the other places it between parentheses. All the same, Duchamp's silence does have something to tell us: it is not an affirmation (the metaphysical attitude), nor a negation (atheism), nor is it indifference (skeptical agnosticism). His version of the myth is not metaphysical or negative, but ironic; it is criticism. On the one hand, it makes fun of the traditional myth. It reduces the worship of the Goddess, both in its religious and in its modern form, cult of the Virgin, or romantic love, to a grotesque mechanism in which desire becomes an internal-combustion engine, love becomes gasoline, and semen is gunpowder. On the other hand, criticism also makes fun of the positivist conception of love and, in general, of everything we call "modern" in the common use of the word: "scientism," positivism, technology, and so on. The *Large Glass* is a comic and infernal portrayal of modern love or, to be more precise, of what modern man has made of love. To convert the human body into a machine, even if it is a machine that produces symbols, is worse than degradation. Eroticism lives on the

frontiers between the sacred and the blasphemous. The body is erotic because it is sacred. The two categories are inseparable: if the body is mere sex and animal impulse, eroticism is transformed into a monotonous process of reproduction; if religion is separated from eroticism, it tends to become a system of arid moral precepts. This is what has happened to Christianity, above all to Protestantism, which is its modern version.

Despite the fact that they are made of materials more lasting than our bodies, machines grow older more rapidly than we do. They are inventions and manufactured objects; our bodies are re-productions, re-creations. Machines wear out and after a time one model replaces another; bodies grow old and die, but the body has been the same from the appearance of man on the earth until now. The body is immortal because it is mortal; this is the secret of its permanent fascination—the secret of sexuality as much as of eroticism. The humorous element of *The Bride* does not lie only in the circular operation of her desire, but also in the fact that Duchamp, instead of painting brilliant and perishable bodies, painted opaque and creaking machines. The skeleton is comical because it is pathetic, the machine because it is icy. The first makes us laugh or weep; the second produces in us what I would call, following Duchamp, a *horror of indifference*. . . . In short, Duchamp's criticism is two-edged: it is criticism of myth and criticism of criticism. The *Large Glass* is the culminating point of the tendency toward the irony of affirmation that inspires the Readymades. It is a critical myth and a criticism of criticism that takes the form of comic myth. In the first

stage of the process, he translates the mythical elements

into mechanical terms, and therefore denies them; in the second, he transfers the mechanical elements into a mythical context, and denies them again. He uses the myth to deny the criticism and criticism to deny the myth. This double negation produces an affirmation which is never conclusive and which exists in perpetual equilibrium over the void. Or as he has said: *Et-qui-libre? Equilibre.*

Some critics have found a theological significance in the division of the *Large Glass* into two halves—the realm of the Bride above and the fief of her bachelors below—and have pointed out that this duality corresponds to the ancient idea of a world above and a world below. Harriet and Sidney Janis have gone further. The lower part is a sort of hell, governed by the laws of matter and gravity, whereas the upper part is the region of the air and of levitation; the Bride is nothing other than an allegory of purified matter or, in Christian terms, of the Ascension of the Virgin. The interpretation contains a grain of truth, but it is incomplete and based, moreover, on guesswork. Robert Lebel sees in the *Large Glass* an antiworld, the equivalent of the antimatter of contemporary physics, which reflects all Duchamp's fears and obsessions, especially those that are infantile or unconscious. Or, to put it in mythical terms, it is the manifestation of what the painter fears and hates just as the Goddess is the manifestation of the fear and anger of the gods. This antiworld is the "vomit, the monstrous and repulsive form of a Bachelor-Machine that is nothing other than an incestuous and masculine hell." It hardly seems necessary to observe that the *Large Glass* is *not* the representation of male desire but the projection of the desire of the Bride, which is in its turn the projection of

an unknown dimension or Idea. . . . Lebel adds that Duchamp's picture belongs to the same family as the *Garden of Earthly Delights* of Hieronymus Bosch. Although the comparison is correct, it has the same defect as the hypothesis of Harriet and Sidney Janis—it is incomplete. Christian religious painting is Trinitarian or tripartite: it consists of the world, of heaven, and of hell. The opposition of dualities is not Christian but Manichaean. Moreover, the division of the *Large Glass* into two halves is not exactly a division into heaven and hell; both parts are hell. The line of division doesn't allude to a theological separation ("the Bride is chaste with a touch of malice," the *Green Box* tells us), but one of power. The division is, if you like, of an ontological nature: the males have no existence in their own right; the Bride, on the other hand, enjoys a certain autonomy thanks to her Motor-Desire. But, as we have seen, the dual division is illusory like the whole painting; there comes a point when we have to reckon that, like the Bride and her Bachelors, we have been victims of an illusion. Duchamp has good reasons for painting images on glass: everything has been a representation and the characters in the drama and their circular actions are a projection, the dream of a dream.

The remarks I have made above do not mean that these critics haven't seen with some shrewdness a central feature of the *Large Glass*. This composition continues, in its own way, the great tradition of Western painting, and for this reason, it stands in violent opposition to what we have called painting since Impressionism. Duchamp has frequently referred to the aims that have inspired him: "It was my intention not to make a painting for *the eyes*, but a

painting in which the tubes of color were a means and not an end in themselves. The fact that this kind of painting is called literary doesn't bother me; the word "literature" has a very vague meaning and I don't think it is adequate. . . . There is a great difference between a painting that is only directed toward the retina and a painting that goes beyond the retinal impression—a painting that uses the tubes of color as a springboard to go further. This was the case with the religious painters of the Renaissance. The tubes of color didn't interest them. What they were interested in was to express their idea of divinity, in one form or another. With a different intention and for other ends, I took the same concept: pure painting doesn't interest me either in itself or as a goal to pursue. My goal is different, is a combination or, at any rate, an expression that only gray matter can produce."[19] This long quotation spares me the need of any commentary. The *Large Glass* continues the tradition not because it shares the same ideals or exalts the same mythology but because, like it, it refuses to turn aesthetic sensation into an end in itself. It continues it, moreover, by being monumental—not only because of its proportions but also because the *Large Glass* is a *monument*. The divinity in whose honor Duchamp has raised this ambiguous monument is not the Bride or the Virgin or the Christian God but an invisible and possibly nonexistent being: the Idea.

Duchamp's enterprise was contradictory, and he saw it as such from the outset. For this reason irony is an essential element in his work. Irony is the antidote that counteracts

19. Conversation with Alain Jouffroy, in *Une Révolution du regard*.

Marcel Duchamp

any element that is "too serious, like eroticism," or too sublime, like the Idea. Irony is the Handler of Gravity, the question mark of *et-qui-libre?* The enterprise is contradictory for the following reason: how can one attempt a painting of ideas in a world that is impoverished of ideas? The Renaissance marked the beginning of the dissolution of the great Greco-Christian Idea of divinity, the last universal faith (in the limited sense of the term: "universal" meaning the community of European and Slavic peoples, the churches of East and West). It is true that the medieval faith was replaced by the imposing constructions of Western metaphysics, but from the time of Kant, all these edifices have begun to crumble and from then on thought has been critical and not metaphysical. Today we have criticism instead of ideas, methods instead of systems. Our only idea, in the proper sense of the term, is Criticism. The *Large Glass* is a painting of ideas because, as I think I have shown, it is a critical myth. But if it was only this, it would merely be one work more and the enterprise would be partially abortive. I should underline the fact that it is also and above all the Myth of Criticism; it is the painting of the *only modern idea.* Critical myth: criticism of the religious and erotic myth of the Bride-Virgin in terms of modern mechanical development and, simultaneously, a myth that burlesques our idea of science and technology. Myth of Criticism: painting-monument that relates one moment of the incarnations of Criticism in the world of objects and erotic relationships. Now, in the same way as religious painting implies that the artist, even if he is not religious, believes in some way in what he is painting, the
75 painting of Criticism requires that the painting itself and

its author be critics or that they participate in the critical spirit. As Myth of Criticism the *Large Glass* is a painting of Criticism and criticism of Painting. It is a work that turns in upon itself, that persists in destroying the very thing it creates. The function of irony now appears with greater clarity. Its negative purpose is to be the critical substance that impregnates the work; its positive purpose, as criticism of criticism, is to deny it and so to tip the balance onto the side of myth. Irony is the element that turns criticism into myth.

It would not be mistaken to call the *Large Glass* the Myth of Criticism. It is a picture that makes one think of certain works that prophesy and reveal the ambiguity of the modern world and its oscillation between myth and criticism. I am reminded of Ariosto's mock epic and of *Don Quixote,* which is an epic novel and a criticism of the epic. It is with these creations that modern irony is born; with Duchamp and other poets of the twentieth century, such as Joyce, the irony turns against itself. The circle closes; it is the end of one epoch and the beginning of another. The *Large Glass* is on the borders of two worlds, that of "modernity," which is in its death throes, and the beginnings of a new world, which hasn't yet taken shape. Hence its paradoxical position, similar to that of Ariosto's poem and Cervantes' novel. *The Bride* continues the great tradition of Western painting that was interrupted by the appearance of the bourgeoisie, the open market for works of art, and the predominance of taste. This painting, like the works of the religious artists, is sign and Idea. At the same time, Duchamp breaks with this tradition. Impressionism and the other modern and contemporary schools

continue the tradition of the craft of painting, although they eradicate the *idea* from the art of painting; Duchamp applies his criticism not only to the Idea but also to the very act of painting—the rift is total. It is a strange situation; he is the only modern painter who continues the tradition of the West and he is one of the first to break with what we have traditionally called the art, or craft, of painting. It could be argued that many artists of the present age have been painters of ideas: the Surrealists, Mondrian, Kandinsky, Klee, and many others. This is certainly true, but their ideas are subjective; their worlds, almost always fascinating, are private worlds, personal myths. Duchamp is, as Apollinaire conjectured, a *public* painter. No doubt someone will point out that other artists have also been painters of social ideas—the Mexican mural painters, for example. In its intentions the work of these painters belongs to the nineteenth century; it is program-painting, at times an art of propaganda and other times a vehicle of simplistic ideas about history and society. (Mexican mural painting is interesting because of its character and other values, as I have shown in another essay.[20]) The art of Duchamp is intellectual and what it gives us is the *spirit of the age*—Method, the critical Idea at the moment when it is meditating on itself, at the moment when it reflects itself in the transparent nothingness of a pane of glass.

The direct antecedent of Duchamp is not to be found in painting but in poetry: Mallarmé. The work that most closely resembles the *Large Glass* is *Un coup de dés*. It is not surprising; despite what the insular critics of painting

20. *Las peras del olmo (Mexico City: Seix-Barral, 1957), pp. 244–64.*

think, it is almost always poetry that anticipates and prefigures the forms that the other arts adopt later. The affected piety of modern times that surrounds painting and often prevents us from *seeing* it is nothing other than idolatry for the object, adoration of a magic object which we can touch and which, like other objects, can be bought and sold. It is the elevation of the object in a civilization dedicated to producing and consuming objects. Duchamp refuses to put up with this superstitious blindness and has frequently emphasized the *verbal*, or poetic, origin of his work. When he talks about Mallarmé, he couldn't be more explicit: "A great figure. Modern art must return to the direction traced by Mallarmé; it it must be an intellectual, and not merely an animal, expression. . . ." The similarity between the two artists springs not from the fact that they both show intellectual preoccupations in their work but from their radical nature—one is the poet and the other the painter of the Idea. Both of them come face to face with the same difficulty: there are no ideas in the modern world, only criticism. But neither of them takes refuge in skepticism and negation. For the poet, chance absorbs the absurd; it is a shot aimed at the absolute and which, in its changes and combinations, manifests or projects the absolute itself. It is the number which, in a state of perpetual motion, rolls from the beginning of the poem to the end and which resolves itself in what may or may not be a constellation, the unobtainable *sum total in formation*. The role that chance plays in the universe of Mallarmé is the same as that assumed by humor and meta-irony in Duchamp. The theme of the picture and of the poem is criticism, the Idea which ceaselessly destroys and renews itself.

In *Los signos en rotación*[21] (it is bad to quote oneself but worse to paraphrase) I endeavored to show how *Un coup de dés* is "a critical poem" and that "not only does it contain its own negation but this negation is its point of departure and its substance . . . the critical poem resolves itself in a conditional affirmation—an affirmation that feeds on its own negation." Duchamp also turned criticism into myth and negation into an affirmation that is no less provisional than Mallarmé's. The poem and the picture are two distinct versions of the Myth of Criticism, one in the solemn mode of a hymn and the other in the mode of the comic poem. The resemblance can be seen more strikingly if we pass on from analogies of an intellectual order to the *form* of these two works. Mallarmé inaugurated in *Un coup de dés* a poetic form that contains a plurality of readings—something very different from ambiguity or plurality of meanings, which is a property common to all language. It is an open form that "in its very movement, in its double rhythm of contraction and expansion, of negation that annuls itself and turns itself into an uncertain affirmation of itself, engenders its own interpretations, its successive readings. . . . Sum total in perpetual formation: there is no final interpretation of *Un coup de dés* because the last word of the poem is not the final word." The incomplete state of the *Large Glass* is similar to the last word that is never final of *Un coup de dés;* it is an open space that provokes new interpretations and evokes, in its incomplete state, the void on which the work depends. This void is *the absence of the Idea.* Myths of Criticism: if the poem is a ritual of absence, the painting is

21. *Los signos en rotación* (Buenos Aires, 1965).

its burlesque representation. Metaphors of the void. The hymn and the mural painting are open works that initiate a new type of creation; they are texts in which speculation, or the idea, or "gray matter" is the only character. An elusive character: Mallarmé's text is a poem in movement and Duchamp's painting is in a state of continual change. *The sum total in formation* of the poet is never complete; each one of its moments is definitive in relation to those that precede it and relative to those that come after; the reader himself is only one *reading* more, another instant in this never-ending tale, this constellation that is shaped by whatever is uncertain in each reading. Duchamp's painting is a transparent glass; as a genuine monument it is inseparable from the place it occupies and the space that surrounds it; it is an incomplete painting that is perpetually completing itself. Because it is an image that reflects the image of whoever contemplates it, we are never able to look at it without seeing ourselves. To sum up, the poem and the painting affirm simultaneously the absence of meaning and the necessity of meaning, and it is here that the meaning of both works resides. If the universe is a language, Mallarmé and Duchamp show us the reverse of language—the other side, the empty face of the universe. They are works in search of a meaning.

The influence of Duchamp's work and of his personality is part of the history of modern painting. If we omit the numerous and persistent offspring of that part of his work that is painting in the strict sense of the word—above all, of the *Nude Descending a Staircase*—and exclude also the equally numerous and not always successful Readymades,

this influence is concentrated at three points: Dada, Surrealism, and contemporary Anglo-American painting. Picabia and Duchamp, as is well known, foresaw, prepared, and inspired the explosion of Dada; at the same time, they gave it elements and tendencies that were lacking in the work of the orthodox representatives of the movement. It is best to quote Duchamp on this point: "While Dada was a movement of negation and, by the very fact of its negation, turned itself into an appendage of the exact thing it was negating, Picabia and I wanted to open up a corridor of humor that at once led into dream-imagery and, consequently, into Surrealism. Dada was purely negative and accusatory. . . . For example, my idea of a capricious metrical unit of length. I could have chosen a meter of wood instead of a thread and broken it in two; this would have been Dada." Duchamp's position in the Surrealist movement follows the same dialectic. In the full frenzy of Surrealism he returned to certain Dadaist gestures and kept alive a tradition of humor and negation that the movement, dominated as it was by the passionate and logical genius of Breton, would perhaps have discarded. His action was, in both cases, that of a precursor and contradictor.

The influence of Duchamp on Anglo-American painting has a different character. It is not a direct though distant activity, as in the epoch of Dada and militant Surrealism; it is an example. Contemporary American painting has gone through two distinct periods. In the first, the painters were influenced by the Mexican muralists and, a little later and more decisively, by the Surrealists: Ernst, Miró, Masson, Matta, Lam, and Tanguy. Among these names the most important were, in my opinion, Masson

and Matta. This stage owed little to Duchamp. Abstract Expressionism was too olfactory and retinal to be the kind of painting he cared for. The second group, that of the young painters, would be unthinkable without his friendship, presence, and influence. It is necessary at this point to make a distinction between Pop art in the proper sense of the term and the work of other young artists such as Jasper Johns and Robert Rauschenberg. Pop art bears only a superficial resemblance to the *gesture* of Duchamp or, for that matter, to the attitude of Picabia, although it is closer to the second. Pop humor lacks aggression and its profanities are not inspired by negation or sacrilege but by what Nicholas Calas defines as the *why not?* Nor is it a metaphysical revolt; fundamentally it is passive and conformist. It is not a search for innocence or the "previous life," like the movement of the Beat poets, although like them, and with greater frequency, it falls into sentimentality. Its brusque recourse to brutality is just this—a way of countering this sentimentality. It is a typical national reaction. The Anglo-Americans swing between these two extremes with the same facility as the Spanish turn from anger to apathy and the Mexicans from the shout to silence. No one is less sentimental than Duchamp; his temperament is sober and his art *dry*. Picabia was exuberant and could laugh or weep copiously, but he never groaned or smirked before the public-as-mirror as the Pop artist does. The common denominator of Duchamp and Picabia is their lucid desperation. The great master of the Pop painters is, in fact, Kurt Schwitters. It is hardly necessary to remind oneself that he called his art of refuse and garbage *Merz*, an allusion to *Kommerz* (commerce), *Ausmerzen* (gar-

bage), *Herz* (heart), and *Schmerz* (grief). It is an art of anguish saved by humor and fantasy but not exempt from self-pity. Finally, Duchamp and Picabia, like all the Dadaists and the Surrealists after them, lived in perpetual conflict with the mass and with the minority; Pop art, on the other hand, is a populism for the well-off.

In the case of Rauschenberg, Johns, and a few other artists, there is a difference. These two artists are extremely talented and their mental gifts are as great as their pictorial ones. Jasper Johns is, I think, the more concentrated and profound; his painting is rigorous—it is target practice and the target is metaphysical. Rauschenberg's sensibility is more on the surface and he has a great painterly instinct which he could turn into the beginnings of something important or which could relapse into mere good taste. Both of them have preoccupations similar to those of Duchamp, though in speaking of influence I mean affinity rather than exact derivation. They are two intrepid artists and their work is a continual exploration. Admittedly I don't see either in them or in the others the prospect of that *total* work that the United States has been promising us for a century and a half. I am thinking as I write this not only of painting but equally of poetry. What Whitman prophesied neither Pound nor Williams, neither Stevens nor Cummings, neither Lowell nor Ginsberg has fulfilled. Lucid or visionary, almost always original and at times extraordinary, they are not the poets of midday but of twilight. Perhaps it is better so.

Being a public painter is not the same as being popular. Art, for Duchamp, is a secret and should be shared and passed on like a message between conspirators. Let us listen

to him: "Today painting has become vulgarized to the utmost degree. . . . While no one has the nerve to intervene in a conversation between mathematicians, we listen every day to after-dinner dissertations on the value of this painter or that. . . . The production of an epoch is always its mediocrity. What is not produced is always better than what is." In another interview he confided to the poet Jouffroy: "The painter has already become completely integrated with actual society, he is no longer a pariah. . . ." Duchamp doesn't want to end up either in the academy or among the beggars, but it is obvious that he would prefer the lot of the pariah to that of the "assimilated artist." His attitude to the current situation in art is not different from that which inspired the Readymades and the *Large Glass*. It is one of total criticism, and therefore, over and above all, criticism of modernity. The history of modern painting, from the Renaissance to our own times, could be described as the gradual transformation of the work of art into an artistic object: a transition from *vision* to the *perceptible thing*. The Readymades were a criticism both of taste and of the object. The *Large Glass* is the last genuinely meaningful work of the West; it is meaningful because by assuming the traditional meaning of painting, which is absent from retinal art, it dissolves it in a circular process and in this way affirms it. With it our tradition comes to an end. Or, rather, the painting of the future will have to begin with it and by confronting it, if painting has a future or the future a painting.

Meanwhile, imitations of the Readymades pile up in our museums and galleries. The isolated gesture is degraded into a dreary collective rite, a blasphemous game becomes

Marcel
Duchamp

84

passive acceptance, and the "objet-dart" turns into an inof-fensive artifact. Since the Second World War the process has accelerated; painting and sculpture have been con-verted, like the other products of industrial society, into consumer goods. We are witnessing the end of the "per-ceptible thing," of retinal painting reduced to optical ma-nipulation. What distinguished modern from classical art was—from Romantic irony to the humor of Dada and the Surrealists—the alliance of criticism and creation; the eradication of the critical element from works of art is equivalent to a veritable castration, and the abolition of meaning confronts us with a production no less insignifi-cant, although much more numerous, than that of the retinal period. Finally, our epoch has replaced the old notion of *recognition* with the idea of publicity, but public-ity dissipates into general anonymity. It is the revenge of criticism.

One of Duchamp's most disturbing ideas is crystallized in an often-quoted sentence: "The spectator makes the picture." Expressed with such insolent concision, it would seem to deny the existence of works of art and to proclaim an ingenuous nihilism. In a short text published in 1957 ("The Creative Act")[22], he clarifies his idea a little. He explains here that the artist is never fully aware of his work. Between his intention and the realization, between what he *wants* to say and what the work actually *says*, there is a difference. This "difference" is, in fact, the work. Now, the spectator doesn't judge the picture by the intentions of its originator but by what he actually sees. This vision

 22. *Art News*, vol. 56, no. 4. (New York, 1957).

is never objective; the spectator interprets and "distills" what he sees. The "difference" is transformed into another difference, the work into another work. In my opinion Duchamp's explanation does not account for the creative act or process in its entirety. It is true that the spectator creates a work that is different from the one imagined by the artist, but between the two works, between what the artist *wanted* to do and what the spectator *thinks* he sees, there is a *reality:* the work. Without it, the re-creation of the spectator is impossible. The work makes the eye that sees it—or, at least it is a point of departure; out of it and by means of it the spectator invents another work. The value of a picture, a poem, or any other artistic creation is in proportion to the number of signs or meanings that we can see in it and the possibilities that it contains for combining them. A work is a machine for *producing meanings.* In this sense Duchamp's idea is not entirely false: the picture depends on the spectator because only he can set in motion the apparatus of signs that comprises the whole work. This is the secret of the fascination of the *Large Glass* and the Readymades. Both of them demand an active contemplation, a creative participation. They make us and we make them. In the case of the Readymades the relation is not one of fusion but of opposition; they are objects made against the public, against ourselves. By one means or another Duchamp affirms that the work is not a museum piece. It is not an object of adoration nor is it useful; it is an object to be invented and created. His interest—indeed, his admiration and nostalgia—for the religious painters of the Renaissance has the same origin. Duchamp is against the museum, not against the cathe-

Marcel
Duchamp

86

dral; against the "collection," not against an art that is founded on life. Once more Apollinaire has hit the mark: Duchamp's purpose is to reconcile art and life, work and spectator. But the experience of other epochs cannot be repeated and Duchamp knows it. Art that is founded in life is socialized art, not social or socialist art; and still less is it an activity dedicated to the production of beautiful or purely decorative objects. Art founded in life means a poem by Mallarmé or a novel by Joyce; it is the most difficult art. An art that *obliges* the spectator or the reader to become himself an artist and a poet.

In 1923 Duchamp abandoned definitively the painting of the *Large Glass.* From then on his activity has been isolated and discontinuous. His only permanent occupation has been chess. There are some people who consider this attitude a desertion, and, inevitably, there are others who judge it as a sign of "artistic impotence." These people never stop to take note of the fact that Duchamp has placed in parentheses not so much art as the modern idea of the work of art. His inactivity is the natural prolongation of his criticism—it is meta-irony. I emphasize the distinction between art and the idea of the work because what the Readymades and Duchamp's other gestures denounce is the concept of art as an object—the "objet d'art"—that we can separate from its context in life and keep in museums and other safe deposits. The very expression "priceless work of art" reveals the passive and lucrative character— there is no contradiction in the terms—of our notion of the work. For the ancients as for Duchamp and the Surrealists art is a means of liberation, contemplation, or knowledge,

an adventure or a passion. Art is not a category separate from life. . . . André Breton once compared his abandonment of painting with Rimbaud's break with poetry. Chess would be in these terms a sort of Harrar in New York, even more "execrable" than that of the poet. But Duchamp's inactivity is of a different order from Rimbaud's silence. The adolescent poet opposes a total negation to poetry and disowns his work; his silence is a wall and we don't know what lies behind this refusal to speak: wisdom, desperation, or a psychic change that converted a great poet into a mediocre adventurer. Duchamp's silence is open; he affirms that art is one of the highest forms of existence, on condition that the artist escapes a double trap—the illusion of the work of art and the temptation to wear the mask of the artist. Both of these petrify us; the first makes a prison of a passion, and the second a profession of freedom. To think that Duchamp is a vulgar nihilist is sheer stupidity: "I love the word 'believe.' Normally when people say *I know*, they don't know what they are saying; they believe that they know. I believe that art is the only activity by which man shows himself as an individual. By this activity he can transcend his animal nature—art opens onto regions that are not bound by time or space. To live is to believe—at least this is what *I believe.*" Is it not strange that the author of the Readymades and the *Large Glass* should express himself in such a way and proclaim the supremacy of passion? Duchamp is intensely human, and it is contradiction that distinguishes men from angels, animals, and machines. Moreover, his "irony of affirmation" is a dialectical process that has the precise intention of undermining the authority of reason. He is not an irration-

alist; he applies rational criticism to reason; his crazy and carefully reasoned humor is the backfired shot of reason. Duchamp is the creator of the Myth of Criticism, he is not a professor who makes criticism of the myth.

His friend Roché has compared him with Diogenes, and the comparison is correct. Like the cynic philosopher and like all of the very limited number of men who have dared to be free, Duchamp is a clown. Freedom is not knowledge but what one has become after knowledge. It is a state of mind that not only admits contradiction but seeks it out for its nourishment and as a foundation. The saints do not laugh, nor do they make us laugh, but the truly wise men have no other mission than to make us laugh with their thoughts and make us think with their buffoonery. I don't know if Plato had a sense of humor, but Socrates did and so did Chuang-tzu and many others. Thanks to humor, Duchamp protects himself from his work and from us, who contemplate, admire, and write about it. His attitude teaches us—although he has never undertaken to teach us anything—that the end of artistic activity is not the finished work but freedom. The work is the road and nothing more. This freedom is ambiguous, or rather, conditional; we can lose it at any moment, above all if we take ourselves or our work too seriously. Perhaps it was to underline the provisional character of all freedom that he didn't finish the *Large Glass;* in this way he did not become its slave. The relation of Duchamp to his creations is contradictory and cannot be pinned down: they are his own and they belong to those who contemplate them. For this reason he has frequently given them away; they are instruments of liberation. In his abandonment of painting there

is no romantic self-pity, nor the pride of a titan; it is wisdom, *mad wisdom*. It is not a knowledge of this thing or that, it is neither affirmation nor negation; it is the void, the knowledge of indifference. Wisdom and freedom, void and indifference resolve themselves into a key word: purity. Something which cannot be sought after but which gushes forth spontaneously after one has traversed certain experiences. Purity is what remains after all the accounts have been made. Igitur finishes with these words: *Le Néant parti, reste le château de la pureté.*

Delhi, October 25, 1966

*WATER WRITES ALWAYS IN *PLURAL:[1]

Given 1. the waterfall

2. the illuminating gas,

one will determine
we shall (determine) the conditions
for the instantaneous State of Rest (or allegorical appearance) ,
of a (succession) [of a group] of (various facts)
seeming to necessitate each other
under certain laws, in order to isolate the (sign)
the
of accordance between, on the one hand,
all the (?)
this State of Rest (capable of (innumerable eccentricities))
and, on the other, a choice of Possibilities
authorized by these laws and (also
(determining them).[2]

1. This expression appears in *"The,"* Marcel Duchamp's first text in English, composed in New York in 1915. The article "the" was systematically replaced by an asterisk and gives the fragment its title.

2. Marcel Duchamp, opening paragraph of the preface to the *Green Box*, translation by George Heard Hamilton, typography by Richard Hamilton, from *The Bride Stripped Bare by Her Bachelors, Even* (New York: Wittenborn, 1960).

We are indebted to Apollinaire for three judgments on Marcel Duchamp, incompatible with one another, and all three true. In one of them he allotted his friend a mission: "to reconcile art and the people." In another he claimed that the young painter (Duchamp was about twenty-five when Apollinaire wrote this) was one of the few artists unafraid of "being criticized as esoteric or unintelligible." The third judgment was no less peremptory nor, apparently, less arbitrary and contradictory: "Duchamp is the only painter of the modern school who today [autumn, 1912] concerns himself with the nude."[3]

The first claim, surprising at the time of its formulation, seems less so today. The Readymades evicted the "art object," replacing it with the anonymous "thing" that belongs to us all and to no one. Though they do not exactly represent the union of art and the people, they acted subversively against the fastidious privileges of artistic taste.

On the other hand *The Bride Stripped Bare by Her Bachelors, Even* does indeed bring about the union that Apollinaire predicted. It does so twice over: it not only adopts the highly publicity-conscious form of illustrations from catalogs of industrial machinery, but it was conceived by Duchamp as a monument whose theme is at once popular and traditional—the apotheosis of the Bride as she is being denuded.

Despite its twofold public character—graphic description of the workings of a machine and representation of an

3. All three quotations, Guillaume Apollinaire, *Les peintres cubistes: Méditations esthétiques* (Paris: Figuière, 1913). English translation by Lionel Abel, *The Cubist Painters: Aesthetic Meditations* (New York: Wittenborn, Schultz, 1949), pp. 47–48.

erotic ritual—the *Large Glass* is a secret work. Its composition is the projection of an object that we cannot perceive with our senses; what we see—outlines, mechanisms, diagrams—is only one of its manifestations in the mechanic-ironic mode. The painting is an enigma and, like all enigmas, is something not to be contemplated but deciphered. The visual aspect is only a starting point. Furthermore, there is another element that radically modifies the innocuous act of seeing a painting and turns it into a kind of initiation rite: the riddle is presented to us by a virgin who is also a machine. It is surely not necessary to recall the ancient and fateful connection between virgins and riddles. There is yet another similarity between the myth and the painting: like the heroes and the knights of old, we confront the enigma with only the innocence left to us and with a sure but hermetic guide—the notes of the *Green Box* and the *White Box*. The public monument to the Bride is transformed into a sexual and mental labyrinth; the Bride is a body made of reflections, allusions, and transparencies. Her clarity dazzles us, and I am afraid that, beside her, this text will seem like the gas lamp held by the naked woman in the Assemblage in the Philadelphia Museum of Art.

At once a scientific description, a monument to a virgin, and an enigma made up of fearful clarities, *The Bride Stripped Bare by Her Bachelors, Even* is a nude. And so it confirms Apollinaire's third assertion. Except that, once again, it is an assertion that belies itself even as we affirm it: the nude is a skeleton. Erotic myth and negation of the myth by the machine, public monument and secret creation, nude that is a skeleton, and skeleton that is a motor,

the *Large Glass* opens out before us like the image of contradiction. But the contradiction is apparent rather than real: what we see are only moments and states of an invisible object, stages in the process of manifestation and concealment of a phenomenon. With that lucidity that is no less unique in him because it is constant, Duchamp alludes to the duplicity of his attempt in one of the first notes in the *Green Box: "*Perhaps make a *hinge picture" (tableau de charnière).* This expression, applicable to all his work, is particularly apt in the case of the *Large Glass:* we are facing a hinge picture that, as it opens out or folds back, physically and mentally, shows us other vistas, other apparitions of the same elusive object.

The *hinge* appears frequently in Duchamp. Thanks to the literal and paradoxical use of the idea of the hinge, Duchamp's doors and ideas open while remaining closed, and vice versa. If we have recourse to the same procedure, the expression "hinge picture," opening out (closing) on itself, reveals to us another expression that also appears in one of the early notes of the *Green Box: "*delay in glass" *(retard en verre).* Duchamp explains that this refers to a "sort of subtitle." Always explicit, even within his extreme succinctness, he adds that we must understand the word "delay" in the "indecisive reunion" of its different meanings. According to the Petit Littré dictionary, the meanings of *retard* are three in number: "What is or what happens too late; the delay of a watch, a clock, part of the movement that serves to slow it down or move it ahead; in harmony, the momentary delay when one starts to play one of the notes of a chord, but prolongs for a few moments the note of the preceding chord, a note that needs

Marcel
Duchamp

94

for its resolution the one which is delayed."[4] As it swings on its hinge, the "delay in glass," *The Bride* leads us on to another composition that is its *resolution,* as much in the musical sense as in any other. This composition, the final chord, is the Assemblage in the Philadelphia Museum. To see it is to hear the note held in abeyance in the *Large Glass.* Is the resolution the solution?

Although it has been described several times—in the noteworthy study by Anne d'Harnoncourt and Walter Hopps,[5] for example—I think it will serve some purpose here to give an idea of the work, since a photographic reproduction is not possible. As everyone knows, it is located in the Philadelphia Museum of Art beyond the large gallery where much of Duchamp's work is collected and where the *Large Glass* occupies the central spot. The visitor goes through a low doorway, into a room somewhat on the small side, completely empty. No painting on the white walls. There are no windows. In the far wall, embedded in a brick portal topped by an arch, there is an old wooden door, worm-eaten, patched, and closed by a rough crossbar made of wood and nailed on with heavy spikes. In the top left-hand corner there is a little window that has also been closed up. The door sets its material doorness in the visitor's way with a sort of aplomb: dead end. The opposite of the hinges and their paradoxes. A real condemned door. But if the visitor ventures nearer, he finds two small holes at eye level. If he goes even closer and dares to peep, he will see a scene

4. In English the third meaning is not apparent. [Translator's note.]

5. "Etant donnés: 1° la chute d'eau, 2° le gaz d'éclairage. Reflections on a New Work by Marcel Duchamp," *Philadelphia Museum of Art Bulletin,* nos. 299, 300 (April–June and July–September, 1969).

he is not likely to forget. First of all, a brick wall with a slit in it, and through the slit, a wide open space, luminous and seemingly bewitched. Very near the beholder—but also very far away, on the "other side"—a naked girl, stretched on a kind of bed or pyre of branches and leaves, her face almost completely covered by the blond mass of her hair, her legs open and slightly bent, the pubes strangely smooth in contrast to the splendid abundance of her hair, her right arm out of the line of vision, her left slightly raised, the hand grasping a small gas lamp made of metal and glass. The little lamp glows in the brilliant light of this motion-less, end-of-summer day. Fascinated by this challenge to our common sense—what is there less clear than light?—our glance wanders over the landscape: in the background, wooded hills, green and reddish; lower down, a small lake and a light mist on the lake. An inevitably blue sky. Two or three little clouds, also inevitably white. On the far right, among some rocks, a waterfall catches the light. Stillness: a portion of time held motionless. The immobil-ity of the naked woman and of the landscape contrasts with the movement of the waterfall and the flickering of the lamp. The silence is absolute. All is real and verges on banality; all is unreal and verges—on what?

The viewer draws back from the door feeling that mix-ture of joy and guilt of one who has unearthed a secret. But what is the secret? What, in fact, has he seen? The scene that takes place without taking place behind the door is no less enigmatic than the diagrams and outlines of the *Large Glass*. Seeking a sign to orient him in his perplexity, the visitor finds the title of the Assemblage affixed to the wall: *Etant donnés: 1° la chute d'eau, 2° le gaz d'éclairage.*

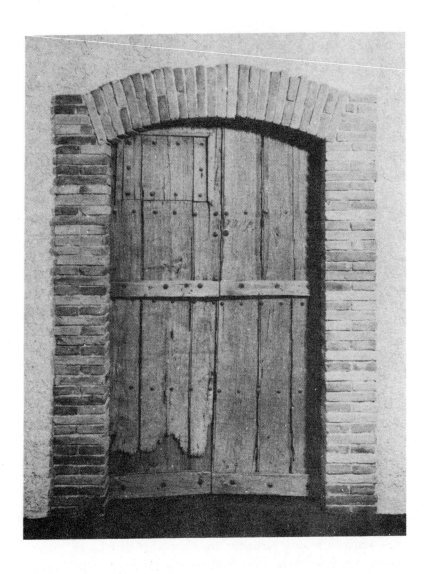

Door of Given: 1. The Waterfall, 2. The Illuminating Gas, *1946–66. (Mixed media assemblage.) Philadelphia Museum of Art: Gift of the Cassandra Foundation.*

(1946–1966). The contradictory relationship between public and secret art, monument and initiation rite, is repeated: the Assemblage leads us to its title, the title to the Preface of the *Green Box*, which begins with precisely the same pseudoscientific formula: *Etant donnés.* . . . The formula leads us to the *Large Glass* and the *Large Glass* to our own image, which, as we gaze at the *Large Glass*, blends with the painted forms and the reflections of the outside world. The play of correspondences and reflections between the Assemblage and the *Large Glass* is upsetting, and it presents itself on the visual plane as well as the textual—the notes of the *Green Box* and those of the *White Box* are the verbal bridge between the two works. In both cases, the mere act of looking at a painting or an Assemblage is turned into the fact of viewing-through. . . . In one case, through the obstacle of the door, which finally becomes the line of vision leading us to the landscape with the woman and the waterfall; in the other, through the glass on which the composition is painted and which, by reason of its very transparency, becomes an obstacle to our vision. Reversibility: seeing through opaqueness, not-seeing through transparency. The wooden door and the glass door: two opposite facets of the same idea. This opposition is resolved in an identity: in both cases we look at ourselves looking. Hinge procedure. The question "What do we see?" confronts us with ourselves.

Twenty-three years separate the date when the *Large Glass* was definitively unfinished and the date when the *Given* was begun. This long period of retirement gave rise to the idea that Duchamp had given up painting. The

truth is that after 1913, with only a few exceptions like the *Tu m'* of 1918, his work not only abandoned strictly pictorial procedures but also, without ceasing to be visual, turned into the negation of what we have called painting for more than two centuries. Duchamp's attitude toward the pictorial tradition is also governed by the hinge principle: the negation of painterly painting, which is the basic concept of the modern tradition since Delacroix, implies negation of the avant-garde. This is a unique position in the art of our era: Duchamp is at one and the same time the artist who carries avant-garde trends to their final consequences, and the artist who, in consummating them, turns them back on themselves and so inverts them. Negation of "retinal" painting breaks with the modern tradition and unexpectedly renews the bond with the central current of the West, anathematized by Baudelaire and his twentieth-century descendants: the painting of ideas.[6] A procedure analogous to that of the *delay in glass,* though in the diametrically opposite direction, the *acceleration* of the modern ends in its devaluation. In 1957 Duchamp was asked, "Do you believe in a forthcoming explosion of the modern spirit?" He replied, "Yes, but it is the word *'modern'* which has run itself out. Look at the *modern style* of the beginning of the century. . . ."[7]

The general system governing Duchamp's work is the

6. "The retinal shudder! Before, painting had other functions: it could be religious, philosophical, moral. . . . Our whole century is completely retinal, except for the Surrealists, who tried to go outside it somewhat. And still, they didn't go so far!" Duchamp quoted by Pierre Cabanne, *Dialogues with Marcel Duchamp,* translated by Ron Padgett (New York: Viking, 1971), p. 43.

7. Jean Schuster, "Marcel Duchamp, vite," *Le Surréalisme, même* (Paris), no. 2, Spring 1957, p. 148.

same as that which inspires the so-called Wilson-Lincoln effect—those portraits that represent Wilson when seen from the left and Lincoln from the right. The Wilson-Lincoln effect is a variant of the hinge principle: the pivot converted into the material and spiritual axis of the universe. Generalized reversibility, circularity of phenomena and ideas. Circularity includes the spectator, also; the Bride is enclosed in our glance, but we are enclosed in the *Large Glass* and included in the *Given.* We are part of both works. Thus there comes about a radical inversion of the position of the terms that intervene in creation and artistic contemplation and that, to a certain extent, constitute it: the artist's subjectivity (or the viewer's) and the work. A certain kind of relationship initiated by Romanticism ends with Duchamp.

The art and poetry of our time come into being precisely when the artist inserts subjectivity into the order of objectivity. This procedure sensitizes nature and the work, but at the same time, it makes them relative. Romantic irony has been the nourishment-poison of Western art and literature for almost two centuries. Nourishment, because it is the leavening of "modern beauty," as Baudelaire defined it: the bizarre, the unique. Or rather, objectivity torn apart by ironic subjectivity, which is always an awareness of human contingency, awareness of death. Poison, because "modern beauty," contrary to that of the ancients, is condemned to destroy itself; in order to exist, to affirm its modernity, it needs to negate what was modern scarcely as long ago as yesterday. It needs to negate itself. Modern beauty is bizarre because it is different from yesterday's, and for that very reason it is historical. It is change, it is

Tu m'. (Oil on canvas with large brush attached.) Yale University Art Gallery: Bequest of Katherine S. Dreier.

perishable: historicity is mortality.

Duchamp's youth coincided with the explosion of the avant-garde movements; that is to say, with the last and most violent manifestation of the modern tradition ushered in by Romanticism. Duchamp has recalled more than once his youthful interest in Jules Laforgue, a poet thought little of in France but who has had a profound influence on Anglo-American poetry and on Latin-American as well. In Laforgue, modern subjectivity turns in on itself—he is a Symbolist poet who uses irony to gnaw away at the Symbolist aesthetic. It was natural that Laforgue should inspire Duchamp, as Mallarmé did later. Apart from the influences that he has revealed himself, others can be quoted. For example, this title of a Laforgue poem could be a phrase from the litany of the Chariot: *"Célibat, célibat, tout n'est que célibat."* Another poem is called "Complainte de crépuscules célibataires." Human history, says Laforgue, is the "histoire d'*un* célibataire." Schopenhauer revised and corrected: the world is the representation of a bachelor self.

Duchamp submits Laforgue's irony to the disorienting action of the Wilson-Lincoln system and in this way changes it, literally turning it inside out. Modern irony, from Romanticism onward, is the action of the bite of subjectivity into the work; in the *Large Glass* and the *Given*, it is not the self that takes over the object, but the contrary: we see ourselves seeing through the opaqueness of the door of the Assemblage or the transparency of the *Large Glass*. The Wilson-Lincoln principle is revealed as a meta-irony, that is, as an "irony of affirmation," as opposed to the Romantic ne-

gation. Irony and subjectivity have become the axis of modern art. Duchamp makes this axis spin on itself, and he overturns the relationship between subject and object: his "laughing picture" laughs at us. The very notion of modernity is demolished. While continuing to be peculiar and different from yesterday's—continuing to be polemical and historical, i.e., modern—Duchamp's art undertakes the criticism of modernity and exchanges nods of recognition with the art of the past.

The negation of painterly painting was far from being a renunciation of art; the twenty-three years separating the *Large Glass* from *Given* were not empty—rather, they were years of search and preparation. The surprising thing is precisely the persistence of Duchamp's underground work, his patience and his coherence. Like Saint-Pol-Roux, who used to hang the inscription "The poet is working" from his door while he slept, Duchamp used to say that he was not doing anything except breathing—and when he was breathing, he was working. His obsessions and his myths were working him: inaction is the condition of inner activity. On various occasions Duchamp denounced the publicity surrounding modern art and maintained that artists should go underground. Here the hinge principle reappears: the man who drew a mustache on the *Mona Lisa* is the same man who, for twenty years, carried out work in secret. Contrary and complementary forms of his rupture with the world: public profanation and the descent to the catacombs, the slap in the face and silence.

Helped by Teeny, his wife and confidante, in assembling this clandestine production, Duchamp worked more or less continuously from 1946 to 1966, first in his study

on Fourteenth Street, and later in modest premises in a commercial building on Eleventh Street. Early in 1969, three months after his death, Anne d'Harnoncourt and Paul Matisse dismounted the Assemblage, took the pieces to Philadelphia, and put them together again in the museum there. They used as a guide a notebook prepared by Duchamp and made up of precise instructions, diagrams, and more than a hundred photographs. An exceedingly difficult task, carried out with great skill and sensitivity.

The *Given* is a combination of materials, techniques, and different artistic forms. As for the former, some have been brought to the work with no modification—the twigs on which the nude is lying, the old door brought from Spain, the gas lamp, the bricks—and others have been modified by the artist. Equally varied are the techniques and forms of artistic expression: the artificial lighting and the theatrical illusion of the scene; the action of the invisible electric motor, which reminds us of the techniques of clockwork toy-making; sculpture, photography, painting, properly speaking, and even window dressing. All these techniques and forms draw together Duchamp's earlier experiences, for example, the window display at the Gotham Book Mart in New York in 1945, advertising Breton's *Arcane 17*, where a half-nude dummy was used. However, there is a difference between Duchamp's earlier works and the *Given*. In the former, he is trying to show what is behind or beyond appearance—the decomposition of movement in the *Nude Descending a Staircase*, a passionate game of chess in *The King and Queen Traversed by Swift Nudes*, the symbolic functioning of an erotic machine in the *Large Glass*—while in the latter the artist

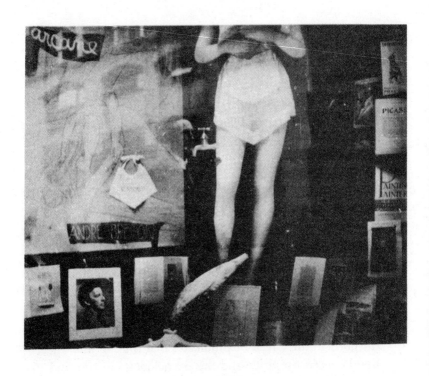

Window installation by Marcel Duchamp and André Breton for publication of Breton's Arcane 17, *at Gotham Book Mart, New York, 1945. Duchamp and Breton can be seen reflected in the glass. Photograph courtesy of Mme Duchamp.*

seems to be satisfied with the appearance. In the *Large Glass*, the spectator must imagine the scene of the bride's delight at being stripped; in *Given* he sees her in the actual moment of fulfillment. The symbolic description of the phenomenon is followed by the phenomenon itself: the machine of the *Large Glass* is the representation of an enigma; the nude of *Given* is the enigma in person, its incarnation.

The bridge or hinge between the *Large Glass* and *Given* is a drawing from 1958: *Bedridden Mountains* [*Cols alités*], *Project for the 1959 Model of The Bride Stripped Bare by Her Bachelors, Even*. The drawing reproduces the *Large Glass*, but in the central region it adds a sketch of hills, with very fine, hardly visible lines. Furthermore, on the far right, after the Chocolate Grinder and as if it were a prolongation of one of the blades of the Scissors, Duchamp drew an electric pole with its wires and insulators. One of the notes in the *Green Box* indicates that the communication between the Bride and the Bachelors is electric, and in the 1958 drawing this idea—which refers rather to a metaphor: the electricity of thought, of the glance, and of desire—is expressed in the most direct and material form: a pole and its wires. And so we have two images of electricity: physical energy and psychic energy. By the title of the drawing Duchamp hints that the mountainous landscape is made up of passes *(Cols)*, but that these passageways are bedridden, ailing *(alités)*. As a result, they are scarcely passable, and communication between the realm of the Bachelors and that of the Bride is difficult. In *Given* communication is even more difficult, in spite of the fact that the landscape of wooded hills possesses an almost tactile

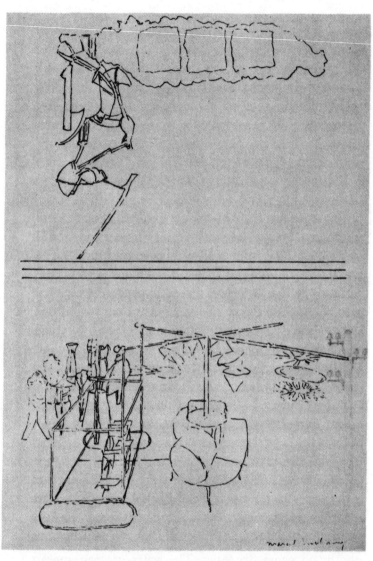

Cols alités (Bedridden Mountains), *1959. Collection Robert Lebel, Paris.*

reality—or perhaps for this very reason: we are dealing with the deceptive reality of *trompe l'oeil*. Last, the title alludes also to the law that governs the conception of the *Large Glass* and of *Given:* ironic causality. *Causalité/Cols alités:* a slight distension of the sounds takes us from the ailing passes of the hills to a universe in which chance and necessity exchange nods. The difference between "causality" and "casuality" lies in the different position of the same *u*. Knowledge is a disease of language.

The road from the *Large Glass* to *Given* is made up of reflections. It is a spiral which begins where it ends and in which over there is here. Identity emerges from itself in search of itself, and every time it is about to meet itself, it bifurcates. But the echoes and correspondences between one and the other can be applied to all of Duchamp's work. We are facing a true constellation in which each painting, each Readymade, and each wordplay is joined to the others like the sentences of a discourse. A discourse ruled by rational syntax and delirious semantics. A system of forms and signs moved by their own laws. The landscape of *Given,* implicit in the *Large Glass,* is an echo or a rhyme of three other pictures in which the same combination of trees, sky, and water appears. One represents the landscape of his birthplace (Blainville) and dates from 1902; another is the well-known Readymade of 1914, *Pharmacy;* the last is the 1953 *Moonlight on the Bay at Basswood.* The gas motif goes back to his adolescence; there is a drawing from 1903/04 that shows a gas lamp *(Hanging Gas Lamp)* with the brand name Bec Auer. The water/gas pair appears constantly in Duchamp's works, word games, and conver-

sations, from the years when he was preparing the *Large Glass* until the year of his death. *Water and Gas on Every Floor* was an inscription found on the doors of new buildings in the Paris of his youth, which he used for the title page of the deluxe edition of Robert Lebel's monograph. Other correspondences could be quoted, but it might be better to concentrate on the water/gas duality: they are the two *authors* of the *Large Glass* and the *Given,* and their writing is in the plural.

In the note to the *Green Box* that serves as epigraph to this text and that gives its title to the Assemblage, it is clearly stated that the Waterfall and the Illuminating Gas literally produce the Bride. Water and gas are human and cosmic elements, physical and psychic. Eroticism and ironic causality at the same time, they come together and separate according to rigorous and eccentric laws. In the *Large Glass* they are invisible forces, and if it were not for the notes of the *Green Box,* we would not know that it is their action that sets the complicated and tragicomic mechanism running. Water and gas, says the *Green Box,* work in the *darkness* and in the *darkness* will emerge the "allegorical appearance," the Bride, like an "ultrarapid exposure."

Because they are elements pregnant with sexuality, erotic signs, it is not strange that one of the most assiduous exegetes of Duchamp's work has identified gas as a masculine and water as a feminine symbol. Two reasons prevent me from accepting this oversimplified interpretation. The first is the discredit into which the Jungian archetypes have fallen. Not because they are false but because people want to explain everything with them—and so nothing is ex-

plained. For that reason I prefer to call the Waterfall and the Illuminating Gas signs and not symbols. Symbols have lost their meaning by virtue of having so many contradictory meanings. On the other hand, signs are less ambitious and more agile; they are not emblems of a "conception of the world" but movable pieces of a syntax. The second reason: signs (and symbols) change their meaning and gender according to the context in which they are placed. They mean nothing by themselves; they are elements in a relationship. The laws that govern phonology and syntax are perfectly applicable in this sphere. No symbol has an immutable meaning; the meaning depends on the relation. We generally think of water as a feminine symbol, but as soon as it becomes running water—waterfall, river, stream, rain—it takes on a masculine tonality: it penetrates into the soil, or it gushes out of it. The same thing happens with air, although it is the masculine principle par excellence, from the Aztec Quetzalcoatl to the Christian Holy Ghost; the air that comes out of the orifices (the genitals, the mouth) of the archetypes of the great Jungian mother is feminine: the all-containing vessel. Air becomes feminine in the sylph and in the "cloud-damsels" of the Sirigiya frescoes. The cloud, image of indetermination, undecided between water and air, admirably expresses the ambivalent nature of signs and symbols. And why not mention fire, which is both Zeus's bolt and the feminine oven, the womb where men are cooked, according to the Nahuatl myth? The meaning of signs changes as their position in context changes. The best thing will be to follow the path of water and gas in the battle of reflections that the *Large Glass* and the *Given* interchange between themselves.

In the *Large Glass* gas appears as the determining element of the Bachelors. Not only does it inspire (inflate) them, but they expire it, in the double meaning of the word. They send it through the Capillary Tubes to the Sieves, where it undergoes an operation, in the surgical sense, emerging as an explosive liquid, to be immediately cut off and atomized by the Scissors; falling into the region of the Spray, it ascends once more and, sublimated by the Oculist Witnesses, who transform it into an image, is thrown into the Bride's domain, turned into a reflection of reflections. Despite all these adventures and misadventures, gas is invisible. In *Given* gas appears—and appears in its most direct and commonplace manifestation, in the form of a phallic gas lamp clutched by a naked girl. In the *Large Glass*, the Illuminating Gas is identified with the Bachelors—it is their desire; in the Assemblage the Bachelors disappear, or rather, are reabsorbed by the gas lamp. Onanism, leitmotif of the litanies of the Chariot, passes from the Bachelors to the Bride. But was the same thing not happening in the *Large Glass?* The *Given* confirms not only the imaginary nature of the operation—emphasized more than once by Duchamp—but also the nonexistence of the Bachelors: they are a projection, an invention of the Bride. In her turn the Bride is an epiphany of another invisible reality, the projection in two or three dimensions of a four-dimensional entity. And so the world is the representation not of a bachelor, as Laforgue said, but of a reality that we do not see and that appears sometimes as the rather sinister machine of the *Large Glass*, sometimes as a naked girl in her culminating moment of

111 ecstasy.

In describing the physiology of the Bride, the *Green Box* mentions a substance that is not water, though it is a liquid and possesses certain affinities with gas: automobiline, the erotic gasoline that lubricates her organs and makes orgasm possible. The Bride is a "wasp" who secretes by osmosis the essence (gasoline) of love. The wasp draws the necessary doses from her liquid tank. The tank is an "oscillating bathtub" that provides for the Bride's hygiene, or, as Duchamp says somewhat cruelly, for her diet. In the *Given*, ideas become images, and the irony disappears: the tank is turned into the lake, and the "wasp-motor" into the naked girl, creature of the waters. But the best example of these changes—from the liquid state to the gaseous or vice versa, equivalent to mutations of gender—is the Milky Way of the *Large Glass*, manifestation of the Bride in the moment when, as she is being stripped, she reaches the fullness of delight. The Milky Way is a cloud, a gaseous form that has been and will again be water. The cloud is desire before its crystallization; it is not the body but its ghost, the *idée fixe* that has ceased to be an idea and is not yet perceptible reality. Our erotic imagination ceaselessly produces clouds, phantoms. The cloud is the veil that reveals more than it hides, the place where forms are dissipated and born anew. It is the metamorphosis, and for this reason, in the *Large Glass*, it is the manifestation of the threefold joy of the Bride as she is stripped bare: ultrarapid instantaneous communication between the machine state and that of the Milky Way.

This digression on automobiline and clouds should not make us forget that Duchamp does not talk about gas and water in general, but very precisely as Illuminating Gas and

Waterfall. In the *Large Glass,* the Waterfall does not appear, but we know its form and location from the *Green Box:* "a jet of water coming from a distance in a semicircle, from above the Malic Molds." The Waterfall could be masculine, as much because it is in the domain of the Bachelors as because it is running water: "Flowing and moving waters," says Erich Neumann, "are bisexual and male and are worshiped as fructifers and movers."[8] However, it is a masculinity dependent on the feminine sign: waterfalls and streams although "looked upon as masculine . . . have the significance of a son." In the *Large Glass* the Waterfall feeds the Bride's imagination and purposes, is part of the seduction mechanism of the Bachelors and cause of their ultimate failure. Moreover, it serves as a "cooler" between them and the Bride. In the Assemblage it is in the Bride's domain.

In the *Large Glass* the Waterfall is invisible, a force we do not see but which produces the movement of the Water Mill; in *Given,* the Water Mill disappears and the Waterfall is a visible presence. And who sees these apparitions and disappearances? The Oculist Witnesses, who are *inside* the *Large Glass*—and we ourselves who, by spying through the cracks in the Spanish door, incarnate the Witnesses as the nude incarnates the Bride. They (we) are the only ones who can tell us something (tell themselves) about the syntax of the Waterfall and the Illuminating Gas and about the text traced out in their conjunctions and metamorphoses.

8. Erich Neumann, *The Great Mother,* Bollingen Series XLVII (Princeton: Princeton University Press, 1963), p. 48.

In the *Large Glass,* the Oculist Witnesses occupy the extreme right of the Bachelors' domain. A little above the third witness there is a circle that represents the hole in the lock through which the voyeur peeps. The positioning of the Oculist Witnesses more or less corresponds to that of the holes in the door of the Assemblage. The spectator, like the Oculist Witnesses, is a voyeur; also, like them, he is an ocular witness, as much in the legal sense of being present in the case as in the religious sense of attesting to a passion or a martyrdom. We are reminded of the "Four Master Analysts of Ireland" in *Finnegans Wake,* with whom the Witnesses share more than one affinity. This is not the only analogy, moreover, between Joyce and Duchamp: the *Large Glass* and *Given* can be considered the visual equivalents of the Letter to Anna Livia Plurabelle, another "untitled Mamafesta memoralizing the Mosthighst." Just as ALP is at one and the same time the inspirer of the Letter and the Letter itself in its different versions, so the Bride is the invisible four-dimensional object *and* its momentary manifestations in the *Large Glass* and in the *Given.* Among the names given to Rrose Sélavy we find the ones given by Joyce to ALP: "Anna the Allmaziful, the Everliving, the Bringer of Plurabilities. . . ." If the Letter contains its own interpretations and its own four Evangelists, the *Large Glass* and the *Given* contain their own viewers. The Oculist Witnesses form part of the *Large Glass,* and the spectator of the *Given,* by his very act of peeping, shares in the dual ritual of voyeurism and aesthetic contemplation. Or rather, without him the ritual would not take place. However, there is one difference between the *Large Glass* and the *Given.* It is not the first

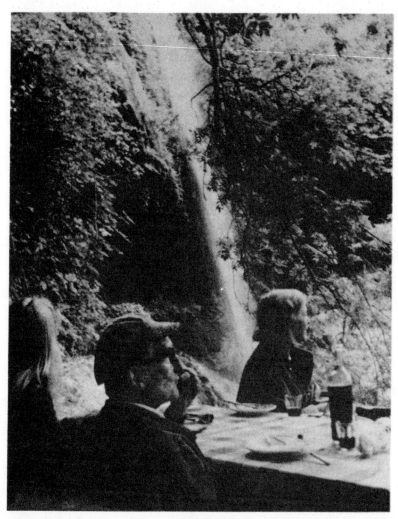

Photo of Duchamp and his wife, Teeny, at the foot of a waterfall extraordinarily like the one in the Assemblage, *in 1965 near Figueras. The photograph was taken at Duchamp's request, without Denise Hare's knowing that it had any connection with the* Assemblage, *of which the world in general was unaware until Duchamp's death. Photo by Denise Browne Hare, courtesy of Ms. Hare.*

time that an artist includes in his painting those who look at it, and in my earlier study on Duchamp I recalled Velázquez and his *Meninas*. But what is representation in *Las Meninas* and in the *Large Glass* is an act in *Given;* we are really turned into voyeurs and also into ocular witnesses. Our testimony is part of the work.

The function of the Oculist Witnesses, despite their marginal position, is central: they receive the Spray from the Illuminating Gas, now converted into Sculpture of Drops, and transform it into a mirror image that they throw into the Bride's domain, in the zone of the Nine Shots. The Oculist Witnesses refine (sublimate) the Illuminating Gas turned Spray of explosive drops: they change the drops into a look—that is, into the most immediate manifestation of desire. The look passes through the obstructed passages *(cols alités)* of the Bride and reaches her. It arrives thus far not as reality, but as the image of desire. The vision of her nudity produces in the Bride the first blossoming, before orgasm. It is, as Duchamp emphasizes, an electric blossoming.[9] The function of the Oculist Witnesses is the sublimation of the Illuminating Gas into a visual image that they transport in a look capable of passing through obstacles. Desire is the "electricity at large" that the *Green Box* mentions. In *Given* electricity is literally everywhere: behind the backdrop (in the motor) and outside as the brilliant light that bathes the landscape and the naked figure.

Who are the Witnesses? Duchamp the artist (not the

9. The second is the denuding voluntarily imagined by the Bride, and the third is the conjunction of the first two: the crown-blossoming in the form of a cloud or the Milky Way, which "cannot be analyzed by logic."

man) and ourselves, the spectators. There is often a tendency to see the Bride as a projection of Duchamp and, consequently, of the viewer. The contrary is also true: we are her projection. She sees her naked image in our desiring gaze, which is born from her and returns to her. Once again, the theme is viewing-through. . . . We see the erotic object *through* the obstacle, be it door or glass, and this is voyeurism; the Bride sees herself naked in our gaze, and this is exhibitionism. Both are the same, as Schwarz has pointed out. But they are united not in Duchamp or in the viewer, but in the Bride. The circular operation starts from her and returns to her. The world is her representation.

The complementary opposite of voyeurism is clairvoyance. The Oculist Witnesses of the *Large Glass* and the beholder of *Given* are clairvoyants; their gaze passes through material obstacles. The relationship is circular, once again: if desire is second sight, clairvoyance is voyeurism transformed by the imagination, desire made knowledge. Eroticism is the condition of second sight. The erotic vision is creation as well as knowledge. Our gaze changes the erotic object: what we see is the image of our desire. "It is the spectators who make the picture." But the object also sees us; more precisely, our gaze is included in the object. My looking makes the painting only on condition that I accept becoming a part of the painting. I look at the painting, but I look at it looking at what I look at—looking at myself. The person peeping through the holes in the Spanish door is not outside the Assemblage: he is part of the spectacle. *Given* is realized by means of his look: it is a spectacle in which someone sees himself seeing something. And what does he really see? What do the Oculist

Witnesses see? *They don't see.* It is the Bride who sees herself. The vision of herself excites her; she sees herself and strips herself bare in the look that looks at her. Reversibility: we look at ourselves looking at her, and she looks at herself in our look that looks at her naked. It is the moment of the discharge—we disappear from her sight.

The dialectic of the look that looks at nudity and nudity that looks at itself in this look irresistibly evokes one of the great myths of pagan antiquity: Diana's bath and Actaeon's downfall. It is strange that to date no one has explored the disturbing similarities between this mythological episode and Duchamp's two great works. The subject matter is the same: the circularity of the look. Actaeon moves from hunter to hunted, from looking to being looked at. But the correspondences, echoes, and rhymes are more numerous and precise than this comparison indicates. I will begin where the scene takes place: Ovid describes Diana's sanctuary as a valley wooded with pines and cypresses, surrounded by mountains. A waterfall tumbles down a rock, into a small lake, hardly more than a pool.[10] Ovid's description seems to anticipate the scene in *Given.*

Diana and the Bride: both are virgins, and Ovid uses a curious expression to describe the goddess's clothing: she is "the scarcely clad one." The Bride's virginity in no way implies frigidity or asexuality. The same is true of Diana: "In spite of the fact that she must be considered a virgin," says Dumézil, in the excavations of the sanctuary at Aricia,

10. Ovid, *Metamorphoses,* Book III, Loeb Classical Library (London and Cambridge, Mass., 1916), vol. 1, p. 134.

The Triumph of Venus. *Tray painting, School of Verona, early fifteenth century. Cliché Musées Nationaux, Paris.*

near Rome, votive offerings were found in the form of masculine and feminine organs, and images of "women clothed, but with their robes open in front."[11] Who corresponds to Actaeon in the *Large Glass* and the Assemblage? Not the Bachelors, since, apart from the fact that they do not exist in their own right, *they cannot see,* but the Oculist Witnesses. The similarity is more remarkable if we are aware that in both cases the visual violation is preceded by disorientation. According to Ovid, the young hunter reaches the sacred confine "wandering and with uncertain steps," that is to say, lost; before turning into the look of the Oculist Witnesses, the Illuminating Gas comes out of the Sieves unable to distinguish left from right; the visitor who goes up to the two holes in the door in the Philadelphia Museum of Art invariably does it after a moment of hesitation and disorientation.

The first study for the Bride (Munich, 1912) had as subtitle "Modesty Mechanism." Time and again Duchamp has emphasized the ambiguous nature of the Bride's modesty, a veil that uncovers her as it hides her, prohibition tinged with provocation. Warm, not cold modesty, and with a "touch of malice." Diana's attitude seems more resolutely and more fiercely chaste. Ovid expressly says that Actaeon's offense was an error, not a crime: it was not desire but destiny that led him to witness the goddess's bath. Nor is Diana an accomplice; her surprise and anger at the sight of Actaeon are genuine. But Pierre Klossowski in a splendid essay suggests that the goddess desires to see

11. Georges Dumézil, *La Religion romaine archaïque* (Paris: Payot, 1966), p. 397.

The Bride Stripped Bare by Her Bachelors, *1912. Courtesy of Cordier & Ekstrom, Inc., New York. Photo by Geoffrey Clements.*

herself, a desire that implies being seen by someone else. For this reason, "Diana becomes the object of Actaeon's imagination."[12] This operation is identical to that of the Bride in the *Large Glass,* who sends herself her own nude image through the medium of the Oculist Witnesses, as Diana does through Actaeon. Klossowski indicates that the look stains, and that the virgin goddess *wishes* to be stained; for his part, Duchamp says that the Bride "warmly rejects (not chastely)" the Bachelors' offering. Lastly, as Diana throws water over Actaeon and transforms him into a deer, the Bride puts a cooler between the Bachelors and herself—the Waterfall.

In both cases we witness not the violation of the two virgins but its homologue: visual violation. But our look really does pass through the material obstacle—the door of the Assemblage, the boughs and leaves of the goddess's sanctuary—and so the transgression is as much psychic as material. Actaeon's punishment is to be turned into a deer—he who stared is stared at—torn to pieces by his own dogs. "Seeing prohibited" is a motif that Duchamp expresses in many ways, especially in his two windows: *Fresh Widow* (french window) and *The Brawl at Austerlitz.* Both prevent us from seeing; they are windows not to see out of. In the title of the former, there is, furthermore, an allusion to the guillotine—the Widow, in popular French jargon—which immediately recalls the fate of the Illuminating Gas cut to pieces by the Scissors, and of Actaeon by his dogs.

12. Pierre Klossowski, *Le Bain de Diane* (Paris: Jean-Jacques Pauvert Editeur, 1956), p. 55.

According to a note from *In the Infinitive* (the *White Box*), the real punishment consists of possession: "No obstinacy, *ad absurdum*, of hiding the coition through a glass pane with one or many objects of the shop window. The penalty consists in cutting the pane and in feeling regret as soon as possession is consummated."[13] Except that voyeurism is not a solution either: if the punishment is eluded, the torture becomes greater. Nonconsummation, desiring without touching what is desired, is no less cruel a penalty than the punishment that follows possession. The solution is the conversion of voyeurism into contemplation—into knowledge.

The same note from *In the Infinitive* contains another curious confession, which is at the same time a lucid description of the circularity of the visual operation: "When one undergoes the examination of the shop windows, one also pronounces one's own sentence. In fact, one's choice is *round trip.*" I have already pointed out the resemblance of the Actaeon myth and Duchamp's two works: the gazer is gazed at, the hunter hunted, the virgin strips herself in the look of him who looks at her. The "round trip" that Duchamp refers to exactly corresponds to the internal structure of the myth as well as of his two works. Actaeon depends on Diana; he is the instrument of her desire to see herself. The same thing happens with the Oculist Witnesses: as they look at themselves looking at her, they give the Bride back her image. It is all a round trip. Duchamp

13. Marcel Duchamp, *A l'infinitif* (the *White Box*, notes from 1912 to 1920) (New York: Cordier & Ekstrom, 1966), p. 5.

has said several times that the Bride is an appearance, the projection of an invisible reality. The Bride is an "instantaneous State of Rest," an "allegorical appearance." Klossowski indicates that Diana's essential body is also invisible: what Actaeon sees is an appearance, a momentary incarnation. In the theophanies of Diana and the Bride, Actaeon and the Oculist Witnesses—we ourselves—are included. The manifestations of Diana and the Bride demand that someone look at them. The subject is a dimension of the object: its reflexive dimensions, its glance.

There are other similarities worth mentioning. In the *Green Box* the Bride is often called Hanged Female *(Pendu femelle)*. The machine outlined by Duchamp is literally suspended, hanging in space like a dead beast on a butcher's hook or a hanged man on a scaffold. The theme of the hanged man appears in many myths, but the sacrificial victim is invariably a god. There is, however, an exception: in the Peloponnesus, where the cult of Artemis was very popular, an effigy of the divinity was hung from a tree and was called Apanchomene (the Hanged Woman). One of the notes in the *Green Box* says that the Bride is an "agricultural machine"; further on, she is a "plowing tool." The plow is predominantly masculine—which is why Ceres was three times plowed. But there is another exception: in the festivals of Artemis Orthia, a plow was dedicated to the virgin goddess. There was also a flagellation of young men and a torch procession. (I will return to the latter detail.) In all these ceremonies, there were reminiscences of human sacrifice.

In order to label the Bride's axis, Duchamp uses the expression "arbor-type" *(arbre-type)*. Diana is an arboreal

divinity and was originally a dryad, like the yakshas of Hindu mythology. The tree that spreads its leaves to the heavens is a feminine tree, and its image, says Neumann, has fascinated all men: "It shades and shelters all living things and feeds them with its fruit which hang on like stars. . . ."[14] The sky in which the tree-goddess stretches out its branches is not the day but the night sky—which is why leaves, branches, fruits, and birds are seen as stars. For his part, Dumézil observes that the name of Diana originally meant "the expanse of the heavens."[15] Referring to the blossoming *(épanouissement)* of the Bride, Duchamp indicates that in the arbor-type the bloom is *grafted on*, and is the Bride's aureole and the conjunction of her "splendid vibrations." This aureole or crown is none other than the Milky Way: the cloud that preserves in its bosom the lightning (Illuminating Gas) and the rain (Waterfall), the cloud that is the halfway point between the incarnation and the dissipation of the feminine form. The movable cipher of desire. Very significantly Ovid says that when Diana sees herself touched by Actaeon's gaze, she blushes like a cloud shot through by the sun. . . . Finally, if Diana's tree is a figure of the mythical imagination, the alchemists saw it in the crystallization obtained by dissolving silver and mercury in nitric acid. It is the spirit of sal ammoniac. Duchamp would have liked this definition.

All the elements of the *Green Box* and the *Large Glass*—the Illuminating Gas, the arbor-type, the cloud or Milky Way, the Waterfall—appear in the Assemblage

14. Neumann, *The Great Mother*, p. 245.
15. Dumézil, *La Religion romaine archaïque*, p. 396.

converted into visual semblances. The vision of the land-
scape and the waterfall, with the naked woman (Milky
Way) stretched on a bed of branches (the tree), would be
a pacifying metaphor if it were not for the glow of the gas
lamp lit in broad daylight. An incongruity that winks at us
roguishly and destroys our idea of what an idyll should be.
Torches appear in the ceremonies in honor of Diana, but
nobody knows for sure why and for what purpose. The
experts agree on only one point: they are not hymeneal
torches. On the Ides of August, Dumézil says, processions
of women would go to Aricia carrying torches. One of
Propertius' loveliest elegies (II, 32) mentions these proces-
sions:

> Hoc utinam spatiere loco, quodcumque vacabis,
> Cynthia! sed tibi me credere turba vetat,
> cum videt accensis devotam currere taedis
> in nemus et Triviae lumina ferre deae.[16]

The relation between torch and goddess is clear in the case
of divinities like Demeter and Persephone; it almost always
symbolizes the union of the virgin mother and her son, as
we see in Phosphora, "bearer of the torch." The flame is
the fruit of the torch. Transposition of vegetal into cosmic
images: the goddess is the tree of night, and her fruits and
branches are the starry sky. The association between fire
and sexuality is age-old, and the act of making fire has often

16. "Ah that thou wouldst walk here in all thine hours of leisure! but the world
forbids me trust thee, when it beholds thee hurry in frenzy with kindled torches
to the Arician grove, and bear lights in honour of the goddess Trivia." *Elegies*,
II, 32, translated by H. E. Butler, Loeb Classical Library (Cambridge, Mass.:
Harvard University Press), p. 159.

been seen as homologous to the sexual act. Fire sleeps in wood and, like desire in a woman's body, is awakened by friction. It is impossible to miss the similarity between the arbor-type of the *Large Glass* and the tongue of flames into which the filament substance is converted, the girl in the Assemblage reclining on a surface of twigs and branches—bed and pyre all at the same time—holding up a lamp of burning gas, and the mythic images of the birth of fire. Though we are talking about a process that is determined by the action of the masculine element, in this case, according to Neumann, the masculine principle is subordinated to the feminine. In all the myths and rituals whose theme is the double relationship between the fruit-bearing earth and the light-producing darkness—the archetype of which would be the Eleusinian mysteries— "before and above all, woman experiences herself. Projected on the image of the Great Goddess, this experience is intimately linked with the principle of universal life."[17] Woman sees herself as a fountain of life. The masculine principle, dominated by the feminine, is a medium through which woman knows, fertilizes, and contemplates herself. The analogy with both Duchamp's works could not be more complete: the Nine Malic Molds of the *Large Glass*, inflated by gas, and the phallic lamp held by the girl are devices by means of which the Bride enjoys, sees, and knows herself.

The fire/log relationship unfolds into another: water/fire. Torches and candles are often thrown ceremonially into rivers and lakes; in the Catholic ritual of conse-

17. Neumann, *The Great Mother*, p. 318.

crating the baptismal font, the priest drops a burning candle into the water. This relationship is accurately reproduced in that of the Bride/Waterfall and the gas lamp burning in the light of day. There is the following difference between Duchamp's images and those of tradition: whereas the Bride is governed by the circularity of solitary desire, mythic and ritual images invariably evoke the idea of fertility. This is also true of the nocturnal processions of the Roman women to Diana's sanctuary in Aricia: though the torches the women carried were not hymeneal, they were associated with maternity and childbearing. Dumézil points out that Diana Nemorensis, although a virgin and incorporated into the severe Artemis, also had jurisdiction over procreation and birth. But whatever the differences between Duchamp's and the traditional images, the essential relationship remains unaffected—tree/fire and water/torch. Both are present in the two signs that *produce* the instantaneous appearance or ultrarapid exposure of the Bride: the Waterfall and the Illuminating Gas. There is another similarity: the darkness that, according to the *Green Box*, is required for the ultrarapid exposure and the shadows which in the Eleusinian mysteries, preceded *heurisis:* "Amid the total darkness the gong is struck, summoning Koré from the underworld . . . suddenly the torches create a sea of light and fire, and the cry is heard: Brimo has borne Brimos!"[18] Again I must point out that the Greek ritual alludes to the birth of a god, whereas the torch held by the girl in the Assemblage does not evoke any idea of mater-

Marcel
Duchamp

18. Ibid.

nity or birth. The Bride begins and ends in herself.

I must still mention the relationship between Diana and Janus, the god of two faces, divinity of doors and hinges. As Dumézil says, his name marks him as a passage. Spatially speaking, he stands in doorways and presides as *janitor* over entrances and exits; in the temporal sense he is the beginning: his month is *Januarius*, the first month, standing between the year that is beginning and the one that has ended. He faces in two directions because every passage implies two places, two states, one left behind and one being approached. Janus is a hinge, a pivot. Though Dumézil says nothing about the relationship between them, we know that the Romans saw Diana as Janus' double. It seems unnecessary to stress the affinity between the Bride, the doors—in a word, the system of pivots that rules Duchamp's universe—and Janus and Diana, circular and double divinities whose end is their beginning and for whom obverse and reverse are one and the same. Divinities who ceaselessly unfold and reflect themselves, reflexive gods turning from themselves to themselves, Janus and Diana embody the circularity not only of desire but also of thought. A bifurcating unity, a duality that pursues unity only to bifurcate again. In them Eros becomes speculative.

The publication of *A l'infinitif* in 1966 and the appearance a year later of the *Entretiens* with Pierre Cabanne gave rise to commentaries on how Duchamp's artistic and philosophic preoccupations had been influenced by the notion of a fourth dimension. These commentaries were more or less personal variations on a well-known theme; it was no secret that the fourth dimension is one of the

intellectual components of the *Large Glass*. Even the earliest studies on the work had picked up this thread. However, the matter deserves more careful scrutiny. Duchamp often talked about the contradiction implicit in his love-hate relationship with science. In the second of his conversations with Cabanne he refers to his interest in the representation of movement. It was an interest that he shared with most of the poets and artists of his time, as we see in the "simultaneism" of Barzun, Delaunay, Cendrars, Apollinaire, and others. Cabanne observed that this preoccupation with movement disappeared almost completely after *The Bride*. Duchamp attributed this change to his rediscovery of perspective: "The *Large Glass* constitutes a rehabilitation of perspective, which had then been completely ignored and disparaged." Of course, it was not a question of realistic perspective but "a mathematical, scientific perspective . . . based on calculations and dimensions." In the *Large Glass* visual representation is subordinated to a story—a legend, Breton used to say—except that anecdote and representation have undergone a radical transposition; instead of things and the sensorial consequences of our perception of them, the painting presents us with the measurements of things, the relationships between them, and the symbols of these relationships. A world *à l'infinitif*.

One of the first notes in the *Green Box* says, "In general the picture is the apparition of an appearance." Other notes explain to us that appearance is the conjoining of sensations—visual, tactile, auditory—at the moment when we perceive the object; apparition is the underlying, stable reality, never wholly visible: the system of relationships

that is at once the mold and the essence of the object. Duchamp set himself to make an art of apparitions and not of appearances. It was a contradictory aim because painting has been up to now—all to the good—an art of appearances: the representation of what we see, with our eyes open or closed. But it is also good that a painter should decide to opt for invisible reality and to paint not things or images but relationships, essences, and signs. On condition, of course, that the painter in question is really a painter. It is exemplary but not strange that Duchamp should have risked taking this step: the very logic of his search urged him to jump from painting movement to painting all that lies beyond movement.

On the other hand, there is nothing less modern than this aim. As he said to Cabanne, "All painting, beginning with Impressionism, is antiscientific, even Seurat. I was interested in introducing the precise and exact aspect of science. . . . It wasn't for love of science that I did this; on the contrary . . . irony was present." The art of the last two centuries has borne a common stamp: it has deified aesthetic values, which have been cut off from other values and turned into a self-sufficient, almost absolute reality in their own right. It is against this conception of art that Duchamp rebelled. He was unique in his negation of the modern tradition—painterly painting, retinal and olfactory painting. He was not unique in his rejection of the painting of appearances; the Cubists and Abstractionists also set themselves to paint essences and archetypes. The same must be said of his interest in theoretical speculations more or less inspired by the new physics: it was a general tendency among the artists of that era.

Poets and painters, especially those of the second generation of Cubists, had many heated discussions of the fourth dimension. In the bistros frequented by avant-garde artists, Maurice Princet, an imaginative, verbose insurance agent, used to hold forth on Lobachevski's and Riemann's geometry. In her memoirs Gabrielle Buffet tells us that "the three Duchamp brothers were enthralled by science and mathematics." Ribemont-Dessaignes, another who reported on that era, observes that the education of the Duchamps was more serious than that of many of their friends. Marcel never hid his affinities, and in the *White Box* he quotes Henri Poincaré and Elie Joufret, author of a *Four-dimensional Geometry*. It is actually from Joufret that the central idea of the *Large Glass* derives: the projection of a four-dimensional figure onto our space is a three-dimensional figure.[19] Jean Suquet has shown that some of Poincaré's concepts could be applied to the Bride: "The beings of hyperspace may be objects with precise definitions like those of ordinary space; we can conceive of them and study them but not represent them." Duchamp would have replied to Poincaré with a smile, "Except as freed forms." For many scientists and artists the new ideas of physics and mathematics were reflected, more or less deformed, in the mirror of the old Neoplatonism. León Hebreo used to say that "the body is the shadow of spiritual beauty" and Pico della Mirandola claimed that the intellect cannot see Venus in "her true form." Poincaré and Duchamp belonged to the same tradition, perhaps without knowing it.

19. The best study of this aspect of Marcel Duchamp appears in Jean Clair, *Marcel Duchamp ou le grand fictif* (Paris: Galilée, 1975).

Duchamp owes his age a debt. Like all true artists, in assuming it he denies it, and sometimes he transcends it. It is true that the *Large Glass* is an offshoot of certain concepts of the new physics, or rather, of the versions of these concepts popularized in artistic and intellectual circles by professors and journalists. But an artist cannot be reduced to his sources any more than to his complexes. Here lies the limitation of the otherwise praiseworthy works of Jean Clair and Arturo Schwarz. Just as Shakespeare is not the sum of his readings, or Proust his asthma, Duchamp is not Gaston de Pawolowski's novel of scientific futurism or his hypothetical incestuous passion for Suzanne. I am not minimizing Schwarz's effort; his book is a monument of patience and devotion, invaluable for the information it contains.[20] Nor is Clair's essay to be overlooked.[21] But no one, not even Clair, would have dug up Gaston de Pawolowski if, in one of his conversations with Cabanne, Duchamp himself had not remembered this name and the impression the book had caused on him. Nor must we exaggerate: Pawolowski was not Duchamp's only source. Really they were both nourished by the works of such scientific disseminators as Poincaré and Joufret. Just as the generation after them talked about psychoanalysis and today's generation about linguistics, in those days they discussed physics and the new space-time. Even before them Jarry was mentioning the names of Riemann and Lord Kelvin with a certain familiarity, to say nothing of the popular successes of *The Time Machine, The Invisible*

20. Arturo Schwarz, *The Complete Works of Marcel Duchamp* (New York: Abrams, 1970).

21. Jean Clair, *Marcel Duchamp ou le grand fictif.*

Man, Tales of Space and Time, and others of Wells' novels and stories.

Undoubtedly Pawolowski's novel, *Journey to the Land of the Fourth Dimension,* is one of the sources of the *Large Glass*. But it must be recognized that the differences between the two works are greater than their similarities. Contrary to the long journey related by Pawolowski, the passage from one dimension to the other in the *Large Glass* is instantaneous. More important, it is illusory: *a round trip.* Pawolowski takes seriously the scientific ideas that he uses as scaffolding to construct a rather ingenuous fiction; in Duchamp's work these ideas have been distended by meta-irony until they are unrecognizable. Pawolowski's little novel is the curious work of an intelligent amateur; the *Large Glass* is the fulgurating allegory of a voyage through space. Fulgurating implies faraway, radiant, and silent. Pawolowski wrote a work to entertain and to divulge ideas in vogue at the time; Duchamp used those ideas like a Readymade no less forcible than the Rembrandt he wanted to turn into an ironing board. It would be useless to look in *Journey to the Land of the Fourth Dimension* for all that makes of the *Large Glass* a unique work: irony and eroticism, intellectual complexity at one with simplicity of execution, philosophical courage, verbal economy. In a word, that "beauty of indifference" whose other name is freedom.

Apart from Roussel, Duchamp's true literary antecedent is Alfred Jarry. Most critics, following Duchamp, have underlined the similarity of his method and Roussel's. The resemblance between them extends to other characteristics: the same attempt to dehumanize by introducing artifi-

cial elements, the substitution of mechanical for psychological resources, and lastly the centrality of word games. In the *White Box* Duchamp talks about creating a "pictorial nominalism"; for Roussel, language has the consistency of things and things have the elasticity and malleability of words. The unusual constructions populating the pages of *Impressions d'Afrique* and *Locus Solus* are akin to Duchamp's plastic and linguistic inventions. His affinities with Jarry are of another kind. First and foremost, that distance between work and author that creates irony. There is no distance between Roussel and his work; the creating subject has been abolished or, more exactly, reduced to a process. Roussel *is* his method; Jarry and Duchamp cannot be reduced to theirs. There is humor, not irony, in Roussel; he does not look at himself in his creations, nor do his creations look at him; he does not make fun of them, nor they of him. Jarry is and is not Ubu; Duchamp is and is not Rrose Sélavy. Actually Duchamp is (in the plural) the Oculist Witnesses. The character Roussel creates is involuntary: it is his emanation or projection, not his invention. Therefore it lacks self-criticism and even consciousness. Jarry's character is Jarry's invention, and this doubling creates a deceiving play of reflections. Of Ubu, Jarry, and Faustroll, who is most real? On the contrary, the man Roussel is no less unreal than the character Canterel. Duchamp's unfaithfulness to his *persona* irritated Breton several times and was indeed scandalous; everyone thought he was playing chess and he was secretly building the Assemblage. He seemed possessed by the nihilistic fervor of the avant-garde, and actually he was

moved by the paintings of the religious artists; he limited

the number of his Readymades and he did not hesitate to authorize reproductions of them.

Roussel believed in science; Jarry and Duchamp used science as a weapon against science. Ubu says *merdre* and Duchamp *arrhe*. One defines pataphysics as the science of the particular, and the other wants "to lose the possibility of recognizing or identifying any two things as being like each other." Both would have liked to live in a world of unique objects and entities, where the exception alone would rule. Roussel lacked a vital and moral dimension common to Jarry and Duchamp; the subversion of the self. . . . The best commentary on the *Large Glass* is *Ethernités*, the last book of the *Gestes et opinions du Docteur Faustroll*. A doubly penetrating commentary because it was written before the work was even conceived, and so does not refer to it at all. Furthermore, in a text dated 1899, an extraordinary composite of reason and humor, Jarry anticipates Duchamp. I am refering to the *Commentaire pour servir à la construction poétique de la machine à explorer le temps*. Jarry's temperament was richer and more inventive than Duchamp's. Also more baroque: he proceded by accumulation, arabesques, and ellipses. Duchamp is limpidity. The *Large Glass* and the *Given* owe their fascination to their elegance in the mathematical sense of the word—that is to say, their simplicity. Ambiguity achieved through transparency.

One whole section of the *White Box* refers to perspective. This confirms that the theme was central to Duchamp's interests during those years. It is significant that this period—Duchamp's sojourn in the Bibliothèque

Sainte-Geneviève—saw the conception of the *Large Glass* and the calculations and speculations of both *Boxes*. It was his period of greatest intellectual productivity. The most remarkable notes are those alluding to a (hypothetical) fourth-dimensional perspective and its relationship with ordinary perspective. They also deal with the analogies between three-dimensional and two-dimensional space. For example, gravity and the center of gravity are properties of three-dimensional space that in the second dimension correspond to perspective and the vanishing point. These preoccupations undoubtedly gave rise to compositions such as *Tu m'* and *To Be Looked at (from the Other Side of the Glass) with One Eye, Close to, for Almost an Hour,* as well as the optical devices. Duchamp was also interested in "curious perspective," as anamorphosis was called in the seventeenth century. In the *White Box* there is an allusion to the mathematician Jean-François Niceron (1613–1646) of the Minorite Order and his treatise on perspective, *Thaumaturgus Opticus.* Niceron is one of the great theorists of anamorphosis, and the book quoted by Duchamp is the amplified Latin version of the first edition of *La perspective curieuse ou Magie artificielle des effets merveilleux.* [22] The recent studies of Jurgis Baltrušaitis on

22. There are three editions of *La perspective curieuse;* the first dates from 1638 and the other two, both posthumous, from 1652 and 1663. Perhaps Duchamp consulted one of these volumes. *Thaumaturgus Opticus* is from 1646. The fundamental study, the only one in fact on this material is *Anamorphoses* (Paris: Olivier Perrin, 1969) by Jurgis Baltrušaitis. Apart from this truly fascinating work we are in debt to Baltrušaitis for having initiated, together with Arthur Van Schendel, director of the Rijksmuseum, the recent *Anamorphoses* exhibition held in Amsterdam (1975) and Paris (1976), also in New York (1977). The prologue for the excellent catalog for this exhibition was also written by Baltrušaitis.

this theme unexpectedly illuminate this aspect of Duchamp's intellectual and artistic activity. It is remarkable that his interest in anamorphosis goes back to 1913, more than a half-century ago.

Perspective is an expedient designed to give us the illusion of a third dimension. Euclid established the basic principle: our field of vision is a pyramid whose apex is the viewer's eye. In the fifteenth century Leon Battista Alberti defined the picture as a transverse section of the visual pyramid. Objects seem to diminish or grow bigger as they move away from or toward the angle of the eye. Perspective is, therefore, the art of restoring appearances. Within perspective, says Baltrušaitis, resides an opposition: "It is science that fixes the exact dimensions and positions of forms in space; and it is the art of illusion which recreates them. Their history is not only that of aesthetic realism. It is also the story of a dream."

One of the simplest devices, used as much in painting as in architecture and in the theater, is what is known as accelerated perspective. It consists of showing objects as if they were farther away than they really are by diminishing their size or by elevating the visual horizon. The opposite procedure, delayed perspective, makes objects seem nearer than they are by augmenting their component parts. There comes a moment when the device is pushed to such extremes that the relationship between reality and representation is broken. The result is anamorphosis: perspective becomes perverted, we might say, and no longer reproduces reality. Either by acceleration, delaying tactics, or some other device like reflecting the image in a cylindrical mirror or elongating perspective by some other means,

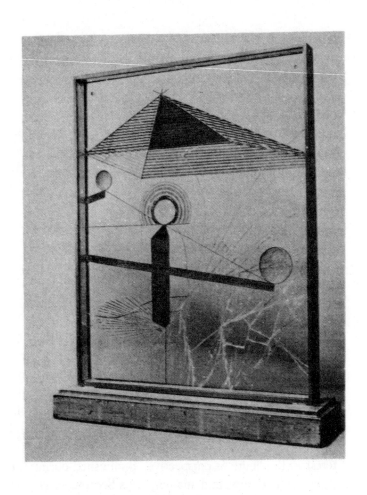

To Be Looked at (from the Other Side of the Glass) with One Eye,
Close to, for Almost an Hour, *1918. Collection, the Museum of
Modern Art, New York: Bequest of Katherine S. Dreier.*

resemblance is lost. Instead of the image of the object, we see a confusion of lines and masses. But all we have to do is look from the intended angle—obliquely, for instance, or into a cylinder, or through two holes, as in the case of the Assemblage—for the realistic appearance to return. *Round trip*. Duchamp's trick: who has been put to the test of watching (from the other side of the glass) with one eye, close to, for almost an hour, *To Be Looked at (from the Other Side of the Glass) with One Eye, Close to, for Almost an Hour*?

Leonardo was interested in deformations of perspective. Dürer, too, during his voyage to Italy was amazed by the "art of the secret perspective," and even conceived of a postern with one transparent pane that would calibrate the lengthening of visual rays in order to calculate the perspectives of anamorphosis. The famous Austrian Jesuit, Athanasius Kircher, who so greatly influenced Sor Juana Inés de la Cruz, perfected this postern. But the great center of speculation and experimentation was the Minorite convent in Paris during the first half of the seventeenth century. Its leading spirit was the theologian and mathematician Father Marin Mersenne, fellow student and friend of Descartes, teacher of Jean-François Niceron. Interest in the "curious perspective" diminished during the eighteenth century, and anamorphosis became an elegant diversion; in the nineteenth it degenerated into a pornographic hobby and a political motif.

Baltrušaitis points out the dual nature of anamorphosis: "It is an evasion that implies a return; stifled in a torrent or whirlwind of confusion, the image emerges resembling itself when looked at sideways or reflected in

a mirror. . . . The destruction of the figure precedes its representation." The image is brought back to life from its tomb of jumbled lines. This reversibility turned the procedure into a sort of "proof by nine" of normal perspective or *costruzione legittima*, as the Italians called it. It soon became independent and appeared as often in paintings with religious themes as in erotic works. Its intrinsic duality explains its vogue: anamorphosis is an act of representation that hides the very object it represents. In a religious painting this property works like a double optics of revelation: the morass of lines and masses hides the sacred object, but when the canvas is seen from the appropriate angle, its jumble is clarified and takes on form, and the object appears. In a licentious painting anamorphosis makes us feel that we are peeping through the keyhole. In both cases it is *ultrarapid exposure*. For a mere instant we are the oculist witnesses.

Symbol of worldly vanity in Holbein's famous picture *The Ambassadors,* erotic image in others, in the seventeenth century anamorphosis gave rise above all to scientific and philosophical speculations. But in the seventeenth century science had not as yet cut itself off from magic, astrology, and other heritages of Neoplatonic hermeticism. The last representative of this trend was Kircher, whose mind was a prodigious blend of erudition and fantasy, science and occultism. I said earlier that Kircher modified Dürer's postern; he thought up an apparatus, which he called a mezopticon, composed of "a square standing on end, covered by a diaphanous cloth such as noblewomen use to veil their faces." Though its purpose was different—it was an optical apparatus and the cloth worked like a screen—the disposi-

tion and form of the mezopticon recall the Three Pistons of the *Large Glass.*

Mersenne's circle was more sober. Descartes was a guest of the Minorite convent on two occasions; there he became interested in the work of Niceron and of Emmanuel Maignon, another member of the group. Preoccupied with geometry and optics, they were all fascinated by the rational mystery of automata. A mystery because it came from a tradition going back to Hermes Trismegistus by way of Albertus Magnus and Cornelius Agrippa; rational because, as Salomon of Caus, another of these young sages, said, automata were "the reasoning embodiments of the forces of movement." (It might have been more accurate to say that they were—and are—the *moving embodiment of reason.*) Now, if automata, although lacking souls, were "moving embodiments of reason," perspective was also automatism, the mechanization of rational calculation. Automata and perspective were offshoots of the same science.

There is an amazing connection between these ideas and the conceptions that brought the *Large Glass* into being. I will point out two similarities that seem central to me. The first has to do with perspective, considered as a more than personal rationality in which neither the artist's hand nor his sensibility plays any part. The second is the invention of machines endowed with free will and movement, which function rationally without depending on a psychology. Reading certain fragments of the *Traité de l'homme,* we feel we are facing another version of *The Bride:* "And, truly, one can very well compare the sinews of the machine I'm describing with the pipes of the workings of these fountains; its muscles and tendons with the

various mechanisms and contraptions that make them function; the animal humors with the activating water, whose heart is the source and whose brain concavities are its eyes." In the description of this garden with automata that twirl as in a mythological ballet, analogies with clockwork and water mills are unavoidable: "Moreover, breathing and other such natural and ordinary acts are, depending on the flow of its humors, like the movements of a clock or a mill, which are made perpetual by the mere flow of water." As Baltrušaitis comments, this is man thought of as a hydraulic machine.

Anamorphosis and automata are themes that can be seen as chapters in the history of physics or of philosophy. In the second case they are forms of illusion, images of our uncertain knowledge and our dependence on appearances. Beyond Cartesian doubt—the transparency of the *Large Glass*—reappears the Platonic distinction that is the axis of the speculations of the *White Box:* the difference between apparition and appearance. How can we distinguish one from the other? The fan of anamorphosis turns the Bride into a Hanged Female; twenty-five years later, it gives her back to us in the shape of a blond girl lying on a bed of twigs. Which, among all these *ultrarapid exposures,* is appearance and which is apparition? The fourth dimension is the heaven inhabited by apparitions, which are archetypes or molds of beings here below. The *White Box* calls it "a sort of mirror-image," a being made of reflections. Is apparition the appearance of another apparition hidden in another dimension? The *Large Glass* is a mirror and in its upper half float ("freed forms") the shadows of the fourth dimension. But what do we see in this

transparency—our shadow or the Bride's? The Assemblage answers our question with a three-dimensional enigma. A lovable, visible, solid—but untouchable—image. Untouchable and untouched. We wander lost among appearances and apparitions. The human spirit is twofold; like the mirror, it is inhabited by essences and ghosts.

Duchamp's interest in optical phenomena, regarded as a dimension of physical science or as one extreme of philosophic doubt, became apparent early in his career. Early, constantly, and in a variety of forms: the problems of linear and anamorphic perspective, chronophotography and simultaneism, projecting the shadows of objects on a wall or screen, painting (delay) in glass, stereoscopic cinema, rotating sheets of glass (precision optics), revolving semispheres, rotoreliefs (optical disks), disks with puns inscribed spirally. . . . In the section of the *Green Box* devoted to the Oculist Witnesses, he foresees "parts to look at cross-eyed like a piece of silvered glass in which are reflected the objects in the room." In the *White Box* he says that there are things, though he doesn't specify them, that must be looked at with only one eye, sometimes the right, sometimes the left. (He also talks of something considerably more difficult: to hear with only one ear, either the left or the right. . . .) The notes I have mentioned refer to the Spray, and like the note in the *Green Box*, they are linked to the Oculist Witnesses and their function of transforming drops into "mirrorical images." And so they are connected with one of his most puzzling compositions: *To Be Looked at (from the Other Side of the Glass) with One Eye, Close to, for Almost an Hour.* This work is a prototype

of the region of the *Large Glass* where the Oculist Witnesses are found. In its upper part, above the magnifying glass floats a pyramid that in its turn contains a series of triangular planes looking like other pyramids; they are the different transverse sections of the visual pyramid of classical perspective. Who looks cross-eyed through the lens? Whoever looks, when he does so, becomes an Oculist Witness. And what does he look at? The floating pyramid is the viewer's visual field and this visual field is the path toward the elusive object that is the Bride. The cruel path of perspective that is narrowed down to a point: the vanishing point. Like the "infinite Jura-Paris road" of the 1912 text, this path has a beginning but no end; the vanishing point is the place where everything disappears. Blending into the horizon, the Bride vanishes.

His preoccupation with the relationship between the second and third dimensions led him, from early on in his artistic career, to an interest in stereoscopy. This was a passion that never left him. In his youth, among the apparatuses designed to create the illusion of relief and depth, stereoscopic spectacles with one red lens and one green were popular, made sometimes of glass, sometimes of mica. *Pharmacy,* one of his first Readymades (1914), was actually "rectified" by adding two stains, one green and the other red. In 1920 he tried to create a stereoscopic film; his rotoreliefs and precision optics machines obey the same principle. There is a doubly "rectified" Readymade that has an undoubted and intimate relationship to the Oculist Witnesses and to *To Be Looked at (from the Other Side of the Glass) with One Eye, Close to, for Almost an Hour.*
It appears in the same year and place as these two works:

1918 in Buenos Aires. It consists of two photos of the same scene: a calm sea, light and shade, a boat manned by a solitary boatsman faintly visible on the far right, the horizon and a clear separation of water and sky. In both photos Duchamp added a pyramid and its inverted projection, floating. Like the pyramid in *To Be Looked at*, the one in the Readymade is the visual field of the apparition and evanescence of the object that always eludes us—and is always present.

The *Given* is another example, the biggest and the best, of his enthusiasm for stereoscopics. There is an obvious relationship between this work of poetic illusionism and the theatrical monuments of Renaissance architecture, such as the Palladian Theater in Vicenza or Borromini's colonnade in the Palazzo Spada in Rome. It is also akin to the "optical chambers" of seventeenth-century Holland, and, of course, to the excellent dioramas in the Museum of Natural History in New York. Toward the end of his life, Duchamp made a sketch for an anaglyphic chimneypiece that was to produce a stereoscopic effect when seen through the appropriate spectacles. His close friends still recall his joy, shortly before his death, on again finding, in the same Parisian shop, the stereoscopic spectacles he was searching for in order to look at his sketch. Just like those of his youth. . . .

All these experiments are one more expression of his preoccupation with what could be called the instability of the notions of right and left, here and there, inside and outside, behind and in front, up and down. These ideas are spatial forms of contradiction. But there is a point at which contradictions end: the hinge. They come to an end only

to be reborn at once, transformed; the hinge is both the resolution of contradiction and its metamorphosis into another contradiction. The dialectic between apparition and appearance is reproduced in the hinge. Duchamp's optical experiments—and the same must be said of his linguistic experiments too—are applications of the general principle of the hinge. His works—paintings, Readymades, Assemblages, puns, speculations—form a system, and in this system the center, the hinge of hinges, is the *Large Glass*. The relationship between the Bride in the *Large Glass* and the woman in the *Given* has already been disentangled: both are appearances of the same apparition. This apparition is an unknown object that in turn reveals and hides itself, unfolds itself and winds itself up again in the folds and transparencies of the fourth dimension. Folds that are veils, now of water, now of glass. Are these veils made out of its thoughts or of ours? Whatever our response to this question, it is clear that the relationship uniting the Bride in the *Large Glass* with the girl in the *Given* is that of two images fused into one. It is not exaggerated to call this relationship stereoscopic. "Unknown reality" works like a stereoscope.

A similar relationship exists between the Bride in the *Large Glass*, the girl in the *Given*, and the Goddess of the ancient Mediterranean religions. This relationship is twofold. On the one hand, each of the three images is a moment in the rotation of an invisible and, by definition, unknown hinge, unknown at least to our senses and even to our reason; on the other hand, within its individual world each image is the center, the pivot. I will attempt to explore this second relationship. There is an obvious

correspondence between each of the three feminine images and the worlds over which they reign. Actually the Bride and her landscape in the *Large Glass* correspond identically to each other. Moreover, this correspondence is made explicit: everything is a representation or projection of the Bride. In the Assemblage the identity is implicit: each one of the girl's physical attributes is, one might say, duplicated in the landscape. The wooded hill, the waterfall, and the lake are her mirror. In the mythic conception the oneness of the Goddess and her world is also presented like a sort of knot of images and reflections. The sacred place *is* the Goddess. Therefore, insists Jean Przyluzki, the location of the sanctuary is a *complete landscape,* made up, that is to say, of wood, hill, and water.[23] The forces of nature are concentrated in the divine presence, but in its turn the divine presence is spread throughout the physical space.

The evolution of the space occupied by the sanctuary will help us understand the function of the stereoscope in Duchamp's system. Once a fairly remote spot where the rites of the cult were celebrated, the sacred place gradually became the center of the world. It then becomes an ideal place: an Eden, a paradise outside physical reality. The center of the world—Eden—coincided with the Goddess; or rather, it *was* the Goddess. The holy tree of the sanctuary became the column of the temple, and the column became the axis of the cosmos. The four cardinal points originated from this center, returned to it, and disappeared in it. The column that was the Goddess, turning back on

Marcel
Duchamp

23. Jean Przyluzki, *La grande déesse* (Paris: Payot, 1950).

itself like the hinge, disappeared and was fused with its essence. This side and that side, right and left, the laws of perspective and gravitation canceled each other out. The identification of the center of the universe with the Goddess, of the Bride with her landscape, is resolved in another analogy: that of the stereoscope. But "stereoscope" is only one more name for the elusive object for which Duchamp searched all his life and which, in the notes of the *Green Box*, is called the *sign of the accordance*.

The opening paragraph of the preface to the *Green Box* reproduced as the epigraph to this study, is as much a program of the work to be realized as the definition of its purpose: "to isolate the sign of the accordance." This sign comes between the State of Rest (or allegorical appearance or ultrarapid exposure) and a series of Possibilities. The Appearance is the Bride in the darkness of the room, surprised in a moment of repose (though capable of "giving herself up to all the eccentricities"). The Possibilities can only be the other possible manifestations produced by the combined action of the Waterfall and the Illuminating Gas, according to the same laws as those that operate in the case of the ultrarapid exposure. In fact, the *sign of the accordance* is not something *between* Appearance and Possibilities but rather the relationship between them both. To clarify his idea Duchamp uses an "algebraic comparison." Let a be Appearance and b Possibilities; the relationship is not $\frac{a}{b} = c$ but the sign (a/b). "As soon as a and b are known, they become units and lose their relative numerical value; the sign that separated them remains (*the sign of the accordance*)." *The sign includes the three elements: a, b, and the diagonal line: a and b are variables*

(*a* is an appearance and *b* the other possible appearances); the relationship symbolized by the diagonal line remains because it is an invariable. The line is separation and unity at one and the same time. An erotic algebra. Now let us move on to meta-ironic geometry.

If the diagonal line becomes a vertical axis turning on itself, it produces a line that always traces a circle, whether it turns in direction *a* (to the right) or *b* (to the left). Duchamp concludes that the figure produced by the original line, *whatever this may be,* cannot be described as right or left of the axis. And, furthermore, in proportion as the axis turns, obverse and reverse take on "a circular significa-tion." The phenomenon affects not only the inside and the outside but the axis itself, for this loses its *"one-*dimen-sional appearance." The sign of the accordance, turning upon itself, is dissolved as appearance: it enters itself and is resolved in pure possibility. It is the *other* dimension. But we can say nothing about it. The only thing we know about the fourth dimension is that it is one dimension *more.* How can we name this dimension that consists of the reabsorp-tion of all dimensions in a void that would have made Buddha himself smile with beatitude? We were looking for the sign of the concordance and we find a diagonal line that becomes a vertical line, a truly magic wand that makes everything around it disappear until it, too, reduced to a one-dimensional state, gyrates, gives one more pirouette, and disappears.

We must go back to the *Large Glass* and try to "isolate the sign of the accordance." This sign links "the allegorical appearance" in a state of "instantaneous rest" to the other possible manifestations or appearances of the Bride. The

sign exists between virtuality and actuality; it separates them, it is a dividing line, and it connects them. Thanks to the powers of the magic wand, possibility is realized and—"ultrarapid exposure"—rests for a moment, turned into appearance. This appearance is an allegory of the other reality whose true form we do not know. Now we have seen the creature in two moments of its "instantaneous rest." Once hanging from a nail, handing out lascivious orders; we called her Hanged Female. Fifty years later we saw her again, naked in the open air, holding up a burning gas lamp; we dared not give her a name. The *sign of the accordance* is a diagonal line separating two signs (two destinies[24]): *a/b.* If we make it vertical, it becomes an axis that fuses here and there in one void as it turns, stereoscope and hinge like the tree-column which is the Goddess. If we move the vertical line down ⌐↘ it becomes a horizontal line. In the middle of the line, just before my eyes, the vanishing point appears: the infinite road that goes from here to there, from the visual angle of the viewer to the Bride. What do I see? Literally, nothing.

The horizon is barely more than a fine line. On it, transparency behind transparency, is there water or glass? It is the Bride's garment. A diaphanous garment, a veil that uncovers her. A veil deceptive in its very diaphaneity: what I see from this side is not exactly what I see from the other side. I always see something *else.* The Wilson-Lincoln system is no less efficacious and is simpler than the Cartesian doubt. Furthermore, this system is not outside man

24. Here Paz plays with the similarity in Spanish of *signo* (sign) and *sino* (destiny or fate, but also a popular derivation of *signo*). See his *Topoemas,* "Ideograma de libertad." [Translator's note.]

but inside him; it is not an optical mechanism but a condition of his spirit. It is the "question of shop windows" with which the *White Box* opens: the shop window proves the existence of the outside world but also its nonexistence. "When one undergoes the examination of the shop windows, one also pronounces one's own sentence. In fact, one's choice is *round trip.*" The *White Box* ends thus: "No obstinacy, *ad absurdum,* of hiding the coition through a glass pane with one or many objects of the shop window. The penalty consists in cutting the pane and in feeling regret as soon as possession is consummated." The round trip of desire is no different from the gyrating of the vertical line, the stereoscope, the hinge, anamorphosis, puns, the Goddess's tree-column, and mathematical and philosophical speculations. Universal reversibility: the journey takes us there and back again.

The logic of the hinge rules this world. The *sign of the accordance* is only the most perfect expression of the hinge principle. What unites, separates; by uncovering the object, transparency interposes itself between that object and my gaze; the negation of the irony of affirmation denies the negation of the laugh; the dividing line between *a* and *b* is really the sign of their union: one cannot live without the other, but they are condemned to see each other without ever blending completely into each other. Apparition is dispersed in Appearance and each Appearance is reabsorbed as it spins upon itself, and returns, not to the Apparition, which is invisible, but to the place of Evanescence, the horizon.

In Duchamp's universe the convergence of its three ruling sciences—eroticism, meta-irony, and metaphysics—

Marcel
Duchamp

152

is the *sign of the accordance,* and it envelops us also: it is the glass that separates us from the desired object but at the same time makes it visible. The glass of otherness and of sameness: we cannot break it or escape from it because the image that reveals us is our own image as we watch it watch. To a certain extent Possibilities and Appearance depend on us—and we on them. We are, while peeping through the glass or the holes in the door, one of the "various facts" that "under certain laws" condition "the instantaneous State of Rest or Allegorical Appearance."

Duchamp devalues art as craft in favor of art as idea; in its turn the idea constantly sees itself negated by irony. Duchamp's visual objects are the crystallization of an idea and the negation, the criticism, of that idea. The ambivalence of the glass, the sign that is separation/union, appears in this realm also. Duchamp did not hide his admiration for the works of art of the past that were incarnations of an Idea, almost always a religious one. The *Large Glass* is an attempt to resuscitate this tradition within a radically different context, both areligious and ironic. But from the seventeenth century onward our world has had no Ideas, in the sense in which Christianity had ideas during its time of apogee. What we have, especially from Kant onward, is Criticism. Even contemporary "ideologies," despite their pretentions of incarnating truth and despite the pseudoreligious fanaticisms they have engendered, present themselves as *methods.* Marxism itself does not claim to be anything more than a theoretical-practical method in which *praxis* is inseparable from criticism. Duchamp's art is public because he sets out to renew the tradition of art 153 *at the service of the Mind;* it is hermetic because it is

critical. Like the tree-goddess who is the center of the universe where the distinction between this side and that side disappears, the Bride in the *Large Glass* is the axis whose turning fuses all spaces into one. Plenitude and emptiness. Unlike the Goddess, the Bride is not a supernatural being but an Idea. But she is an Idea continually destroyed by herself: each one of her manifestations denies her, even as it realizes her. For this reason I dared to say, in my first study on Duchamp, that the Bride is the (involuntary) representation of the only Myth-Idea of the modern West: Criticism.

In the last few years Duchamp's work has received two kinds of interpretation, the psychological and the alchemical. I have already said what I think about the first of these: psychological interpretations often have an impoverishing effect. And they are also misleading. Freud himself warned us of the limitations of his method: it serves to give an account of the author's character and psychical conflicts, but not of the ultimate value and meaning of his work. In Duchamp's case Lebel cautioned us elegantly: "We beg the reader to note that we keep a safe distance from psychiatry, which others would not hesitate to requisition." Following a suggestion of Breton in "Phare de la Mariée,"[25] Lebel was one of the first to hint that, perhaps, in order to fully understand the *Large Glass*, it was necessary to have recourse to "the esoteric hypothesis." Later on, in a treatise on alchemy by Solidonius, Ulf Linde discovered an

25. André Breton, "Phare de la Mariée," *Minotaure*, vol. 2, no. 6 (December 1934), pp. 45–49.

illustration of the disrobing of a virgin by two personages that is extraordinarily like the first version of *The Bride Stripped Bare by Her Bachelors* (Munich, 1912). From this discovery originates "the fashionable notion that alchemy provides a key to the iconography of the *Glass.*"[26] Hamilton sensibly calls into question the pertinence of the esoteric explanation, and insists that Duchamp never gave it credit. Indeed, when his friend Lebel questioned him expressly about this, he answered, "If I have practiced alchemy, it has been in the only way admissible nowadays— that is, without knowing it." A conclusive disavowal.

Certainly, as John Golding points out, the world of Duchamp's youth saw the end of Symbolism, and almost all the Symbolist poets and artists—as later happened with the Surrealists—were attracted by esoteric cults. In Jarry pataphysics walked arm in arm with alchemy and heraldry. But it is one thing to bring to light the particles of occultism, cabalism, and alchemy scattered throughout Duchamp's ideas, almost like dust specks and sediments, and another to say that the *Large Glass* and the Assemblage are works expressly and deliberately inspired by alchemy. We have only to read the notes of the two *Boxes* to agree with Richard Hamilton that "the subject of the *Large Glass* is space and time." This theme, in which physics embraces metaphysics, is closely linked to another: love. They are two inseparable themes that have been one from

26. Richard Hamilton, "The Large Glass," p. 58, in *Marcel Duchamp*, the catalog published jointly by the Philadelphia Museum of Art and the Museum of Modern Art in New York, edited by Anne d'Harnoncourt and Kynaston McShine to commemorate the extensive *Marcel Duchamp* exhibition in 1973. Also on this theme, see *The Machine as Seen at the End of the Mechanical Age* by K. G. Pontus Hultén (New York, 1968).

Plato onward. Love and knowledge have been the dual subject matter not only of Western thought, but of our poetry and art as well. Duchamp's work is appreciably more traditional than is commonly thought. Moreover, here lies one of the proofs of its authenticity. There are many profound relationships linking his two great works, the *Large Glass* and the Assemblage, with our traditions of erotic philosophy and poetry. I do not mean, of course, that Duchamp was inspired by the Provençal poets, nor do I claim him as an assiduous reader of Marsilio Ficino, León Hebreo, or Giordano Bruno. I think that his vision of love and his idea of the *other* dimension fit into our philosophic and spiritual tradition. They are part of it. René Nelli tells us that the Provençal concept of love has survived into the twentieth century, and the same is true of Neoplatonic hermeticism. In our erotic and spiritual lives both trends are still actively, though almost always invisibly, present.

Time and again the meaning of the division of the *Large Glass—Bride above, Bachelors below—*has been discussed. This duality does not refer to position alone, but also to number: unity above and plurality below. Whatever interpretation we may give to this opposition—later I will return to the unity/plurality theme—the division of the *Large Glass* corresponds to that of lady and troubadour in the courtly love tradition. The amatory code of Provence was a projection of the chivalric world onto the realm of sentiments and ideas, and it naturally reproduced, in the relationship between the lady and her swain, the hierarchic structure of medieval society. In its early days, Provençal love was a relationship between equals: the ladies and their suitors belonged to the same aristocratic circles; in its later

stage—that of the great Provençal poetry—the troubadours almost always came from lower social strata than did their ladies.[27] Not all scholars accept this explanation. No matter; whatever the origin of the division, it is certain that in the classic era of courtly love, during the twelfth and thirteenth centuries, the concept predominating in poetic texts is that of the *Large Glass:* the lady above, her lover below. It is less a social than a ceremonial and spiritual distinction; the lover is subordinated to the lady, whatever his condition and state.

Love was *service.* René Nelli says that "the barons and poets regarded themselves as their ladies' vassals and servants, obliged to bow down before them." A great lord, William IX, calls himself *obedienz,* and Cercamon, a troubadour of modest origins, proclaims himself *a coman* (servant) of his lady. Timidity was one of the lover's virtues, probably as a means of purifying and intensifying desire at the same time. The lover's timidity contrasts with the lady's boldness. From the earliest texts onward, Nelli says, "It is always the lady who takes the initiative and puts the lover to the test *(assaia, prueva).*" Cecco d'Ascoli used to say: *"La donna e umida."* The ministry of love was a pilgrimage from lower to higher. A journey that was a rite of purification like that of the Illuminating Gas and with a similar outcome: not physical possession but vision. Through a series of operations that are proofs of purifica-

27. Cf. René Nelli, *L'Erotique des troubadours* (Toulouse: Edouard Privat, 1963). Also, Robert Briffault, *The Troubadours* (Bloomington, Ind.: Indiana University Press, 1965). The latter work is a translation by Briffault himself of his *Les Troubadours et le sentiment romanesque* (Paris, 1945), but with many changes and important additions.

tion, the Illuminating Gas reaches a nonmaterial state: converted into an image, into "mirrorical drops," it is now only a gaze, a contemplation of the naked Bride; in his turn the troubadour passes through the different stages of his amorous ministry—each of them ending in a test—until sexual desire undergoes a sublimation like that of the gas: the troubadour at last attains the contemplation of his naked lady. Sight triumphs over touch. León Hebreo used to call this contemplation visual copulation.

The lady lives in the realm of the ideal, and the troubadour seeks the *other* reality in her and by means of the vision of her naked body—that reality of which she (and he) are images, likenesses. It is not difficult to perceive in this idea certain Platonic echoes, identical to those found in Duchamp, though there the mode is meta-ironic: love not as possession but as contemplation of an object that transports us to a higher sphere. *Instantaneous crossing.* The Provençal poets say little of their desire to possess the lady sexually, but none of them hides his desire to see her naked. The rites of amorous servitude ended with this contemplation. The ceremony of the disrobing was almost always clandestine, though the lady's maids and even her husband were sometimes present. The lover had to *spy* on his lady, like the spectator of the Assemblage. Just as the Bachelors never take off their uniforms—they couldn't, they are empty suits—the courtly lover watched, fully dressed, the ritual of the disrobing. As the dogma of the servitude of love demanded, the ceremony went through various stages. For example, the lady could allow herself to be seen either in transparent garments or completely in the nude. The last stage was the *asag* (test of love): the lover

reached the bed and lay beside the naked lady, on top of the coverlet or underneath, without possessing her or without consummating the act completely *(coitus interruptus)*. [28] The texts also describe, though with no undue emphasis, the caresses the lady and her lover exchanged.

The value attributed to contemplation of the naked female body can be explained by the reason noted above: the identification of woman with Nature. Woman is her own landscape, whether we are dealing with the Goddess of mythology or with Duchamp's Bride or the Lady of the Provençals. I have already mentioned that in all these cases the lady took the initiative, and the ceremony could be realized only as she decreed. The Top Inscription was a social and psychological reality before it was an erotic pseudomechanism. In the *asag* the lady's decision was the condition *sine qua non* of the ceremony, and Nelli quotes various testimonies to this fact, among them the unequivocal text of a *trobairitz,* the Countess of Die, Provence's Sappho. It can be claimed that these analogies are less meaningful than the obvious contrast: whereas the ceremony of courtly love was a ritual of erotic sublimation, that of the *Large Glass* is a parody. But it is an ambivalent parody, love mocked by voyeurism, and at the same time voyeurism transformed into contemplation. We see a naked woman, a universe; like all universes, she is a mechanism; like all mechanisms, this one is "a moving embodiment of reason." Reason, which, in the girl in the Assemblage, is idea become presence. It is a fact worth repeating: Duchamp's work is a vast anamorphosis that unfolds

28. Nelli, *L'Erotique des troubadours.*

before our eyes throughout the years. From the *Nude Descending a Staircase* to the naked girl in the Assemblage—different moments in the journey back toward original form.

The *Green Box* tells us that the Bride "instead of being an asensual icicle, warmly rejects (not chastely)" the Bachelors. Nor was Provençal love a form of Platonism, though in its origins it was more or less indebted to Arabic erotica, itself impregnated with Platonic concepts. Briffault's information is invaluable on this score: until its last phase, when it was overcome and condemned by the Catholic Church, courtly love oscillated between sexual freedom and idealization. It was always a love outside marriage, a transgression consecrated by poetry and philosophy. In its essence, courtly love was a sublimated naturalism. Rather than a metaphysics, it was a physics of love. Nelli points out that this expression—*physics of love*—appears in the novel *Flamenca.* For the troubadours, love enters through the senses: "It wounds in two places, the ear and the eye." The metaphor is very old, and appears in early India as well as in Rome and Japan. The eyes are love's archers, and Provençal poetry is full of arrows, darts, and shafts that tear open and pierce bodies and souls. There are palpable correspondences with the *Large Glass:* the Nine Shots, the final fate of the Illuminating Gas, the Oculist Witnesses, the spectators peering through the holes in the door of the Assemblage. The 1948–49 relief, a "study" for the naked woman of the Assemblage, is another example of Duchamp's loyalty to the old metaphor, which in this case takes on a literal cruelty: the naked body is covered with tiny marks as if it had been pierced by arrows.

The metaphor of the arrows was only part of the physics of love. The "fire of the gaze" told a material truth: the eyes transmitted a warm, luminous fluid. As among the Neoplatonists and Duchamp himself, fire was associated with water: *en foc amoros arosat d'una douzor.* The cause of love is physical: a substance, an element that can be put into a philter or transmitted in a song. This substance is no garden-variety liquid, but a subtle fluid, like that warm draft which moves the cloth of the Three Pistons and which constitutes the Bride's sighs. Later on, erotic fluid became magnetic fluid; in Baroque poetry the magnet was as popular a symbol as Cupid's quiver in Latin: "If to the magnet of your graces, drawing me,/my breast acts as obedient steel . . ." says Sor Juana in a sonnet. Metaphors in Duchamp tend to become literal: erotic fluid is called automobiline, the Waterfall produces amorous electricity, the Illuminating Gas becomes explosive liquid.

Right from the start Duchamp works a radical subversion: in the *Large Glass* the "physics of love" is a dazzling system of forces and relationships, a parody of "the heavenly mechanism." A literally *bedeviled* physics, ruled by laws that are *calembours.* A double negation: against the modern world of conditioned reflexes and psychic automatisms, Duchamp sets his imaginary physics of elastic principles, emancipated metals and freed forms; in opposition to physics, the science that for us occupies the place theology did in the Middle Ages, he invents ironic causality and subsidized symmetry. Through the double hole of this negation the Bride and Eros, the Oculist Witnesses and we ourselves escape. Here a second stage begins, the operation of meta-irony in the proper sense of the term. All these

grotesque phenomena produce a sublimation as does the amorous servitude of the Provençals: the Illuminating Gas becomes a stare and the Bride's orgasm transforms her into the Milky Way. Provençal erotica and Duchamp's own rely on physics. In both cases the operation consists of distilling the erotic fluid until it is transmuted into a gaze. The contemplation of a naked body in which alternately nature is revealed and the *other* reality hidden. The Bride's veil is her nakedness.

In the Middle Ages love was conceived of as a force at once psychic and material, the animating principle of human beings and celestial bodies. Love for Dante is not only an appetite, a propensity common to all creatures, but also a universal principle, physical and spiritual by turn, that binds things together, gives cohesion to the cosmos, and sets it in motion: "Neither the Creator nor His creatures . . . were ever without love/ either natural or mind-directed, as you well know" (Purgatory, XVII). Natural love never errs, "but the other may err through bad intentions." The often-quoted line about the love that moves the sun and the other stars refers to divine power and to a physical force no less real than Newton's gravitation, though, like it, impalpable. The cosmological conceptions of the Middle Ages were dislodged by Copernicus and his followers. The change did not immediately affect ideas about love. The rediscovery of the works of Plato and Plotinus, oddly confused with the revelations of Hermes Trismegistus, gave rise to a tradition of *trattati d'amore*. In these treatises the influence of the new astronomy is nil. Giordano Bruno was the exception to this rule. For this

reason—and for others that will soon be explained—it seems useful to recall some facts about Bruno himself.

The tradition of the love treatises begins with Marsilius Ficino's commentary on Plato's *Symposium* and culminates a century later with Bruno's *Eroici Furori* (1585). The theme of the latter work is intellectual love. His book has two parts, each one composed of five dialogues. Each dialogue is a commentary on some erotic sonnets written by Bruno himself. Critics have pointed out the similarities between this work and the *Vita Nuova:* "the author is not only the poet and the commentator but also the protagonist of his poems."[29] The relationship between the sonnets and the commentaries is like that between the *Large Glass* and the two *Boxes*. Bruno defines his book as "a natural and physical discourse," but warns that its language is erotic. In the dedication to the English poet Philip Sidney—the book was published during Bruno's stay in England—he claims as his model the *Song of Songs:* he wanted to deal with divine and intellectual themes in the language of earthly love. Nothing less like Bruno with his impassioned and contradictory genius, at once huge and puerile, than Duchamp: the freedom of indifference and meta-irony. And yet Duchamp's theme was also a "natural and physical discourse"—space and time—and his language was that of love in its most colloquial expressions. In the middle of the twentieth century his work is one more example of the interpenetration of the two

29. Giordano Bruno, *Dialoghi italiani* (Florence, 1957). See also Frances A. Yates, *Giordano Bruno and the Hermetic Tradition* (New York: Vintage, 1969), and John Charles Nelson, *Renaissance Theory of Love* (New York: Columbia University Press, 1958).

themes that enthralled Bruno: love and knowledge.

For Bruno there are two sorts of furors. Some are irrational and lead us to bestiality, but others consist of the predisposition of the soul to "a certain divine abstraction." The latter, which are found in superior men, are again of two kinds. Some men, possessed by a god or a spirit, do noble deeds or utter marvelous words without knowing what they are doing or saying; others, and these are the best, are aware of their furor and, grown skillful in reflection and contemplation, "cease to be recipients and vehicles, and become true craftsmen and creators." The theme of his book is this type of furor. It is heroic as much because of the subject who experiences it—the craftsman and creator—as because of the object that inspires it, itself most lofty and most difficult: knowledge. Intellectual love is a heroic passion. This heroic furor moves the soul upward and impels it to climb Diotima's ladder from love of the beautiful body to the contemplation of spiritual beauty, and from this to union with the still uncreated. There is a clear division between above and below, but it is neither social nor ceremonial in kind as with courtly love, for it is essentially ontological. The spatial division is complemented by another, which derives from Plato and which the Gnostics adopted: that of light and dark. Our place is here below, but we do not wholly belong to darkness; our kingdom is the penumbra. We live among the shadows and reflections of the lights up there. The world up above, the world of light, is also and especially—here lies its ontological superiority—that of unity, while the world below is that of plurality. The Bride and her Bachelors. There is a continuous dialogue between above and below. This dialogue

consists of the conversion of the one into the other, better yet, into the others, and of the others into the one. It is a process that Plato himself had defined as "deducing multiplicity from unity and reducing multiplicity to its unity." Deduction and reduction: the two central operations of the spirit. The emanations of unity moving downward: the engendering of earthly and visible things; heroic furor moving upward: the contemplation of forms, essences, ideas. Except that these ideas are also shadows, projections of the One hidden in the folds of its unity. Dialogue of apparitions and appearances, dialogue of shadows, dialogue of the Bride with herself.

Critical studies have hardly touched on the theme of colors and the place they occupy in Duchamp's erotic physics and in his physics of "distended laws." This is strange, for a whole chapter of the *Green Box* and another of the *White Box* are devoted to color. The distinction between apparition and appearance extends to color: there are, says the *Green Box*, native colors and apparent colors. Apparition is not only the mold of appearance—that is to say, of the ensemble of sensations that make up our perception of an object—it is also its *negative*, a film that, as it passes through the darkroom, produces the revelation of the ultrarapid exposure. The passage of apparition to appearance is brought about by a phenomenon called "physical dye." No one knew what this phenomenon was until the *White Box* was published. There Duchamp tells us in a note that "physical dye, as opposed to chemical dye, is the molecular essence." *Native colors* are the apparition of apparent colors on a negative. According to the *White Box*, they are

"the colors that are in molecules and determine real colors." These are changing "because of the lighting in their appearance." Really, "native colors are not colors (in the sense of blue, red, and so forth, reflections of lighting X coming from the outside); they are luminous sources producing active colors. . . . Color-source differences (and not colors subjected to a source of light exterior to the object)." Further on, the *White Box* makes another distinction: "The object is illuminant. Luminous source. The *body* of the object is composed of luminous molecules and becomes the *source* of the *lighted* object's substance. . . ." Each object has a "phosphorescence" that does not come from any outside source of light. Each object, in its state of apparition or mold, is a little sun of its own light.

Duchamp's optical speculations drew inspiration from the molecules of the physics and chemistry of his youth, but his ideas on native and apparent colors are also found in the Renaissance treatises of Neoplatonic hermeticism, from Ficino and Pico della Mirandola to Cornelius Agrippa and Giordano Bruno. One of the recurring themes is that of the different kinds of light, from supercelestial light to that of our sublunar world. In his book on memory Bruno affirms that, on the planets, opaque, sublunar metals shine with their own light. They are true "emancipated metals." These ideas traveled as far as Mexico in the late seventeenth century, and Sor Juana Inés de la Cruz, basing herself on Kircher (*Ars Magna Lucis et Umbrae*, Rome, 1646), says in her philosophical poem that things beyond our sublunar world have not only their own light but also "splendid colors," visible even "without light." As in Duchamp, those colors not only radiate from things, but are

the things themselves and do not depend on any external illumination.

The theme of colors in Duchamp would need a separate study. Here I will point out only that "physical dye" is molecular *essence*. Dye is color in itself, the nature or being of the molecular object; at the same time it is a sort of negative print of real, visible color; lastly it is a secretion. Dye is found in all realms, from the ontological to the optical and from the optical to the botanical and the zoological. It is an essence, a definition, a color, and an odor. Thanks to "physical dye," colors are colors and, moreover, perfumes. Duchamp's molecules have the property of changing their nature as if they were subject to incessant punning. Perfumes from reds, blues, greens, or grays that slide toward yellow and even toward the "weaker maroons." Colors that are bred like silkworms or cultivated like asparagus. Fruit-bearing colors, except that "the fruit still has to avoid being eaten. It's this dryness of 'nuts and raisins' that you get in the ripe imputrescent colors. (Rarefied colors.)" The irony that distends physical laws and makes of the *Large Glass* "the mold design for a *possible reality*" also creates the uncorruptible beauty of indifference. Duchamp's colors exist not to be seen but thought: "There is a kind of *inopticity*, a kind of cold consideration in those colorings that only affect imaginary eyes. . . . A bit like a present participle turning past." Verbal colors, mental colors we see with our eyes closed. Each color, the *White Box* insists, will have a *name*. A pictorial nominalism.

When I touched on the theme of the *physics of love* in Provence, I mentioned the duality fire/water, elements

that are intertwined in the poetics of the troubadours. The Neoplatonic tradition also used these symbols. For those poets and philosophers, sight was the queen of the senses; by analogy, understanding and knowledge, intellection, were thought of as a sort of superior vision. Contemplation is seeing not with the eyes but with the mind. Therefore, the dividing line between the world up there and the one down here is precisely the line of the horizon, which limits our visual field. If our eyes are organs of contemplation, our heart is the seat of love. The dialogue between the eyes and the heart is the struggle between water and fire. In Duchamp the elements become part of an industrial, urban landscape ("water and gas on all floors") and in Bruno a mythic landscape, as we see in the lines of this sonnet, which anticipates Baroque rhetoric:

> I who bear love's high banner,
> Have hopes frozen and desires boiling:
> I tremble, I freeze, I burn, and I shimmer,
> I am mute, and fill the sky with burning cries:
>
> From my heart I send sparks, and from my eyes I drip
> water;
> I both live and die, and I laugh and lament:
> The waters live, and the fire dies not,
> So I have Thetis in my eyes, and Vulcan in my heart.

Death by water or by fire? The heroic lover is paralyzed by contrary impulses, as is the Illuminating Gas as it emerges from the Sieves of the "three-directional labyrinth":

Marcel
Duchamp

168

I love another, I hate myself;
But if I put on feathers, the other changes to stone;
I put the other in heaven, if I put myself low;

Always the other flees, if I cease not to follow;
If I call, he does not respond;
And the more I search, the more he hides.[30]

The mixture of water and fire is explosive: the Illuminating
Gas leaps upward; the heroic lover also hurls himself, mad-
dened by passion, after the object of his desire. The theme
of desire is that of the pursuit of a ceaselessly fleeing object,
whether this is a body, an idea, or an idea made body. The
pursuance of an ever-receding object implies an equally
endless movement. This *metaphysical movement*, unlike
material movement, can only be perpetual and therefore
circular. A race in which the subject reaches its object only
to let it go and run after it again. A hunt that has no end.

Bruno's book reaches its moment of greatest tension
and lucidity with the image of the hunt. In the second
dialogue of Part Two we find two surprising personifica-
tions of inaccessible divinity and its manifestation: Apollo
and Diana. Bruno accentuates Diana's subordinate nature,
making her a projection of Apollo: "Diana is of the order
of secondary intelligences who receive the splendor of the
primary intelligence in order to communicate it to those
who are deprived of a fuller vision. . . . No one has been
able to see the sun, universal Apollo, and his absolute light,
but we can see his shadow, his Diana." The goddess is "the
light that shines in the midst of the opacity of matter." She

169

is the light shining on things and she is the things themselves: she is nature. Diana is her landscape. Bruno insists: "This Diana, who is being itself, this being that is truth itself, this truth that is nature itself. . . ." Diana is different from the sun that she reflects, and is identical to it because "unity reveals itself in what it generates and in what is generated, the producer and the product." If the object of heroic love is identified with Diana, the subject can be none other than Actaeon. The hunter wanders through the woods looking for his object, his prey. In trees and in animals, in everything, he sees Diana's reflection: shadows of a shadow. As in Ovid's poem and in the Assemblage, water is of fundamental importance: it is the transparent labyrinth of the reflections that make up appearance—"In the water, a mirror of similitude, Actaeon sees the most beautiful form and face." Water fulfills the same function as the horizon because in it are united the "waters from above with those below . . . in it, seeing is possible." Again, like the line dividing the signs *a* and *b*, like the sign of the accordance and like the glass of the shop window, the water-horizon unites as it divides.

In Klossowski's commentary on the myth, Diana's desire to see herself leads her to see her reflection in Actaeon's gaze; Bruno inverts the process: Actaeon is transformed into the object of his desire and sees himself in the deer that his dogs—the Goddess's thoughts—must devour. But before this, the deer sees Diana naked at the water's edge. In Klossowski's interpretation, Diana desires herself and sees herself through Actaeon; in Bruno's, Actaeon is transformed into the very thing he desires. As a hunter he pursues a deer that, like everything else in the wood, is a

reflection of Diana. And so, when Actaeon turns into a
deer, he becomes part of the Goddess's nature. In both
cases the process is circular, and in both, Actaeon, the
subject, is only a dimension of Diana, the object. The same
logic governs the *Large Glass* and the Assemblage. Ac-
taeon, the Bachelors, and the viewer spying through the
holes in the door are subjects transformed into the objects
of an object: Diana sees herself naked in them.

The most remarkable similarity with the *Large Glass*
occurs in the fourth dialogue of Part Two of *Eroici Furori*.
The hero, the furious lover—the Actaeon who sees the
deer he is hunting disappear at the horizon, where the
moon, which is hunting him, appears—is multiplied into
nine blind men. Each of the nine recites a poem in which
he defines the type of blindness with which he is afflicted.
The nine blind men represent nine of the lover's physical
and psychological limitations; at the same time they are an
allegory of negative theology: "We see *more* when we close
our eyes than when we open them." The nine blind men
are Bruno himself; they are also representations of the nine
spheres that "Cabalists, wise men, Chaldeans, Platonists,
and Christian theologians" have divided into nine orders
of spirits. The number nine has immense prestige. Nine is
three times three, and three is the number into which,
according to Dumézil, the Indo-European vision of the
world is concentrated. Nothing more natural than that
Duchamp add one more Bachelor to Eros' Matrix, origi-
nally composed only of eight.

In the fifth dialogue the nine blind men finally receive
the gift of sight. Their pilgrimage takes them to England,
and there they meet some nymphs, daughters of Father

Thames. In the presence of the nymph who leads the aquatic troupe and whose name is Una, the miracle occurs: a sacred urn, the gift of Ceres, opens of its own accord. Then the nine blind men are granted enlightenment, and contemplate the Goddess. But what do these blind men see when they are transformed into *illuminati?* What do the Bachelors see when they are turned into "mirrorical drops"? They see the transparency of the horizon, the nakedness of space—nothing. We cannot go beyond our horizon, the boundary of our visual field. The pyramid whose apex is our eyes has no base: it floats in an abyss. We see the nakedness of the Bride reflected in the glass water. We see the vanishing point.

Negative theology: in order to see we must close our eyes. In the darkness, Diana surprised in the bath: *ultrarapid exposure.* A new concordance: all the Neoplatonic texts, beginning with Plotinus, say that the vision never arrives slowly, it is a sudden illumination. A *flash.* Instantaneous passage. The similarity with carnal copulation has been pointed out a thousand times, and I have already mentioned León Hebreo's energetic expression: visual copulation of the intellect with its object. Likewise all the texts affirm that union is imperfect. Imperfection is built into man's capacity to know and to see. Creatures of the third dimension, we live in penumbra and exist among appearances. Bruno says that this defect must not discourage the heroic lover: "It is enough to see divine beauty *on the limits of one's own horizon."* This sentence is a commentary anticipating the speculations of the two *Boxes,* and it could be considered another formulation of "the question of the shop windows."

Like the Illuminating Gas, the heroic lover climbs, and as he climbs, the object of his desire retreats along the horizon until it disappears. The One is folded back among its folds, the three-dimensional figure disappears in the mold-mirror of the fourth dimension. The One is not visible, or sayable, or thinkable. Like the vertical line of the *Green Box*, which, as it turns upon itself, loses even its *one dimension* and again becomes part of the nullity of space, the One is beyond all duality. It not even *is* because being necessarily implies nonbeing. The One exists before being. With our eyes glued to the horizon, that line of water hardened into glass, we pass from desire to contemplation—of what and of whom? The reply lies in Actaeon's sacrifice and in the fate of the Illuminating Gas: the subject becomes part of its own object. *Mors osculi,* that state in which death and life are conjoined. We cannot see the Goddess, but while the flash of the ultrarapid illumination lasts, says Bruno, "to see the goddess is to be seen by her."

The similarities between Duchamp's concepts and the two great erotic traditions of the West, courtly love and Neoplatonism, are many and perturbing. I have already stated my belief: these similarities are not the result of any direct or consciously sought influence. Duchamp had not read Bernard de Ventadour or Ficino. He did not need to read them: Duchamp is a link in a chain, he belongs to a tradition whose origins date back twenty-five hundred years. The similarities are no more significant than the differences, principally his subversive spirit, his ironic negation. This is the defining feature of modernity, and it appears in all poetic and artistic works from the end of the

eighteenth century onward. But Duchamp's irony is an irony of affirmation: meta-irony. It is this that distinguishes him from almost all his immediate predecessors and from most of his contemporaries. This is what distinguishes him, above all else, from Picasso. Picasso's nihilism is of a different moral and intellectual order from Duchamp's skepticism. Picasso's weakness—which will be seen more and more clearly as the years pass—lies not in his hand or in his eye, but in his mind. This great artist was also supremely incredulous, and therefore superstitious (which is why he could embrace communism at the very moment of Stalinism—that is, at the time when Marxism had lost its critical and rational values). Duchamp was a skeptic like Pyrrho; therefore he was free, and with a free spirit he accepted the powers of the unknown and the intervention of chance.

Where does Duchamp fit into twentieth-century art? He is thought of as avant-garde *à outrance.* He was. At the same time, his work came into being as a reaction *against* modern art, especially against the art of his time. In a few years he exhausted Fauvism, Futurism, and Cubism. Later on he turned against them. As to Abstractionism, he kept his distance; he never believed in form for form's sake, nor did he make an idol out of the triangle or the sphere. He was part of the Dada movement for what it denied, not what it affirmed—if it affirmed anything. He felt a deeper affinity for Surrealism, but though his participation in the movement was constant, it was always tangential. His most daring gesture—the invention of the Readymades—was ambivalent. The Readymades stand as criticism not of the art of the past, but of works of art, ancient or modern,

insofar as they are considered as *objects*. This is exactly what sets him against *all* modern art. For Duchamp, there is no *art in itself;* art is not a thing but a medium, a cable for the transmission of ideas and emotions. If the *Large Glass* is an avant-garde work by virtue of its mechanical forms, it is not avant-garde in what these forms say—it is a legend, a grotesque, marvelous story. Modern art does not aspire to say, but to be: the *Large Glass* "says," it tells us something. In this, it resembles the art of the "religious painters of the Renaissance," as Duchamp insisted more than once. In the long quarrel between "order and adventure," his work also functions according to the hinge-principle. His meta-irony dissolves the Romantic and avant-garde opposition between subject and object. All this corroborates what I have been thinking and saying for a long time: when they are not a caricature of the authentic avant-garde of the first third of our century, the so-called avant-garde movements of the last thirty years are nostalgic and anachronistic.

Duchamp's work is a variation—yet another one—on a theme that belongs to the traditional art and thought of our civilization. It is a twofold theme: love and knowledge. It has a single goal: to penetrate the nature of reality. It is a variation in meta-ironic mode: love leads us to knowledge, but knowledge is barely a reflection, the shadow of a transparent veil on the transparency of a glass. The *Bride* is her landscape, and we ourselves, who contemplate her naked, form part of that landscape. We are the eyes with which the Bride sees herself. Avid eyes by which she is stripped, eyes that close at the moment her garment falls on the glass horizon. The Bride and her landscape are a

shadow, an idea, the outline of an invisible being on a mirror. A speculation. The Bride is our horizon, our reality; the nature of that reality is ideal or rather hypothetical: the Bride is a point of view. More exactly, she is the vanishing point. Real reality, the reality of the fourth dimension, is a *virtuality:* "not the Reality of the sensory appearance but the virtual representation of a mass (analogous to its reflexion in a mirror)." *(A l'infinitif.)*

The body of the Bride—the body of reality (its appearance)—"is the result of two forces: attraction in space and *distraction* in extension." The Bride is stretched out on her bed of branches and thus is extended, distended, distracted, and drawn away from her point of attraction: we, the mirrors that reflect her. The same movement unfolds in time: her body enjoys an "alternative freedom" with respect to the center of gravity. During certain intervals the body is free and not subject to attraction; at others it is determined by it. While these intervals last, the body is *outside* time. At least outside linear time, in another time. The Bride escapes among the figures and hands of the clock: she is a pendulum seen in profile. Like the line separating the signs *a* and *b*, which disappears as it spins on itself, time is dissolved; through this empty clarity, through this abyss of reflections, the Bride disappears. Time goes into itself and, like space and the sign of the accordance, becomes a virtuality. An ambiguous optical and mental reality, the Bride is also an imprecise auditive reality: "She is a virtual sound." An echo and a silence. But all these are negative ways of seeing her, hearing her, and thinking of her. If the Bride is a negative proof, she is a virtuality, she is a desire. The desire to be.

Like Mallarmé's poem *Un coup de dés*, the *Large Glass* and the Assemblage not only contain their negation, but this negation is their motor, their animating principle. In both works the moment of the apparition of the feminine presence coincides with the moment when she vanishes. Diana: pivot of the world, appearance that evaporates and appears again. Appearance is the momentary form of the apparition. It is the form which we apprehend with our senses and which vanishes through them. Apparition is not a form but a conjunction of forces, a knot. Apparition is life itself, and it is governed by the paradoxical logic of the hinge. The essential difference between the *Large Glass* and the Assemblage is that the Bride is presented in the former like an appearance that must be decoded, whereas, in the second, appearance is denuded to become a *presence* that is offered to our contemplation. There is no solution, Duchamp said, because there is no problem. We could say more precisely: the problem is resolved in presence, the Idea incarnate in a naked girl.

The Assemblage in Philadelphia is Duchamp's reconciliation with the world and with himself. But there is neither abdication nor renunciation; criticism and meta-irony do not disappear. They are the gas lamp burning in the sunlight; its weak, flickering flame makes us doubt the reality of what we see. The lamp produces the *darkness* that Duchamp demanded for the ultrarapid exposure; it is the reflective element that makes the work enigmatic. The enigma lets us glimpse the other side of the presence, the single and double image: the void, death, the destruction of appearance, and simultaneously, momentary plenitude, vivacity in repose. The zero is full; plenitude opens up, it

is empty. Feminine presence: the true waterfall in which is made manifest what is hidden, what is inside the convolutions of the world. The enigma is the glass that is separation/union: *the sign of the accordance.* We move from voyeurism to clairvoyance: the curse of sight becomes the freedom of contemplation.

Mexico, December 27, 1972

Door of Given: 1. The Illuminating Gas, 2. The Waterfall, *1948–49. (Painted leather over plaster relief, mounted on velvet.) Collection Mme Nora Martins Lobo, Sofia, Bulgaria. Photo by Jacques Faujour, © Centre G. Pompidou.*

CHRONOLOGY[1]

1887 Henri-Robert-Marcel Duchamp born near Blainville (Seine-Inférieure), in Normandy, on July 28 to Justin-Isidore (known as Eugène) Duchamp and Marie-Caroline-Lucie Duchamp (née Nicolle). Duchamp's maternal grandfather Emile-Frédéric Nicolle was a painter and engraver. His father was a notary, whose disapproval of an artist's career for his sons caused Duchamp's two elder brothers to change their name when they went against his wishes. Gaston (born 1875) called himself Jacques Villon and became a painter and engraver, while Raymond (born 1876) assumed the partial pseudonym Duchamp-Villon and became a sculptor. Their sister Suzanne (born 1889, and closest to Duchamp in age) also became a painter. Two more children completed the family: Yvonne (born 1895) and Magdeleine (born 1898).

Despite the striking difference in ages between the siblings, family ties were and remained close, with shared interests in music, art, and literature. Chess was a favorite pastime.

1902 Begins painting. Group of landscapes done at Blainville considered to be his first works.

1904 Graduates from the Ecole Bossuet, the *lycée* in Rouen.
Joins his elder brothers in Paris in October and lives with Villon in Montmartre on the Rue Caulaincourt. Studies painting at the Académie Julian until July 1905, but by his own account prefers to play billiards.
Paints family, friends, and landscapes in a Post-Impressionist manner.

1905 Following the example of Villon, executes cartoons for *Le Courrier Français* and *Le Rire* (continues this intermittently until 1910).
Volunteers for military service. To obtain special classification, works for a printer in Rouen and prints a group of his grandfather's engraved views of that city. As an "art worker," receives exemption from second year of service.
Duchamp family moves into house at 71 Rue Jeanne d'Arc, Rouen, where they continue to live until the death of both parents in 1925.

1906 Resumes painting in Paris in October, living on the Rue Caulaincourt. With Villon, associates with cartoonists and illustrators.

1908 Moves out of Montmartre and establishes residence at 9 Avenue Amiral de Joinville, just outside of Paris in Neuilly, until 1913.

1909 Exhibits publicly for the first time at the Salon des Indépendants (two works). Three works included in the Salon d'Automne.
Exhibits at the first exhibition of the Société Normande de Peinture Moderne at the Salle Boieldieu in Rouen (December 20,

1909–January 20, 1910), organized by a friend, Pierre Dumont. Designs poster for the exhibition.

1910 Most important "early works" executed in this year. Paintings with a debt to Cézanne and Fauve coloring *(Portrait of the Artist's Father* and *Bust Portrait of Chauvel)* are followed by work with a new symbolic element *(Portrait of Dr. Dumouchel* and *Paradise)*.

Attends Sunday gatherings of artists and poets at his brothers' studios at 7 Rue Lemaître in Puteaux (a Parisian suburb adjacent to Neuilly). The group includes Albert Gleizes, Roger de La Fresnaye, Jean Metzinger, Fernand Léger, Georges Ribemont-Dessaignes, Guillaume Apollinaire, Henri-Martin Barzun, the "mathematician" Maurice Princet, and others.

About this time, meets Francis Picabia, probably introduced by Pierre Dumont. Shows four works at the Salon des Indépendants and five (including *The Chess Game*) at the Salon d'Automne.

Becomes Sociétaire of the Salon d'Automne and is thus permitted to enter paintings in the Salon without submission to jury.

1911 Continues work with symbolic overtones and begins paintings related to Cubism, with emphasis on successive images of a single body in motion. Aware of the chronophotographs of Etienne-Jules Marey and perhaps affected by similar ideas in the current work of Frank Kupka (his brothers' neighbor in Puteaux).

Shows *The Bush* and two landscapes at the Salon des Indépendants.

Executes a series of drawings and paintings analyzing the figures of two chess players (his brothers). Final painting executed by gaslight, as an experiment.

Marriage of his sister Suzanne to a pharmacist from Rouen. (The marriage ends in divorce a few years later.)

Exhibits again at Société Normande de la Peinture Moderne, Rouen. The Société sponsors an exhibition with the Cubist group in Paris at the Galerie d'Art Ancien et d'Art Contemporain, in which *Sonata* is included.

Shows *Young Man and Girl in Spring* and *Portrait (Dulcinea)* at Salon d'Automne.

Executes a group of drawings (of which three are known)

inspired by poems of Jules Laforgue.

Toward the end of the year, paints *Sad Young Man in a Train* (a self-portrait) and oil sketch for *Nude Descending a Staircase*.

Duchamp-Villon asks his friends, including Gleizes, La Fresnaye, Metzinger, and Léger, to do paintings for the decoration of his kitchen at Puteaux. Duchamp executes *Coffee Mill*, his first painting to incorporate machine imagery and morphology.

1912 Climactic year of his most important oil-on-canvas works.

Paints *Nude Descending a Staircase*, which he submits to the Salon des Indépendants in March. Members of the Cubist hanging committee (including Gleizes and Henri Le Fauconnier) are disturbed by the painting and ask his brothers to intercede with him to at least alter the title. He withdraws the painting.

Attends opening of Futurist exhibition at Bernheim-Jeune gallery in February and pays several visits to the show.

During the spring, executes series of studies culminating in the mechanomorphic painting *King and Queen Surrounded by Swift Nudes.*

Nude Descending a Staircase is first shown in public at the Cubist exhibition at the Dalmau Gallery in Barcelona in May.

From friendship of Duchamp, Picabia, and Apollinaire there develop radical and ironic ideas challenging the commonly held notions of art. This independent activity precedes the official founding of Dada in Zurich, 1916.

With Picabia and Apollinaire, attends performance of Raymond Roussel's *Impressions d'Afrique* at the Théâtre Antoine, probably in May.

Crucial two-month visit to Munich during July and August, where he paints *The Passage from the Virgin to the Bride* and the *Bride,* and executes the first drawing on the theme of *The Bride Stripped Bare by the Bachelors.* Returns home by way of Prague, Vienna, Dresden, and Berlin.

Gleizes and Metzinger include him in their book *Du Cubisme,* published in Paris in August (*Sonata* and *Coffee Mill* reproduced).

In October, takes a car trip to the Jura mountains near the Swiss border with Apollinaire, Picabia, and Gabrielle Buffet. Records this stimulating event in a long manuscript note.

Begins to preserve notes and sketches jotted on stray pieces of

paper which will eventually serve as a cryptic guide to the *Large Glass* and other projects, and which he will publish later in facsimile editions *(Box of 1914,* the *Green Box, A l'infinitif).*

Nude Descending a Staircase finally shown in Paris at the Salon de la Section d'Or (October 10–30) at the Galerie de la Boétie, organized by the Duchamp brothers and their friends. Five other works by Duchamp also included.

Walter Pach visits Duchamp and his brothers and selects four works by Duchamp for inclusion in the International Exhibition of Modern Art (the Armory Show).

1913 A year of critical change in the artist's career. Virtually abandons all conventional forms of painting and drawing. Begins to develop a personal system (metaphysics) of measurement and time-space calculation that "stretches the laws of physics just a little." Drawings become mechanical renderings. Three-dimensional objects become quasi-scientific devices: e.g., *Three Standard Stoppages,* a manifestation of "canned chance" that remained one of the artist's favorite works.

Experiments with musical composition based on laws of chance.

Begins mechanical drawings, painted studies, and notations that will culminate in his most complex and highly regarded work: *The Bride Stripped Bare by Her Bachelors, Even* (the *Large Glass*), 1915–23. Begins first preparatory study on glass: *Glider Containing a Water Mill in Neighboring Metals.*

Employed as librarian at the Bibliothèque Sainte-Geneviève, Paris.

Spends part of summer at Herne Bay, Kent, England, where he works on notes for the *Large Glass.*

In October, moves out of Neuilly studio back into Paris, to apartment at 23 Rue Saint-Hippolyte.

Mounts a bicycle wheel upside down on a kitchen stool as a "distraction," something pleasant to have in the studio. This object becomes a distant forerunner of the Readymades and also foreshadows a later preoccupation with rotating machines that produce optical effects.

In New York, *Nude Descending a Staircase* becomes the focus of national attention and controversy at the Armory Show (February 17–March 15) and travels with the show to Chicago and

Boston. It is bought sight unseen by dealer Frederic C. Torrey from San Francisco for $324. Chicago lawyer Arthur Jerome Eddy buys *Portrait of Chess Players* and *King and Queen Surrounded by Swift Nudes* from the show. The architect Manierre Dawson buys the fourth work, *Sad Young Man in a Train,* thus giving the artist his first (perhaps greatest?) commercial success.

In winter of this year, draws full-scale study for the *Glass* on the plaster wall of the Rue Saint-Hippolyte studio.

Publication in Paris of Apollinaire's *Les Peintres cubistes,* with its prophetic assessment of Duchamp's contribution to modern art (*The Chess Game,* 1910, reproduced).

1914 Continues work on major studies for the *Large Glass: Chocolate Grinder, No. 2; Network of Stoppages; Glider;* and another work on glass, *Nine Malic Molds.*

Collects a small group of notes and one drawing in the *Box of 1914,* of which three photographic replicas are made.

Buys a *Bottlerack* at a Paris bazaar and inscribes it. Adds touches of color to a commercial print and calls it *Pharmacy* (executed again in an edition of three, a favorite number for Duchamp). These constitute the first full-fledged appearances of the (still unnamed) genre Readymade, an unprecedented art form involving the infrequent selection, inscription, and display of commonplace objects chosen on the basis of complete visual indifference. Thus quietly begins a revolution whose effects continue to expand as artists propose the intrusion of wholly nonart elements into the aesthetic frame of reference.

With the outbreak of war, Villon and Duchamp-Villon are mobilized. Walter Pach, returning to France in autumn, urges Duchamp (exempt from service on account of his health) to visit the United States.

1915 Prior to first visit to New York, sends seven works (probably through Pach) to two exhibitions of modern French art at the Carroll Gallery there. Collector John Quinn purchases two paintings and a watercolor.

Sails on the S.S. *Pochambeau* to New York, arriving June 15, and greeted as a celebrity. Pach meets the boat, takes Duchamp directly to see Louise and Walter Arensberg, who at

once become his close friends and enthusiastic patrons. In their apartment at 33 West 67th Street, Arensberg begins to assemble what will be the largest collection of Duchamp's work, assisted by the artist.

Lives with the Arensbergs for three months; moves to furnished apartment at 34 Beekman Place for month of October.

Later this fall, establishes a studio at 1947 Broadway (Lincoln Arcade Building). Acquires two large glass panels and begins work on the *Large Glass* itself.

Buys and inscribes two more manufactured objects (snow shovel and ventilator), for which he now coins term "Readymade."

Through efforts of Pach and Quinn, obtains job as librarian at French Institute for a brief period.

First published statement, "A Complete Reversal of Art Opinions by Marcel Duchamp, Iconoclast," in September issue of *Arts and Decoration* (New York), followed by a number of brief interviews in the New York press.

Meets Man Ray, who becomes lifelong friend and fellow conspirator.

Circle of artists and poets with whom he mingles until 1918, often at lively gatherings at the Arensbergs, includes: Albert and Juliette Gleizes, Gabrielle Buffet and Picabia, Jean and Yvonne Crotti, John Covert, Charles Demuth, Charles Sheeler, Morton Schamberg, Joseph Stella, Marsden Hartley, Walter Pach, Louise and Allen Norton, Mina Loy, Arthur Cravan, Elsa Baroness von Freytag-Loringhoven, Isadora Duncan, William Carlos Williams, Beatrice Wood, Edgard Varèse, Marius de Zayas, Fania and Carl Van Vechten, and Wallace Stevens. Evenings at the Arensbergs involve vigorous debates on current art and literature, the planning of exhibitions and "little magazines," and much chess playing.

1916 Two Readymades are shown, together with five paintings and drawings (including both *Chocolate Grinders*), in an exhibition of modern art at the Bourgeois Gallery, New York (April 3–29).

Included in "Four Musketeers" exhibition at Montross Gallery, New York (April 4–22), with Gleizes, Metzinger, and Crotti.

Henri-Pierre Roché arrives in New York and joins Arensbergs'

circle. Roché becomes close friend of Duchamp, and they later collaborate in several ventures of buying and selling art on commission.

In October, moves from Lincoln Arcade Building into studio above Arensbergs at 33 West 67th Street. The Arensbergs gradually acquire ownership of the *Large Glass* in return for paying his rent.

About this time, makes a replica of the *Bicycle Wheel* (the original had remained in Paris) and hand-colors a full-scale photograph of the *Nude Descending a Staircase* for Arensberg. Importance of "original" or "unique" work of art thus brought into question.

As a founding member of the Society of Independent Artists, Inc., meets with Arensberg, Pach, John Sloan, George Bellows, and others to plan first exhibition with motto "No Jury. No Prizes. Hung in Alphabetical Order." Serves as chairman of hanging committee, with Bellows and Rockwell Kent.

Meets Katherine S. Dreier, also involved with Independents.

1917 Resigns from board of directors of Society of Independent Artists upon rejection of his Readymade *Fountain*, which he submitted under the pseudonym "R. Mutt" for their first annual exhibition. Arensberg also resigns in protest; *Fountain* is photographed by Alfred Stieglitz.

During Independents exhibition at the Grand Central Galleries, New York (April 10–May 6), organizes with Picabia a lecture in the galleries by Arthur Cravan, which ends in a scandalized uproar.

With aid of Roché, Arensberg, and Beatrice Wood, promotes the publication of two Dadaist reviews, *The Blind Man* and *Rongwrong*.

Becomes friendly with Carrie, Ettie, and Florine Stettheimer, three wealthy and cultivated sisters to whom he gives occasional French lessons. Other means of making a modest living include translations of French correspondence for John Quinn.

In October, takes a job for several months at French Mission for the War, as secretary to a captain.

1918 With execution for Katherine Dreier of *Tu m'*, his first oil painting in four years, which takes him several months to com-

plete, Duchamp gives up painting altogether.

When the United States enters the war, he moves to Buenos Aires, where he continues his creative activity for nine months. Sails from New York August 13 on the S.S. *Crofton Hall,* arriving in Argentina about a month later.

Takes a small apartment at 1507 Sarmiento and works on drawings for the *Large Glass.*

Executes third glass study, *To Be Looked at with One Eye, Close to, for Almost an Hour.*

Attempts to organize a Cubist exhibition in Buenos Aires; writes to Gleizes, Henri-Martin Barzun, and Marius de Zayas in New York, but the project does not materialize. Informs Arensbergs by letter that, "according to my principles," he will not exhibit his own work. He asks them not to lend anything of his to exhibitions in New York.

Plays chess avidly, and designs set of rubber stamps to record games and to permit him to play chess by mail.

Deeply distressed by death of Raymond Duchamp-Villon in France on October 9, which is followed a month later by the death of Apollinaire. Makes plans to return to France

1919 Joins chess club in Buenos Aires and plays constantly, to the point where he refers to himself as a "chess maniac."

Marriage of Suzanne Duchamp to Jean Crotti in Paris in April. Duchamp sends her instructions from Buenos Aires for *Unhappy Readymade* to be executed at long distance on the balcony of their Paris apartment.

Despite his desire not to exhibit, three drawings included in "Evolution of French Art" organized by Marius de Zayas at the Arden Gallery, New York, in May.

Returns to Europe, sailing June 22 from Buenos Aires on the S.S. *Highland Pride.*

Stays with Picabia in Paris until the end of the year, with intermittent visits to his family in Rouen.

Establishes contact with the Dada group in Paris and joins gatherings at the Café Certà near the Grands Boulevards; group includes André Breton, Louis Aragon, Paul Eluard, Tristan Tzara, Jacques Rigaut, Philippe Soupault, Georges Ribemont-Dessaignes, and Pierre de Massot.

Using reproduction of the *Mona Lisa* as a Readymade, executes scurrilous *L.H.O.O.Q.*, which becomes a talisman for the Dada movement.

1920 Returns to New York for the year in January, bringing *50 cc of Paris Air* as a present for Arensberg.

A version of *L.H.O.O.Q.* (without goatee) published by Picabia in March issue of *391* in Paris.

Takes a studio at 246 West 73rd Street, where, with the assistance of Man Ray, he executes *Rotary Glass Plates (Precision Optics)*, his first motor-driven construction.

Collaborates with Man Ray on experimental anaglyphic film shot with two synchronized cameras. Man Ray photographs "dust breeding" on the *Large Glass*.

With Katherine Dreier and Man Ray, conceives and founds (on April 29) the Société Anonyme: Museum of Modern Art 1920. The pioneering activity of this organization presents eighty-four exhibitions by 1939 as well as numerous lectures and publications, and builds up a large permanent collection of international modern art. Duchamp serves first as chairman of the exhibition committee and later for many years as secretary to the Société.

Contributes work to first and third Group Exhibitions of the Société in its headquarters at 19 East 47th Street, New York.

Louis Eilshemius, discovered by Duchamp in the 1917 Independents, given his first one-man show by the Société.

Joins Marshall Chess Club, New York.

In winter, moves back into Lincoln Arcade Building, which witnesses birth of "Rrose Sélavy," a feminine alter-ego who lends her name henceforth to published puns and Readymades.

Photographed by Man Ray in his guise as a woman.

Another variation on the concept of the Readymade, *Fresh Widow*, is constructed to his design by a carpenter.

1921 With Man Ray, edits and publishes single issue (April) of *New York Dada*, including contributions by Tzara and Rube Goldberg.

In reply to invitation to enter Salon Dada (June 6–30) at the Galerie Montaigne in Paris, sends rude cable PODE BAL, dated June 1. Exhibition organizers are forced to hang placards bearing

only catalog numbers (28–31) in space reserved for his work.

Sails for Europe on the *France* in June and spends next six months with the Crottis at 22 Rue la Condamine, Paris.

Man Ray arrives in Paris in July; Duchamp meets him at the station. During the summer, they continue film experiments with revolving spirals in Villon's garden at Puteaux.

First puns published in July issue of *391*, Paris.

As Rrose Sélavy, signs Picabia's painting *L'Oeil cacodylate*, which is shown at the Salon d'Automne and later hung in the Paris restaurant Le Boeuf sur le Toit.

Has hair cropped in the pattern of a comet (with a star-shaped tonsure) by Georges de Zayas.

Ownership of unfinished *Large Glass* passes to Katherine Dreier when Arensbergs move permanently to California in the late fall.

Writes Arensbergs of his plans to return to New York to complete the *Large Glass*, and mentions his intention to find a job in the movies "not as an actor, but rather as assistant cameraman."

1922 Sails for New York on S.S. *Aquitania* on January 28 to continue work on the *Large Glass* in the Lincoln Arcade studio. Occupied with silvering and scraping the Oculist Witnesses section of the *Glass*.

Gives French lessons.

With Leon Hartl, another French expatriate artist in New York, starts fabric-dyeing establishment that fails after about six months.

Designs layout for selection of art criticism by his friend Henry McBride. *Some French Moderns Says McBride* published by Société Anonyme, New York, in small edition.

Experiments with the secret truth of numbers, applied to games.

In a letter to Tzara in Paris, proposes lucrative scheme for marketing a gold insignia with the letters DADA as a "universal panacea" (the project was never realized).

Publication of first major critical essay on Duchamp, by André Breton, in October issue of *Littérature* (Paris).

Poet and medium Robert Desnos in Paris apparently receives puns "in a trance" from Rrose Sélavy in New York, and Breton publishes them in December issue of *Littérature*.

1923 Ceases work on the *Large Glass* and signs it, having brought it to a state of incompletion.

Returns to Europe in mid-February on the S.S. *Noordam* via Rotterdam.

Settles in Paris, where he remains until 1942, save for occasional trips around Europe and three brief visits to New York (1926–27, 1933–34, 1936).

Moves into the Hotel Istria, 29 Rue Campagne-Première. Man Ray has a studio nearby. Friendship with Brancusi.

Meets Mary Reynolds, an American widow living in Paris, and they establish a close friendship that lasts for several decades.

Works on optical disks, later used in *Anémic Cinéma.*

Travels to Brussels in March, where he spends several months, during which he participates in his first major chess tournament.

His passion for chess involves serious training and professional competition, which absorb increasing amounts of time for about the next ten years.

Member of the jury for this year's Salon d'Automne.

The idea reaches the public that Duchamp has ceased to produce art.

1924 In the course of several trips to Monte Carlo, invents a roulette system whereby one "neither wins nor loses."

Works all year on motorized *Rotary Demisphere*, commissioned by Paris collector Jacques Doucet.

Gives French lessons to Americans in Paris.

Death of John Quinn, New York, July 28.

Issues a major group of puns, published by Pierre de Massot in Paris as *The Wonderful Book: Reflections on Rrose Sélavy.*

Becomes chess champion of Haute-Normandie.

Appears with Man Ray, Erik Satie, and Picabia in René Clair's film *Entr'acte,* which is shown during the intermission of the Instantanéist ballet *Relâche* by Picabia and Satie, produced by the Swedish Ballet at the Théâtre des Champs-Elysées in December. Also appears in a brief tableau as Adam to Brogna Perlmutter's Eve, probably in a single evening performance of the review *Ciné Sketch* (on December 24?) during the short run of the ballet.

1925 Duchamp's mother dies on January 29; his father dies on February 3.

Participates in chess tournament, Nice, for which he designs poster.

Completes *Rotary Demisphere,* which he asks Doucet not to lend to any exhibition.

Continues to work on his roulette system.

1926 Incorporates optical experiments and puns into *Anémic Cinéma,* a seven-minute movie filmed in collaboration with Man Ray and Marc Allégret.

Sponsors sale of eighty paintings, watercolors, and drawings by Picabia at Hôtel Drouot, Paris, on March 8 (catalog introduction signed by Rrose Sélavy).

Begins speculative purchases and sales of art works, many on behalf of the Arensbergs, an activity ironically counter to his life-long aversion to the commercial aspects of art.

Rents top-floor studio at 11 Rue Larrey in Paris, which he is to occupy for next sixteen years.

Société Anonyme commissions *Portrait of Marcel Duchamp* by Antoine Pevsner.

Travels to Milan and Venice in May. Assists Katherine Dreier in the organization of the International Exhibition of Modern Art sponsored by the Société Anonyme at the Brooklyn Museum (November 19, 1926–January 9, 1927). Exhibition includes 307 works by artists from twenty-three countries.

Sails on the *Paris* on October 13 to New York, where he arranges a Brancusi exhibition at the Brummer Gallery (November 17–December 15). Stays with Allen Norton at 111 West 16th Street. During exhibition meets Julien Levy.

Arranges showing for *Anémic Cinéma* at Fifth Avenue Theater.

The *Large Glass* shown publicly for first time at the International Exhibition in Brooklyn. This work is accidentally shattered in transit following the exhibition. Its condition remains undiscovered until the *Glass* is removed from storage by Katherine Dreier several years later.

1927 With Roché and Mrs. Charles Rumsey, and at Brancusi's request, arranges to buy John Quinn's collection of Brancusi sculp-

ture before the public auction in February. Also buys back three of his own paintings before Quinn sale.

Brief visit to Chicago in January to arrange Brancusi exhibition at the Arts Club there (January 4–18).

Returns to Paris in late February and moves into 11 Rue Larrey studio, where he installs one door that serves two doorways. (The door is removed in 1963 and shown as an independent work of art.)

Continues chess activity in a pattern characteristic of the next five years: the winter months spent training in Nice and playing in a steady sequence of tournaments.

First marriage, on June 7 in Paris, to Lydie Sarazin-Levassor, twenty-five-year-old daughter of an automobile manufacturer. Formal church wedding. Bridal procession filmed by Man Ray. Marriage ends in divorce the following January.

1928 Chess continues, with tournaments in Hyères, Paris, The Hague, and Marseilles.

Arranges with Alfred Stieglitz for Picabia exhibition at the Intimate Gallery in New York.

1929 Visits Spain with Katherine Dreier.

Chess tournaments in Paris.

Begins work on chess book, detailed exposition of special end-game problems.

1930 Chess tournaments in Nice and Paris. Member of French team of the third Chess Olympiad, Hamburg. Duchamp draws with Frank Marshall, the U.S. champion.

Nude Descending a Staircase shown for the first time since 1913 in exhibition of Cubism at De Hauke Gallery, New York, in April.

Apparent relaxation of determination not to exhibit. *Belle Haleine, Pharmacy, Monte Carlo Bond,* and two versions of *L.H.O.O.Q.* included in exhibition of collages, "La Peinture au Défi," organized by Louis Aragon at Galerie Goemans, Paris, in March.

Asked by Katherine Dreier to select works in Paris for a Société Anonyme exhibition in New York the following January. The selection includes Max Ernst, Joan Miró, Amédée Ozenfant, and Piet Mondrian.

Criticized by Breton in the *Second Manifesto of Surrealism* for abandoning art for chess.

1931 Important chess tournament in Prague. Becomes member of Committee of French Chess Federation and its delegate (until 1937) to the International Chess Federation.

1932 With Vitaly Halberstadt, publishes *L'Opposition et les cases conjugées sont réconciliées.* Layout and cover designed by Duchamp.
 Chess tournament at La Baule. Plays in radio match against Argentine Chess Club of Buenos Aires. Wins Paris Chess Tournament in August, a high point in his chess career.
 About this time, sees Raymond Roussel playing chess at nearby table at the Café de la Régence, Paris, but they do not meet.
 Invents for Alexander Calder's movable constructions the name "mobiles" and encourages their exhibition at the Galerie Vignon in Paris. (Arp then names the static works "stabiles.")

1933 Last important international chess tournament, at Folke-stone, England.
 Translates Eugène Znosko-Borovsky's chess book into French: *Comment il faut commencer une partie d'échecs,* a study of open-ing moves that neatly counters his own interest in end games.
 Sails for New York on October 25 to organize a second Brancusi exhibition at the Brummer Gallery (November 17–January 13, 1934).

1934 Returns to Paris in February.
 Begins to assemble notes and photographs pertaining to the *Large Glass.* These are reproduced in a painstaking facsimile edi-tion of three hundred, which he publishes in September in Paris: *La Mariée mise à nu par ses célibataires, même* (known as the *Green Box*).

1935 Produces a set of six *Rotoreliefs* in an edition of five hun-dred which he displays at the annual Paris inventors' salon, the Concours Lépine (August 30–October 8), with no commercial success. Refuses to allow Katherine Dreier to charge more than

three dollars per set since they were so inexpensive to print.

Starts assembling material for the *Box in a Valise*, another special edition that is to include reproductions of all his major works.

Included in "Exposición Surrealista," Tenerife, Canary Islands.

Serves as captain of French team of First International Chess by Correspondence Olympiad. He is undefeated.

Designs a binding for Alfred Jarry's *Ubu Roi*, executed by Mary Reynolds.

Publication of André Breton's "Phare de la Mariée" (Lighthouse of the Bride), in winter issue of *Minotaure* (Paris)—the first comprehensive and illuminating essay on the *Large Glass*.

1936 Continues interest in optical phenomena with *Fluttering Hearts,* design for cover of issue of *Cahiers d'Art* (Paris), containing an important article on his work by Gabrielle Buffet.

Readymades including *Why Not Sneeze?* shown at the *Exposition Surréaliste d'Objets* at the apartment of the dealer Charles Ratton, Paris (May 22–29).

Four works included in the vast International Surrealist Exhibition in London at the New Burlington Galleries (June 11–July 4).

Sails May 20 on the *Normandie* for New York, to undertake the month-long painstaking restoration of the *Large Glass* at Katherine Dreier's house in West Redding, Connecticut.

In August, travels across the United States by train to San Francisco, and then visits the Arensbergs in Hollywood. Stops on return trip in Cleveland, where *Nude Descending a Staircase* is included in the Cleveland Museum of Art's Twentieth Anniversary Exhibition.

Sails for France on September 2.

Eleven works (largest selection to this date) included in *Fantastic Art, Dada, Surrealism,* the first major exhibition of its kind in the United States, organized by Alfred H. Barr, Jr., at the Museum of Modern Art, New York (December 9, 1936–January 17, 1937).

1937 First one-man show held at the Arts Club of Chicago (February 5–27), while he remains in France. Nine works included. Preface to catalog by Julien Levy.

Designs glass doorway for André Breton's Galerie Gradiva, at 31 Rue de Seine, Paris.

Writes a chess column every Thursday for Paris daily journal *Ce Soir*, edited by Louis Aragon.

Continues work on reproductions for *Box in a Valise*.

Assists Peggy Guggenheim with her London gallery, Guggenheim Jeune. First show planned for Brancusi, then changed to drawings of Jean Cocteau.

1938 As "generator-arbitrator," participates in organization of the *Exposition Internationale du Surréalisme*, Galerie Beaux-Arts, Paris (January 17–February). Collaborates with Breton, Eluard, Salvador Dali, Ernst, Man Ray, and Wolfgang Paalen. Proposes ideas for elaborate installation, which includes a ceiling of twelve hundred coal sacks. Shows five works including *Rotary Demisphere* and *Nine Malic Molds* of 1914. Contributes mannequin (Rrose Sélavy) dressed only in his own hat and coat to row of artists' mannequins in the Rue Surréaliste. Leaves for England on the day of the opening. Eight works reproduced in the "Dictionnaire abrégé du surréalisme," a section of the exhibition catalog.

Prepares summer exhibition of contemporary sculpture for Guggenheim Jeune gallery, London. Selection includes Arp, Brancusi, Calder, Duchamp-Villon, Pevsner.

1939 Publishes volume of puns, *Rrose Sélavy, oculisme de précision, poils et coups de pieds en tous genres*, in Paris.

Monte Carlo Bond given by Duchamp to the Museum of Modern Art, New York (first work in a public collection).

Preoccupied with reproduction of the *Large Glass* on transparent plastic for *Box in a Valise*.

1940 Continues work on his *Valise*.

Summer with the Crottis in Arcachon, in the Occupied Zone of France.

Man Ray moves to the United States, settling in California.

Previously unpublished notes included in Breton's *Anthologie de l'humour noir*, which was intended to have a special cover by
Duchamp.

1941 Official date of first publication of *Box in a Valise*. Individual *Valises* are assembled slowly over the years by Duchamp and various assistants, including Joseph Cornell, Xenia Cage, and Jacqueline Matisse.

As trustee, with Katherine Dreier, of the permanent collection of the Société Anonyme, authorizes its presentation to Yale University Art Gallery, New Haven, Connecticut. *Rotary Glass Plates* of 1920 included in this gift.

Obtains permanent pass for the "free zone" as a cheese dealer from his merchant friend Gustave Candel; travels between Paris and the south of France, moving the contents of the *Valises* to Marseilles, whence they will be sent to New York.

1942 Returns to the United States, where he resides for the rest of his life. Sails from Lisbon on the *Serpa Pinto*, arriving in New York on June 25.

Lives briefly in the Ernsts' apartment at 440 East 51st Street, then moves to 56 Seventh Avenue, where he stays with Frederick Kiesler.

Associates with Surrealist group of artists and writers temporarily living in New York during the war, including Breton, Ernst, Matta, André Masson, Wifredo Lam, and Yves Tanguy.

With Breton and Ernst, serves as editorial adviser for several issues of the review *VVV*, founded by David Hare in New York.

Peggy Guggenheim's gallery Art of This Century, which serves as a museum for her private collection and a gallery for temporary exhibitions, opens at 30 West 57th Street in October. Installation by Kiesler includes reproductions from Duchamp's *Valise* seen through holes in a revolving disk which the viewer turns with a wheel.

Collaborates with Breton, Sidney Janis, and R. A. Parker on catalog and exhibition of *First Papers of Surrealism*, shown at 451 Madison Avenue, New York (October 14–November 7) and sponsored by the Coordinating Council of French Relief Societies. Designs spectacular and frustrating installation with a mile of string. Encourages Janis children to play energetic games in the gallery during opening (at which he is not present).

Meets John Cage through Peggy Guggenheim.

1943 Moves into top-floor studio at 210 West 14th Street, which he occupies for about twenty-two years.

With Breton, and Kurt Seligmann, designs show window at Brentano's bookstore on Fifth Avenue for publication of *La Part du diable* by Denis de Rougemont.

Takes part in a sequence of Maya Deren's uncompleted film *The Witch's Cradle.*

His collage *Genre Allegory* rejected by *Vogue* magazine as a design for a George Washington cover.

Large Glass placed on extended loan to the Museum of Modern Art, New York, and is part of international exhibition there, *Art in Progress* (first public appearance of the *Glass* since its repair in 1936). Remains on view until it is returned to Katherine Dreier in April 1946.

1944 Executes drawing of nude figure, first known sketch for his major last work, *Etant donnés: 1° la chute d'eau, 2° le gaz d'éclairage,* on which he was to work in secret for twenty years.

Describes daily existence to Katherine Dreier: "Chessing, lessoning, starting a few boxes, my usual life."

Hans Richter begins his film *Dreams That Money Can Buy,* including sequence of Duchamp with his *Rotoreliefs.* Other collaborators are Calder, Ernst, Léger, and Man Ray.

Designs catalog for *Imagery of Chess* exhibition at Julien Levy Gallery in December and referees six simultaneous games of blindfold chess between champion George Koltanowski and Alfred Barr, Ernst, Kiesler, Levy, Dorothea Tanning, and Dr. Gregory Zilboorg.

The Société Anonyme publishes *Duchamp's Glass: An Analytical Reflection,* by Katherine Dreier and Matta.

1945 March issue of *View* (New York) devoted to Duchamp, providing first important illustrated anthology of writings on his work.

Family group exhibition of *Duchamp, Duchamp-Villon, Villon* at Yale University Art Gallery (February 25–March 25). Ten works shown. An exhibition of Duchamp and Villon organized by the Société Anonyme travels to college art galleries in Virginia, California, Pennsylvania, Minnesota, and Maine during 1945–46.

With Breton installs show window at Brentano's on Fifth Avenue for publication of Breton's *Arcane 17*. After protests from League of Women, installation is moved to Gotham Book Mart at 41 West 47th Street.

With Enrico Donati, installs show window at Brentano's for second edition of Breton's book *Le Surréalisme et la peinture*.

In December the Museum of Modern Art, New York, purchases *The Passage from the Virgin to the Bride* from Walter Pach (first painting to be bought by a museum).

1946 Begins twenty years of work on the tableau-assemblage *Etant donnés* in his 14th Street studio.

Guest director of the Florine Stettheimer exhibition at the Museum of Modern Art, New York (catalog by Henry McBride).

Serves, with Alfred Barr and Sidney Janis, on jury for *Bel Ami International Competition and Exhibition of New Paintings by Eleven American and European Artists* on the theme of the Temptation of St. Anthony. First prize awarded to Max Ernst.

First important extended interview, with James Johnson Sweeney, published in *The Museum of Modern Art Bulletin*, "Eleven European Artists in America."

Helps Katherine Dreier decorate her recently purchased house in Milford, Connecticut. Paints the small elevator installed in the entrance foyer with a trompe-l'oeil leaf pattern matching the wallpaper.

Visits Paris in the fall, where he and Breton design and prepare exhibition *Le Surréalisme en 1947* at the Galerie Maeght (July–August 1947). Duchamp's suggestions for the Labyrinth and Rain Room carried out by Kiesler. Returns to New York in December, long before the opening. Kiesler also executes photo-collage *The Green Ray* for the exhibition on Duchamp's behalf—"art by proxy."

1947 In collaboration with Enrico Donati in New York, designs catalog cover for *Le Surréalisme en 1947* and hand-colors 999 foam-rubber "falsies," labeled "Prière de Toucher," for the deluxe edition.

Applies for United States citizenship.

1948 Executes vellum-and-gesso study for nude figure in *Etant donnés,* which he gives to Maria Martins, the Brazilian sculptress.

Included in group exhibition with Joseph Cornell and Tanguy, *Through the Big End of the Opera Glass,* at the Julien Levy Gallery, New York, in December, for which he designs catalog.

1949 Participates in three-day session of the Western Round Table on Modern Art, held at the San Francisco Museum of Art, April 8–10. Other panelists are Gregory Bateson, Kenneth Burke, Alfred Frankenstein, Robert Goldwater, Darius Milhaud, Andrew Ritchie, Arnold Schönberg, Mark Tobey, and Frank Lloyd Wright, with George Boas as moderator; *Nude Descending a Staircase* shown in an exhibition assembled for the event at the museum. Afterward, visits Max Ernst in Sedona, Arizona, for a few days.

Largest group of works (thirty) exhibited to date included in *Twentieth Century Art from the Louise and Walter Arensberg Collection* at the Art Institute of Chicago (October 20–December 18).

Visits Chicago, with Arensbergs, at the time of the exhibition.

1950 Contributes thirty-three critical studies of artists (written 1943–49) to catalog of the *Collection of the Société Anonyme,* Yale University Art Gallery.

Takes brief trip in September to Paris, where Mary Reynolds is seriously ill. She dies on September 30.

As a trustee of the Arensbergs' Francis Bacon Foundation, joins in decision to donate the Arensbergs' collection of twentieth-century art and Pre-Columbian sculpture to the Philadelphia Museum of Art.

Appearance of first plaster erotic objects *(Not a Shoe, Female Fig Leaf).*

1951 Publication of *Dada Painters and Poets: An Anthology,* edited by Robert Motherwell, New York. Includes contributions by and about Duchamp, who also gave advice and assistance to the editor.

1952 Helps to organize *Duchamp Frères et Soeur, Oeuvres d'Art,* an exhibition at the Rose Fried Gallery, New York (February 25–March).

Death of Katherine Dreier on March 29.

Collaborates with Hans Richter in the latter's film *8 × 8* based on chess. Sequences filmed in Southbury, Connecticut, with Ernst, Calder, Tanguy, Arp, Kiesler, Dorothea Tanning, Julien Levy, Jacqueline Matisse.

Gives address at banquet of New York State Chess Association on August 30.

Assists in organization of memorial exhibition of Katherine Dreier's own collection at Yale University Art Gallery in December. Writes preface for catalog. Miss Dreier's collection, which includes major works by Duchamp, is bequeathed to several museums including Yale University Art Gallery, the Museum of Modern Art, New York, and the Philadelphia Museum of Art. As an executor of her will, Duchamp plays an important role in the division of the collection.

1953 Assists with assembly and installation of the exhibition *Dada 1916–1923* at the Sidney Janis Gallery, New York. Shows twelve works. Designs catalog on single sheet of tissue paper which is crumpled into a ball before being distributed. Extended (unpublished) interview with Harriet, Sidney, and Carroll Janis.

Death of Picabia on November 30.

Death of Louise Arensberg on November 25, followed shortly by the death of Walter Arensberg on January 29, 1954.

Five works included in exhibition *Marcel Duchamp, Francis Picabia* at Rose Fried Gallery (December 7, 1953–January 8, 1954).

1954 Marries Alexina (Teeny) Sattler, who had previously been married to Pierre Matisse, on January 16 in New York. Duchamp thus acquired a new family of three stepchildren, Paul, Jacqueline, and Peter. Duchamp and his wife live in a fourth-floor walk-up apartment at 327 East 58th Street (formerly occupied by the Max Ernsts) for next five years.

Musée National d'Art Moderne in Paris acquires oil sketch of *Chess Players,* 1911, first work in a French public collection.

Publication in Paris of study by Michel Carrouges on Kafka, Roussel, and Duchamp, *Les Machines célibataires,* which provokes comment and controversy in French literary circles.

Opening of permanent exhibition of the Louise and Walter Arensberg Collection at the Philadelphia Museum of Art, which received this major bequest in 1950. Forty-three works by Duchamp included. Comprehensive catalog published. Installed by Henry Clifford with the assistance of Duchamp.

The *Large Glass,* bequeathed by Katherine Dreier, is permanently installed in the Arensberg galleries.

1955 Televised interview with James Johnson Sweeney at the Philadelphia Museum of Art, which is broadcast by NBC in "Wisdom Series" in January 1956.

Becomes a naturalized United States citizen. Alfred Barr, James Johnson Sweeney, and James Thrall Soby are witnesses at the ceremony.

About this time, begins to work on elaborate landscape for *Given.*

1956 Publication of *Surrealism and Its Affinities,* catalog by Hugh Edwards of the Mary Reynolds Collection of rare books, periodicals, and her own bookbindings, at the Art Institute of Chicago. Preface by Duchamp, who also designed the bookplate.

Sends remaining contents of unpublished *Valises* back to Paris, where various assistants continue the slow and painstaking work of their assembly.

1957 Major exhibition and catalog of *Jacques Villon, Raymond Duchamp-Villon, Marcel Duchamp* at the Solomon R. Guggenheim Museum, New York (February 19–March 10), prepared by James Johnson Sweeney. Duchamp suggested the idea for the joint exhibition, advised on the selection, and designed the catalog. Exhibition later travels to Houston, Texas.

Delivers important lecture "The Creative Act" at convention (April 3–11) of the American Federation of Arts in Houston.

1958 Publication in Paris of *Marchand du Sel, écrits de Marcel Duchamp,* compiled by Michel Sanouillet. The most com-

prehensive collection to date of Duchamp's writings and statements, with bibliography by Poupard-Lieussou.

About this time, begins to spend summers in Cadaqués, on the Costa Brava, Spain; visits to Paris often included.

1959 Moves to apartment at 28 West 10th Street, New York, where he and his wife live until his death.

Assists in design and publication in Paris of *Sur Marcel Duchamp* by Robert Lebel. (English translation by George Heard Hamilton published in New York.) The most comprehensive and definitive work on Duchamp to that date. Includes a catalogue raisonné with 208 detailed entries and an extensive bibliography. Two new works executed for incorporation in deluxe edition: *Self-Portrait in Profile* and enamel plaque *Eau & gaz à tous les étages.* This publication celebrated in one-man exhibitions at the Sidney Janis Gallery, New York, Galerie La Hune, Paris, and the Institute of Contemporary Arts, London.

Enters the Collège de Pataphysique in France in the year 86 E.P. (Ere pataphysique) with the rank of Transcendent Satrap (the highest in this life) and the supplemental honor of being Maître de l'Ordre de la Grande Gidouille. (Note: E.P. in vulgar chronology is based on 1873, the year of Alfred Jarry's birth.)

With Breton, helps arrange the *Exposition Internationale du Surréalisme* at the Galerie Daniel Cordier, Paris (December 15, 1959–February 1960). Contributes *Couple of Laundress' Aprons* to *Boîte alerte*, special edition of catalog.

In Cadaqués for the summer, experiments with plaster casting from life *(With My Tongue in My Cheek, Torture-morte).*

1960 Publication in London of *The Bride Stripped Bare by Her Bachelors, Even,* first full English translation of the *Green Box,* by George Heard Hamilton with typographic layout by Richard Hamilton.

Exhibition *Dokumentation über Marcel Duchamp,* at the Kunstgewerbemuseum, Zurich (June 30–August 28).

Participates in symposium, "Should the Artist Go to College?" at Hofstra College, Hempstead, Long Island, New York, on May 13.

Elected to National Institute of Arts and Letters, New York, on May 25.

Collaborates with André Breton on direction of exhibition *Surrealist Intrusion in the Enchanter's Domain,* at the D'Arcy Galleries, New York (November 28, 1960–January 14, 1961). Designs catalog cover.

Contributes extended pun to broadside for Jean Tinguely's machine, *Homage to New York,* which destroyed itself in the Museum of Modern Art Sculpture Garden on March 17. Duchamp attends the event.

About this time a number of American artists, including Robert Rauschenberg, Jasper Johns, and Robert Morris, become interested in Duchamp's work and career, through reading Lebel's monograph, the translation of the notes of the *Green Box,* and visits to the Arensberg Collection in Philadelphia. Rauschenberg, for example, dedicates the combine painting *Trophy II,* 1960–61, to Teeny and Marcel Duchamp. Duchamp in turn takes an interest in contemporary manifestations; for example, attends Claes Oldenburg's *Store Days* performances in February–March 1962, and befriends younger artists in New York.

1961 Featured in *Art in Motion* exhibition and catalog, organized by Stedelijk Museum, Amsterdam (March 10–April 17), and Moderna Museet, Stockholm (May 17–September 3). Plays (and wins) chess by telegram with a group of students in Amsterdam on the occasion of the exhibition. First replica of *Large Glass* made by Ulf Linde included in exhibition and signed by Duchamp, who visits Stockholm for the occasion.

Participates in panel discussion "Where Do We Go from Here?" at the Philadelphia Museum College of Art on March 20. Other panelists are Larry Day, Louise Nevelson, and Theodoros Stamos, with Katharine Kuh as moderator. Delivers statement including the prophetic words "the great artist of tomorrow will go underground."

Assists with reinstallation of Arensberg Collection at Philadelphia Museum of Art in May.

Interviewed by Katharine Kuh on March 29, and on September 27 by Richard Hamilton for BBC television *Monitor* program.

Featured in *The Art of Assemblage* exhibition and catalog organized by William Seitz at the Museum of Modern Art, New York (October 2–November 12). Exhibition travels to Dallas and San Francisco. Participates in symposium at Museum on October 19,

delivering a brief prepared statement "Apropos of Readymades." Other panelists are Roger Shattuck, Robert Rauschenberg, and Richard Huelsenbeck, with Lawrence Alloway as moderator.

Receives honorary degree of Doctor of Humanities from Wayne State University, Detroit, Michigan, on November 29, and delivers an address. Lectured on his work at the Detroit Institute of Arts the previous day.

Dissertation completed by Lawrence D. Steefel, Jr., at Princeton University, New Jersey: *The Position of "La Mariée mise à nu par ses célibataires, même" (1915–1923) in the Stylistic and Iconographic Development of the Art of Marcel Duchamp.*

1962 Lectures on his work at Mount Holyoke College, Massachusetts, and at the Norton Gallery, Palm Beach, Florida.

1963 Designs poster for *1913 Armory Show 50th Anniversary Exhibition* at Munson-Williams-Proctor Institute, Utica, New York (February 17–March 31), and delivers lecture at the Institute on February 16. The exhibition travels to the Armory in New York (April 6–28).

Delivers lecture on his work, "Apropos of Myself," at Baltimore Museum of Art, Maryland, and Brandeis University, Waltham, Massachusetts.

Death of Jacques Villon, June 9.

Death of Suzanne Duchamp Crotti, September 11, whose husband Jean had died in 1958.

One-man exhibition (of replicas made by Ulf Linde) at Galerie Burén, Stockholm, in conjunction with publication of a major monograph, *Marcel Duchamp*, by Linde.

Continues to grant increasing numbers of interviews to critics and journalists.

First major retrospective exhibition, *By or of Marcel Duchamp or Rrose Sélavy*, organized by Walter Hopps at the Pasadena Art Museum (October 8–November 3). Duchamp designs poster and catalog cover; 114 works included. Visits California (with a side trip to Las Vegas) on the occasion of the exhibition.

1964 Galleria Schwarz, Milan, produces thirteen Readymades in editions of eight signed and numbered copies. One-man exhibition

Omaggio a Marcel Duchamp at Galleria Schwarz (June 5–September 30) followed by European tour to Bern, Switzerland; London; the Hague and Eindhoven, the Netherlands; and Hannover, West Germany. Catalog includes contributions by Arturo Schwarz, Hopps, and Linde.

Jean-Marie Drot makes a film, *Game of Chess with Marcel Duchamp*, including extensive interview, for French television. Film wins first prize at the International Film Festival at Bergamo, Italy.

Delivers lecture "Apropos of Myself" at the City Art Museum of St. Louis on November 24.

1965 Major one-man exhibition, *Not Seen and/or Less Seen of/by Marcel Duchamp/Rrose Sélavy 1904–64*, at Cordier & Ekstrom Gallery, New York (January 14–February 13). Includes ninety items from the Mary Sisler Collection, many never exhibited previously. Catalog introduction and notes by Richard Hamilton; cover by Duchamp.

"Profiled" in the *New Yorker* magazine by Calvin Tomkins in February. The *New Yorker* article, plus three others (on John Cage, Jean Tinguely, and Robert Rauschenberg), published by Calvin Tomkins as *The Bride and the Bachelors*.

Attends dinner on May 15 in honor of Rrose Sélavy, at Restaurant Victoria in Paris, sponsored by the Association pour l'Etude du Mouvement Dada.

During summer spent in Cadaqués, executes nine etchings of details of the *Large Glass*, which are published by Arturo Schwarz two years later.

In October, paintings representing the murder of Duchamp are shown by artists Aillaud, Arroyo, and Recalcati at the Galerie Creuze, Paris. Duchamp declines to sign a protest.

About this time, forced to vacate the 14th Street studio. Moves the nearly completed *Given* to a small room in a commercial building at 80 East 11th Street.

1966 Assists organization of *Hommage à Caissa* exhibition at Cordier & Ekstrom Gallery, New York (February 8–26), to benefit Marcel Duchamp Fund of American Chess Foundation.

Large Glass reconstructed, together with studies, by Richard Hamilton at the University of Newcastle-upon-Tyne, England.

Exhibited in May as *The Bride Stripped Bare by Her Bachelors, Even, Again,* with photoreportage catalog.

First major European retrospective exhibition, *The Almost Complete Works of Marcel Duchamp,* organized by Richard Hamilton for the Arts Council of Great Britain at the Tate Gallery, London (June 18–July 31). Catalog by Richard Hamilton includes 242 items and "Elements of a Descriptive Bibliography" by Arturo Schwarz. Duchamp visits London on the occasion of the exhibition.

Tristram Powell makes a film, *Rebel Readymade,* for BBC television, which is shown on *New Release* on June 23.

Interviewed by William Coldstream, Richard Hamilton, Ronald Kitaj, Robert Melville, and David Sylvester at Richard Hamilton's home in London on June 19 for BBC (unpublished).

Special July issue of *Art and Artists* (London), with cover by Man Ray, devoted to Duchamp.

Publication of *The World of Marcel Duchamp,* by Calvin Tomkins and the Editors of Time-Life, Inc., New York.

Completes and signs last major work, *Given: 1. The Waterfall, 2. The Illuminating Gas,* 1946–66, in the secrecy of room 403, 80 East 11th Street.

Nine works included in the *Dada Austellung* at the Kunsthaus, Zurich (October 8–November 7); the exhibition travels to the Musée National d'Art Moderne, Paris (November 30, 1966–January 30, 1967).

1967 Writes notes and assembles photographs in New York for book of instructions for dismantling and reassembling of *Given.*

Publication of important extended interviews by Pierre Cabanne, *Entretiens avec Marcel Duchamp,* in Paris. English translation by Ron Padgett published in New York (in 1971).

Publication by Cordier & Ekstrom Gallery, New York, of *A l'infinitif,* a limited boxed edition of seventy-nine unpublished notes dating from 1912 to 1920, reproduced in facsimile. Accompanied by English translation by Cleve Gray.

Publication in Milan by Arturo Schwarz of *The Large Glass and Related Works* (Volume I), including nine etchings by Duchamp of the *Glass* and its details.

Important family exhibition *Les Duchamps: Jacques Villon, Raymond Duchamp-Villon, Marcel Duchamp, Suzanne Duchamp-Crotti* at the Musée des Beaux-Arts, Rouen (April 15–June 1). Eighty-two works included. Catalog essay on Duchamp by Bernard Dorival.

First major showing in Paris at Musée National d'Art Moderne: *Duchamp-Villon, Marcel Duchamp* (June 6–July 2). Eighty-two works included. Catalog of Rouen exhibition, with alterations.

Exhibition *Editions de et sur Marcel Duchamp,* at Galerie Givaudan, Paris (June 8–September 30). Duchamp designs poster.

Begins work on nine etchings on theme of The Lovers for future publication by Arturo Schwarz.

One-man exhibition *Marcel Duchamp/Mary Sisler Collection* tours New Zealand and six museums in Australia during 1967–68.

Publication in Paris of monograph by Octavio Paz, *Marcel Duchamp ou le château de la pureté.*

1968 Sometime prior to his departure for Europe this summer, takes Bill Copley to see the completed *Given* in his secret studio and expresses the wish that it join the large group of his works already in the Philadelphia Museum of Art. Copley feels that the Cassandra Foundation, with which he is at that time associated, could assist in making this possible.

Participates in *Reunion,* a musical performance organized by John Cage in Toronto, Canada, on February 5, during which Duchamp, Cage, and Teeny Duchamp play chess on a board electronically wired for sound.

Attends premiere performance (March 10) of Merce Cunningham's *Walkaround Time,* presented during the Second Buffalo Festival of the Arts Today at the State University College at Buffalo, New York. Music . . . *for nearly an hour* . . . composed by David Behrman, and played by John Cage, Gordon Mumma, David Tudor, and David Behrman. Decor based on the *Large Glass* supervised by Jasper Johns.

Featured in exhibition and catalog of *Dada, Surrealism, and Their Heritage,* organized by William S. Rubin at the Museum of Modern Art, New York (March 27–June 9). Thirteen works included. Duchamp attends opening. Exhibition travels to Los Angeles and Chicago.

Works on handmade anaglyph of the fireplace and chimney that he had had constructed in the Duchamps' summer apartment in Cadaqués.

Orders Spanish bricks for use around door of *Given* in permanent installation.

Dies on October 2 in Neuilly, during his customary summer and early fall visit to Paris and Cadaqués. Buried with other members of Duchamp family in the Cimetière Monumental at Rouen. At his request, his gravestone bears the inscription "D'ailleurs c'est toujours les autres qui meurent."

<div align="center">*　*　*</div>

Publication of *To and from Rrose Sélavy*, by Shuzo Takiguchi, Tokyo, in a deluxe edition upon which Duchamp had collaborated, as did Jasper Johns, Jean Tinguely, and Shusaku Arakawa.

Publication of *Marcel Duchamp, or the Castle of Purity*, by Octavio Paz, in a boxed folio designed by Vicente Rajo (Mexico City: Era). French translation, Galerie Givaudan (Paris), 1968; Gallimard, 1970. English translation, Cape Goliard (London) in association with Grossman Publishers (New York), 1970.

Featured in exhibition and catalog of *The Machine as Seen at the End of the Mechanical Age*, organized by Pontus Hultén for the Museum of Modern Art, New York (November 28, 1968–February 9, 1969). Thirteen works included. Exhibition travels to Houston and San Francisco.

1969　Publication by Arturo Schwarz in Milan of *The Large Glass and Related Details* (Volume II), including nine etchings by Duchamp on theme of "The Lovers."

As Duchamp had hoped, his last major work, *Given*, enters the Philadelphia Museum of Art (as a gift from the Cassandra Foundation). The existence of the work remains a secret until it is finally installed in the museum. It is disassembled by Paul Matisse in collaboration with the museum staff, following Duchamp's written instructions, and transported in February from New York to Philadelphia. It is reassembled and installed in the small room Duchamp had suggested, at the rear of the galleries containing the Arensberg Collection. The room is opened to the public on July 7.

Publication of Arturo Schwarz's major monograph and catalogue raisonné, *The Complete Works of Marcel Duchamp*, accom-

panied by a volume of *Notes and Projects for the Large Glass*, which includes reproductions and English translations of 144 notes.

Featured in special summer issue of *Art in America*, New York. This section edited by Cleve Gray.

Publication of summer issue of *Philadelphia Museum of Art Bulletin* devoted to *Given*, "Reflections on a New Work by Marcel Duchamp," by Anne d'Harnoncourt and Walter Hopps. The first extended study of this work.

Since the public appearance of *Given* in 1969, and the resulting apparent "completion" of what the Tate Gallery exhibition called "The Almost Complete Works of Marcel Duchamp," exhibitions, books, and articles devoted to those works have proliferated. Suffice it to cite here the two most comprehensive exhibitions, whose catalogs also contain extensive bibliographical references:

September 22, 1973–April 21, 1974. *Marcel Duchamp.* Organized jointly by the Philadelphia Museum of Art and the Museum of Modern Art, New York. Also traveled to the Art Institute of Chicago. Contained 292 items.

January 31–May 2, 1977. *Marcel Duchamp.* Musée National d'Art Moderne, Centre National d'Art et de Culture Georges Pompidou, Paris. Contained 202 items.

The most complete anthology of Duchamp's writings to date appeared in 1973: *Salt Seller: The Writings of Marcel Duchamp*, ed. Michel Sanouillet and Elmer Peterson (New York: Oxford University Press). A revised and slightly expanded French edition (*Duchamp du Signe*, published by Flammarion) appeared in 1975. Duchamp's work never seems to be quite complete, however. Over 200 previously unpublished notes by Duchamp, dating from the same years as those in *The Green Box* and *A l'infinitif*, are currently being prepared for publication by the Musée National d'Art Moderne in Paris.